WEARABLE ART
Accessories & Jewelry
1900-2000

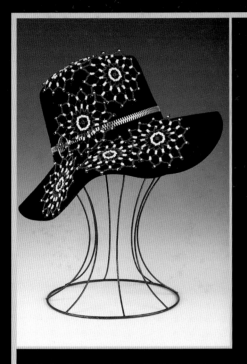
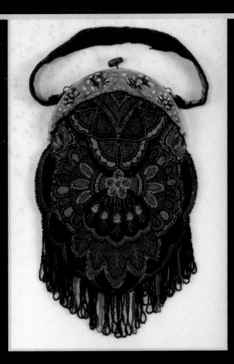
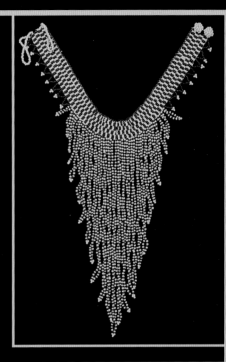

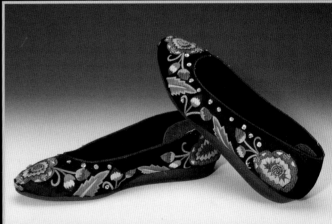

Leslie Piña & Shirley Friedland

Schiffer Publishing Ltd

4880 Lower Valley Road, Atglen, PA 19310 USA

Dedicated to the creators and lovers of beauty everywhere

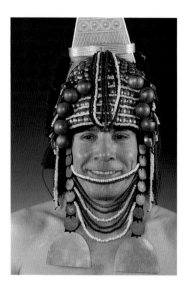

Book Design by Leslie Piña
Layout by Bonnie M. Hensley
Type set in DiskusDMed/Korinna BT

ISBN: 0-7643-0971-4
Printed in China
1 2 3 4

Published by Schiffer Publishing Ltd.
4880 Lower Valley Road
Atglen, PA 19310
Phone: (610) 593-1777; Fax: (610) 593-2002
E-mail: Schifferbk@aol.com
Please visit our web site catalog at **www.schifferbooks.com**

In Europe, Schiffer books are distributed by Bushwood Books
6 Marksbury Avenue Kew Gardens
Surrey TW9 4JF England
Phone: 44 (0)181 392-8585; Fax: 44 (0)181 392-9876
E-mail: Bushwd@aol.com

This book may be purchased from the publisher.
Include $3.95 for shipping. Please try your bookstore first.
We are interested in hearing from authors with book ideas on related subjects.
You may write for a free printed catalog.

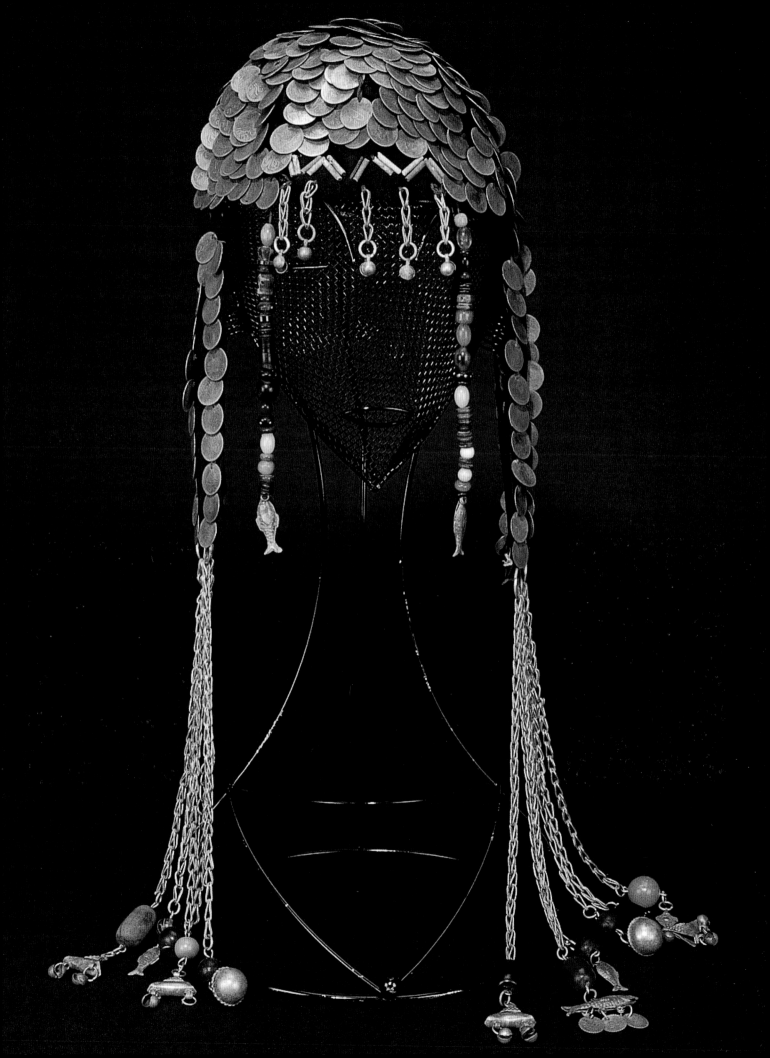

Acknowledgments

The authors would like to thank the many contributors who created and/or loaned items to be photographed. Most are identified in the photo captions or before a grouping, as noted. If the line states "by someone" it means that the article was designed and constructed by that person. "Courtesy" means that the person named allowed us to photograph the article. Thanks to Barbara Bachman, Paulette Batt (Paulette's Antiques & Vintage Clothing, Shaker Heights, OH), Lynn Landy Benade, Marilyn Bennett, Bonnie (Bonnie's Goubaud, Eton Square, Woodmere, OH), Linda Bowman (Legacy Antiques, Shaker Heights, OH), Susan Cavey (Odd Ball Bags, 4806 Euclid Ave. #24, Cleveland, OH 44103), Linda Cohen, Katharine Moore Coss, Cheri Discenzo, Lois Epstein and the estate of Rose Allen, Diana Papp Finn, Nancy Goldberg, Cyndy Goodwin, Joan B. Goulder, Anna Greenfield, Lillian Horvat, Donna Kaminsky, Connie Korosec, Ruth Kyman and the estate of Zelta Schulist Glick, Emma Lincoln, Ruth K. Marcus, Janet King Mednik, Denise Newman (Isle of Beads, Cleveland Heights, OH), Paula Ockner, Sandy Osborne, Sharon Ramsay, Riley Hawk Galleries (Cleveland, OH), Beverlee Rosenbluth, Saks Fifth Avenue (Beachwood Place, Beachwood, OH), Arlene Schreiber, Barbara MacDonald Shenk, Anita Singer, Susanne Bodenger Skove, Liz Tekus (Fine Points, Cleveland, OH), Veronica Trainer, Charlotte Michell Trenkamp, Bunnie Union, Ursuline College Historic Costume Study Collection, Donna Wasserstrom, Lorita Winfield, and Timmy Woods (Beverly Hills).

Special thanks to Paula Ockner for proofreading and to Peter and Nancy Schiffer, Jennifer Lindbeck, Bonnie Hensley, and the staff at Schiffer Publishing.

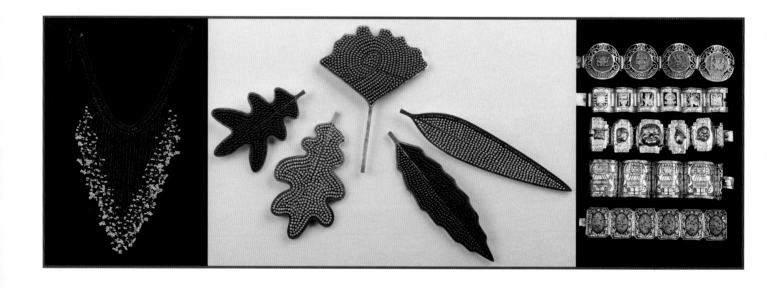

Contents

Introduction.....6

Chapter 1: Hats.....10

Chapter 2: Scarves & Collars.....22

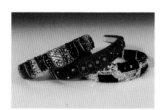

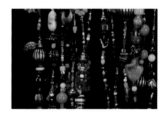

Chapter 3: Jewelry.....34

Chapter 4: Handbags.....99

Chapter 5: Belts, Gloves, & Miscellany......156

Chapter 6: Shoes & Boots.....165

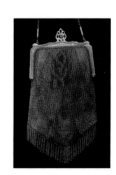

Glossary.....181

Bibliography.....183

Index.....184

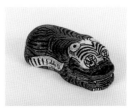

Introduction

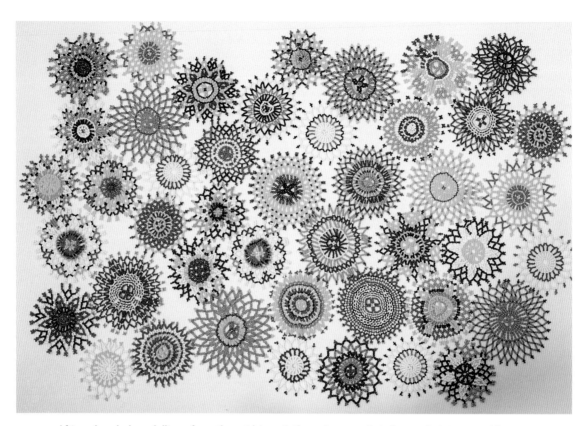

African beaded medallions from the mid-twentieth century, ready to be made into wearable art.

Wearable Art 1900-2000, the companion volume to this book, begins by admitting that wearable art is as difficult to define as other forms of art; however, there are qualities and portions of a definition on which many people can agree. The easiest part of wearable art is that it is "wearable." Whatever it is, it can be worn as apparel and to accessorize.

Wearable art is designed and made by someone. Now, one might argue that all apparel and accessories are designed and made by someone, and that is true. But there is a line between what we are calling wearable art and most commercially made items. It might be easier to first suggest what *is* definitely wearable art and what is definitely *not* wearable art. If someone with a good sense of design and color, and with a degree of skill in construction and embellishment techniques, makes a visually distinctive and hopefully beautiful item, then it is very likely to be wearable art. If this person begins with another artist's idea or pattern and adapts and modifies it so it becomes a completely different design, it is also likely to be wearable art. So a definition might include criteria like original design or original adaptation of a

design. Conceivably, even an unmodified good copy could be considered wearable art. A definition might also include skilled and original or interpretative use of traditional methods of construction and decoration.

These descriptions apply to many of the pieced, knitted, beaded, embroidered, appliquéd, molded, cast, carved, painted, enameled, and otherwise artistically embellished items that can be seen at shows and in specialty boutiques, galleries, and even museums. In some cases the components are first fabricated by the artist—glass beads or Femo for example. In others, the original fabricator is unknown, but the artistic components are later used to make a new final product, e.g., a necklace using antique Venetian glass beads or figural silver charms. In either case, both the individual parts and the final work of art to wear represent creative and technical skill and an artistic result. Artistic is the operative word.

There are well-designed and well-made wearable accessories that are both useful and beautiful, but they do not necessarily qualify for inclusion in a definition of wearable art. A strong decorative aspect is needed, whether incorporated in the form or applied as embel-

lishment. This decoration is usually expected to be hand made by painting, carving, enameling, etc. Even if it was a production item, like the Art Deco mesh handbags, the enameled graphic design gives each bag its artistic quality and consequent desirability.

The early twentieth-century wearable art accessories shown herein were originally made and sold commercially, and were intended to be wearable, but probably not art. Today, these beautifully designed and crafted items are also considered by many to be wearable *and* art. And why not? Must an item be one-of-a-kind to be considered art? Of course not. For example, prints are not unique like paintings; yet they are not reproductions, but rather, multiple originals. Mass-produced furniture or glassware or other decorative art is no less desirable because there are multiple copies. A mass-produced piece by an important designer from the 1950s might be more significant as a work of modern design than another one made by hand, and it might be far more collectible and costly than even a much older example.

We have presented a sampling of both contemporary and vintage wearable art accessories. The book is divided into chapters, displaying accessories from top (hats) to bottom (shoes). The chapters are arranged visually as well, e.g., by similar styles or techniques; in some cases

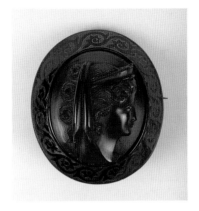

Carved jet cameo brooch, late Victorian. *Courtesy of Paula Ockner.*

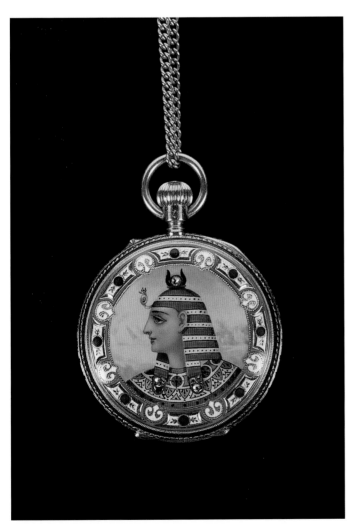

Gold pocket watch, Swiss movement made in France (detailed labels and engraved markings), with enameled and jeweled case, mid-19th century; an example of Museum-quality wearable art but of an earlier period than the parameters of this book.

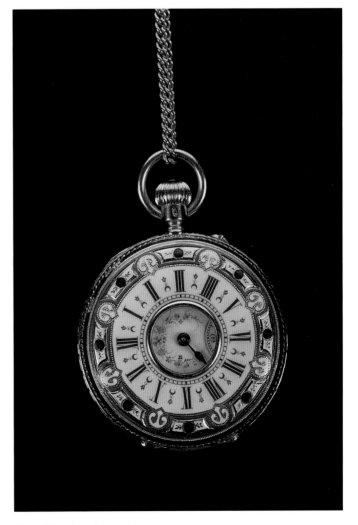

Face side of pocket watch.

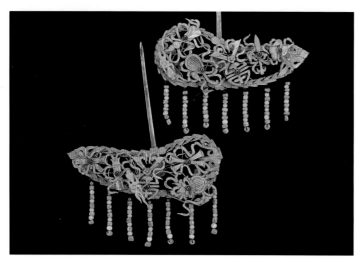

Chinese 18th-century feather art: rare example of delicate hair ornament made of turquoise feathers on gold, with coral beads. *Courtesy of Lorita Winfield.*

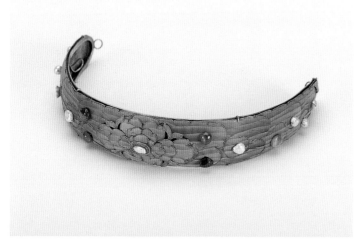

Chinese feather art tiara with semi-precious stones. *Courtesy of Lorita Winfield.*

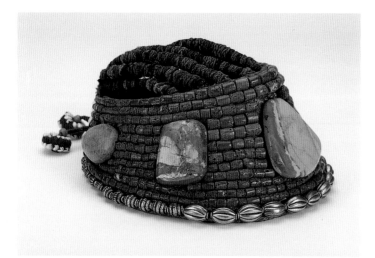

Tibetan headpiece of coral and silver beads with large turquoise stones, 18th century; another example of the non-Western museum-quality wearable art from periods earlier than we are including in this book. *Courtesy of Lorita Winfield.*

Tibetan headpiece of coral beads with turquoise, 18th century. *Courtesy of Lorita Winfield.*

we have made an attempt to place the items in chronological order. In most cases, while vintage and contemporary articles are interspersed, groups of vintage often wind up together because of similarities in style. Some date from the early part of this century when things were typically made or decorated by hand with painstaking detail.

Earlier wearable art, regardless of its beauty or significance, is not included. From European enameled gold watches to exotic tribal headwear, these objects, though certainly wearable art, warrant separate treatment in appropriate cultural and historical contexts. For the purposes of this book, the time element is the easiest qualifier with which to work.

It is more difficult to determine what to exclude from the range of twentieth-century wearable art, because there are always exceptions that resist the boundaries of a definition. Do all new commercially-made accessories fall outside of our definition? No, but most probably do. In other words, the definition must be flexible and able to incorporate the unexpected. As long as an item is designed and made with a conscious effort to be as artistic as it is functional, it could be eligible. Any potential article of wearable art must be judged on its own merits. It is not for us to determine what all wearable art is or is not. What we hope to do is to present some good and some extraordinary examples of recent creations that can be considered wearable art by most definitions. We also want to suggest that some categories of vintage

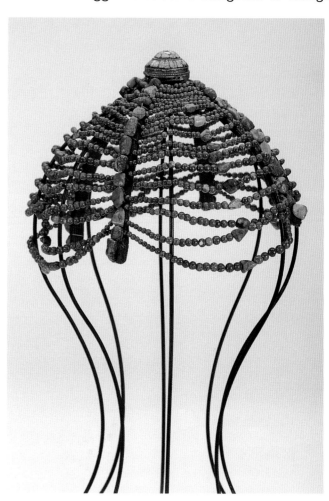

fashion and even some commercially-made items legitimately fall within these flexible outlines of a definition.

Commercial manufacture is still the exception, and most of what we are calling wearable art is made by an individual by hand or by a combination of hand and machine work—be it in construction, decoration, or both. There are many different techniques used to make these articles. Most photo captions include materials and techniques, and the glossary includes these terms with general definitions for additional explanation. But this is not a how-to book—it is a visual presentation of some of the wearable art accessories available today. And because so many are unique, by the time this book goes to press, there are likely to be many different innovative ideas and techniques to see. It is precisely this dynamic quality that makes the concept and the developing field of wearable art so exciting, and we hope that the readers will agree.

The uniqueness of some items can be particularly problematic when assigning them a monetary value. If something is so unusual that there is no established market, then the price is difficult to set. In the case of contemporary work by an active artist, the listed price represents what a gallery, show, or other retail source might ask. This is usually given as a range, since the price can vary according to the retailer's mark up. For some of the more commercial items, such as the Judith Leiber jeweled handbags, the actual retail price from the store tag is listed.

Most vintage items are already included in a category of the collectible market and fall within a known range. Beaded handbags, for example, are widely collected in all parts of the country, so there are many examples from which to derive an appropriate value range. However, some are so unusual that they must be evaluated as individual works of art rather than examples of a familiar category. The benefit of listing a price for an exceptional item is precisely that—to separate the item from others in its category. Whether a rare beaded bag is valued at $1,200 or $1,500 is less important than knowing that it *is* a rare example. Similarly, whether a very pretty, but more ordinary bag is valued at $100 or even $200 is less significant than the fact that it is certainly not worth much more or much less. In other words, the guide can be instructive if used to identify categories and distinguish quality. It is really not meant to set prices or even to influence your shopping.

Some items are too "old" to be given a current retail asking price, yet too "new" to be part of the established vintage market. Shoes, for example, are very difficult to value. A new pair of designer shoes at a fine retail store might be many hundreds of dollars, while an equally artistic pair ten or twenty years old might command only a small fraction of the price. It is not unusual to collect vintage handbags for their artistic quality rather than function—delicate beaded bags are rarely worn. But shoes are not as easy to display or even to justify as a collectible. Vintage shoes are often purchased to be worn—so they must *fit*. Retro is part of current fashion as much as it is a focus of collectors. This can influence both the collection and its valuation.

As with other categories of vintage fashion, the value range for accessories may be more realistic in some areas of the country than in others. There is often a fine line between "used clothing" and "collectible vintage fashion," and the line moves. We can only guarantee that there will be changes, so we ask the reader to consult the price guide very cautiously, and to be aware that prices are variable and constantly changing.

Neither the authors nor the publisher can take any responsibility for the outcomes from consulting this price guide. We would, however, like very much to have a hand in the enjoyment the reader will get from looking at the pictures of these wonderful wearable works of art.

Detail of extremely fine European petit point handbag from mid-twentieth century. *Estate of Rose Allen.*

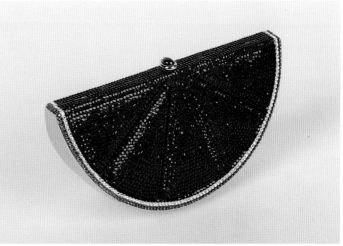

Jeweled watermelon handbag by Judith Leiber, 1999. *Courtesy of Saks Fifth Avenue, Beachwood Place.*

Chapter 1: Hats

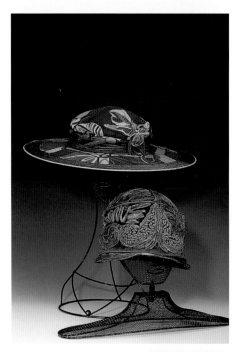

Wide rimmed hat of printed and pieced fabric on straw, with straw band and decoration with hanging beads, c. 1915; cloche made of silk knots, with metallic thread decoration, c. 1920s. *Courtesy of Anna Greenfield.* $100-125 each.

Detail of cloche.

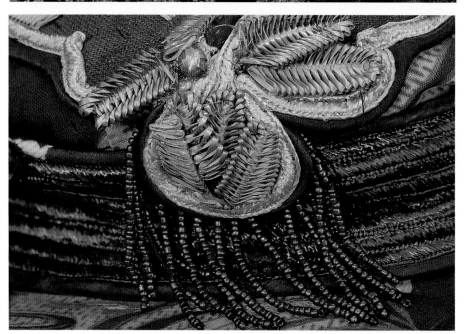

Detail of wide rim.

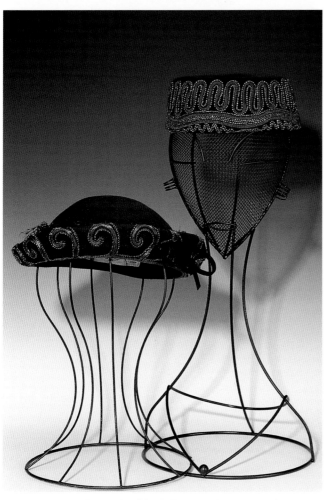

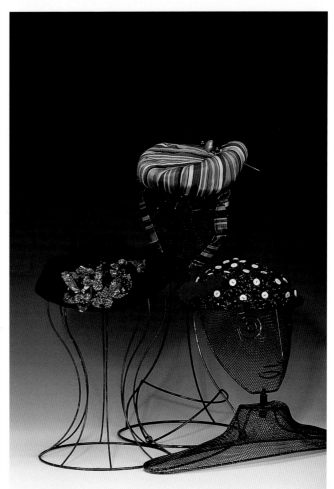

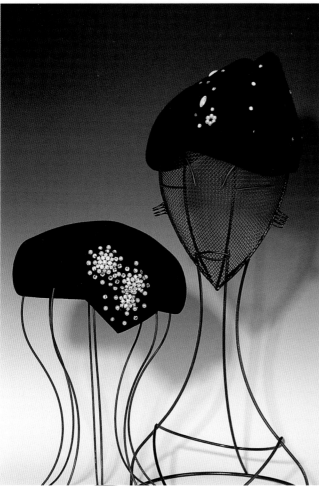

Top left: *Left:* brown felt, turned brim with brown satin cording bordered with gold glass cut beads, label: A. Polsky Co., Akron, Ohio; *right:* brown pillbox with brown satin thread embroidery bordered with gold metal seed beads, Mr. D. designer; all c. 1960s. *Courtesy of the Ursuline College Historic Costume Study Collection.* $75-100 each.

Bottom left: Black velvet caps embellished with rhinestones and faux pearls, c. 1950s. *Courtesy of the Ursuline College Historic Costume Study Collection.* $25-35 each.

Top right: Felt with sequins; Roman stripe silk; straw with buttons. c. 1950s. *Courtesy of Anna Greenfield.* $25-35 each.

Bottom right: Detail of stripe.

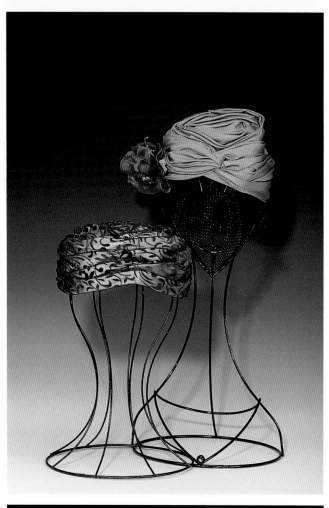
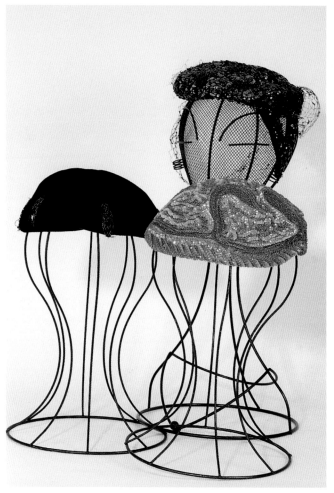
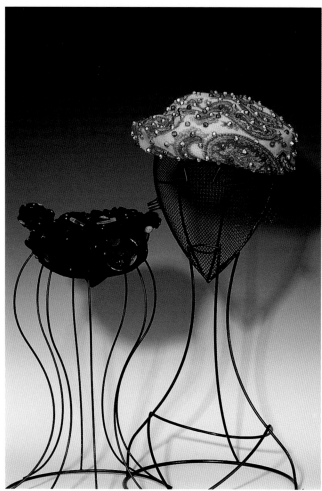
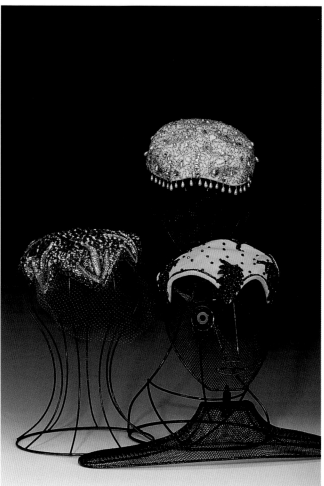

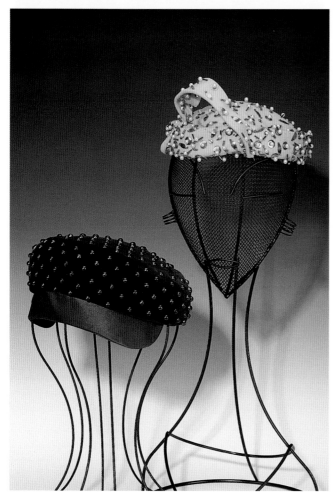

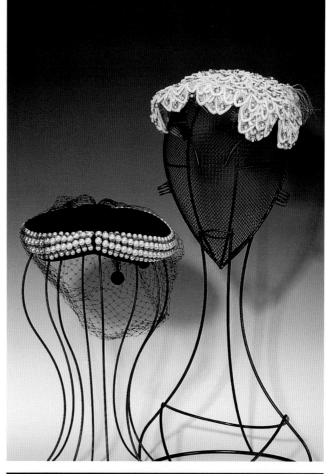

Above: *Left:* royal blue velvet with satin brim, studded with faux pearls; *right:* cream felt with gold sequins and pearl centers, c. 1950s. *Courtesy of the Ursuline College Historic Costume Study Collection.* $25-35 each.

Top right: *Left:* black velvet pillbox bordered with rows of faux pearls, with veil, c. 1950s; *right:* cream lace, beaded with pearls and bugles, with veil, label: The Halle Bros. Co., c. 1950s. *Courtesy of the Ursuline College Historic Costume Study Collection.* $40-60 each.

Bottom right: *Left:* black satin cap with black cording bordering beaded crescent shapes, designed by Schiaparelli, made in Paris, c. 1950s. *Courtesy of Charlotte Michell Trenkamp.* $100-125. *Right:* brown satin crown with tambour stitched iridescent sequins, glass beads in vermicelli pattern, c. 1960s. *Courtesy of the Ursuline College Historic Costume Study Collection.* $50-75.

Opposite page:
Top left: *Left:* colorful turban; *right:* blue silk turban with hot pink flower. c. 1960. *Courtesy of Anna Greenfield.* $40-60 each.

Top right: 1950s hats. *Left:* navy velour, 6-gore cap with beaded appliqués; *top right:* navy with beads and sequins, triangular flap, veil, reproduction of a Jacques Fath design, made in Paris by Lessere; *bottom right:* rose with beads and sequins. *Courtesy of Donna Kaminsky.* $40-50 each.

Bottom left: *Left:* purple velour with faux jewels, c. 1930s; *right:* paisley with large beads, c. 1940s. *Courtesy of the Ursuline College Historic Costume Study Collection.* $20-25 each.

Bottom right: *Left:* sky tones of iridescent sequins, scalloped cap, c. early 1950s; *top:* beige with seed beads and edge of teardrop faux pearls, c. 1960; *right:* white felt cap with midnight blue iridescent seed beads in leaf motif, scalloped edge, c. early 1950s. *Courtesy of Anna Greenfield.* $40-50 each.

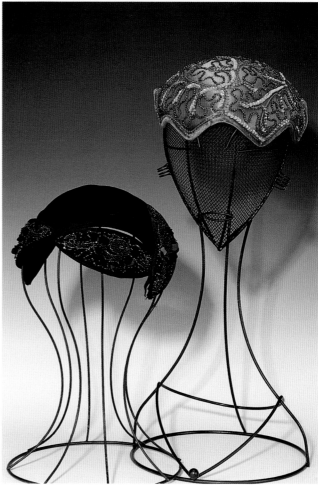

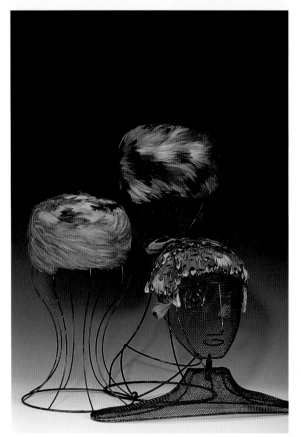

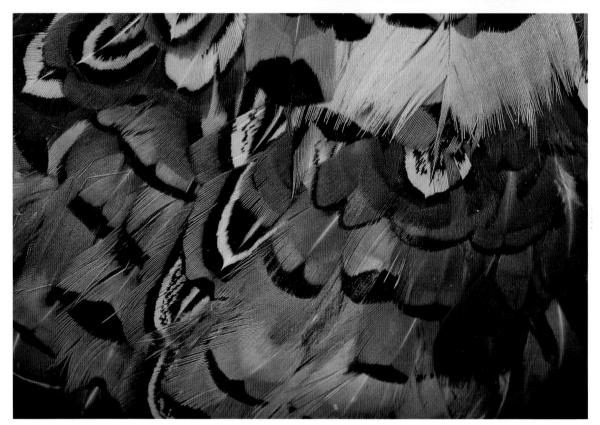

Top left: Three styles of feather art on pillbox hats and cap, c. 1950s-1960s. $50-75 each.

Top right & bottom: Detail.

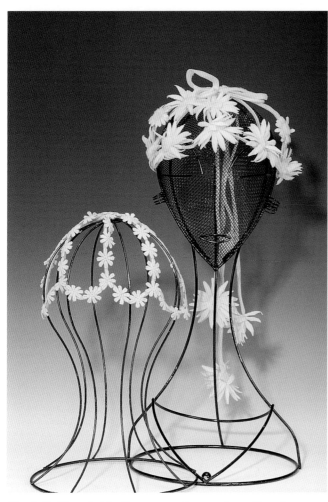

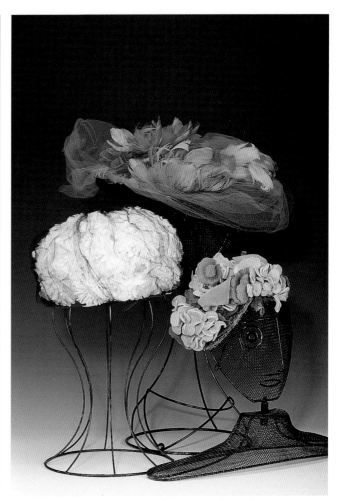

Top left: Cap of white flowers on wire; another with yellow flowers with streamers, c. 1950s. *Courtesy of Anna Greenfield.* $15-25 each.

Top right: Three different styles of flower art on hats, c. 1950s. *Courtesy of Anna Greenfield.* $20-30 each.

Bottom right: White woven straw covered with ribbon and silk flowers, c. 1950s.-*Courtesy of Ruth Kyman.* $20-25.

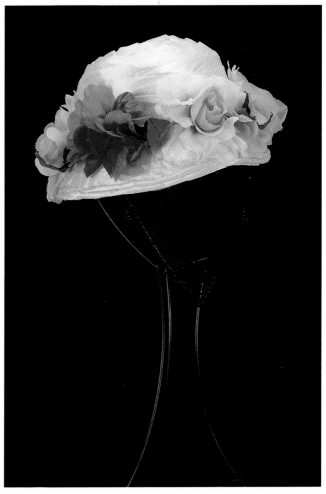

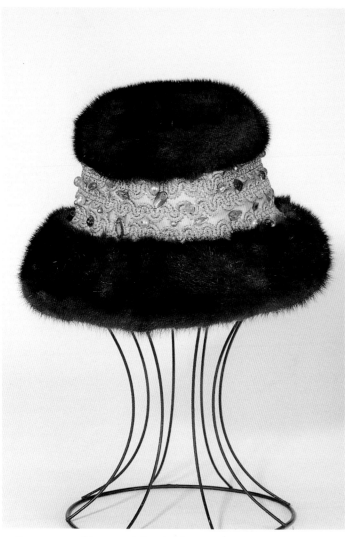

Fur crown and brim, with band of braiding and colored stones, c. 1960s. *Courtesy of Linda Bowman, Legacy Antiques.* $50-75.

Colorful cut ribbon secured onto white felt hat with pink yarn, amber plastic beads, c. 1960s. $25-35.

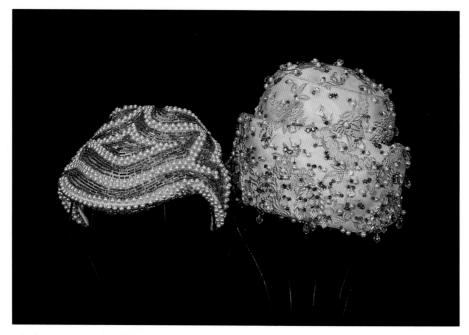

Left: cap covered with bugle beads and faux pearls, c. 1950s; *right:* turquoise pillbox with lace, beads, sequins, and faux pearls, c. 1960s. *Courtesy of Anna Greenfield.* $50-60; $25-35.

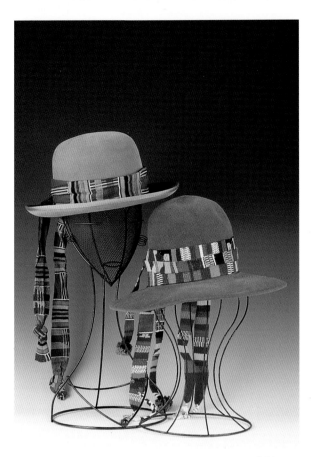

Fine felt velour hats with bands and streamers of African (*left*) and Guatemalan fabric, c. 1970s. $100-125 each.

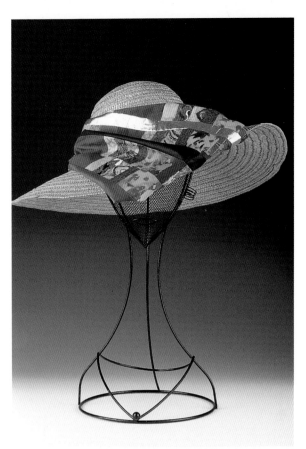

Wide brim straw hat trimmed with vivid colors of patchwork, c. 1990s. $60-80.

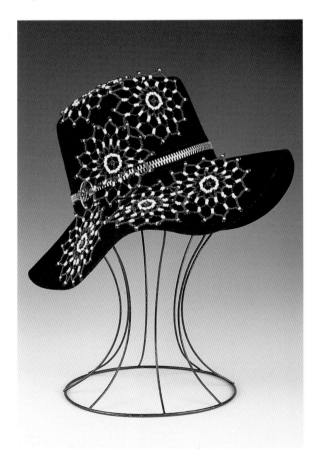

Black wool felt with oversized zipper connecting the crown to the brim, embellished with African beaded medallions, c. 1970s. $100-125.

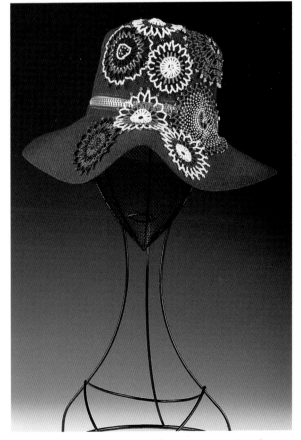

Orange wool felt with oversized zipper connecting the crown to the brim, embellished with African multi-colored beaded medallions, c. 1970s. $125-150.

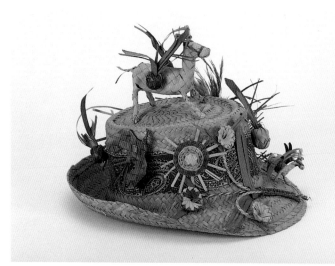 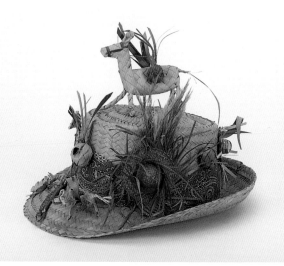

Mexican straw hat with applied figural decorations of donkeys, fruit, and flowers, c. 1940s. *Courtesy of Ruth Kyman*. $40-60.

Reverse side with applied miniature hat.

Peruvian crocheted cotton hat in vibrant colors and abstract animal motifs, label: Two City Girls, New York. $35-45.

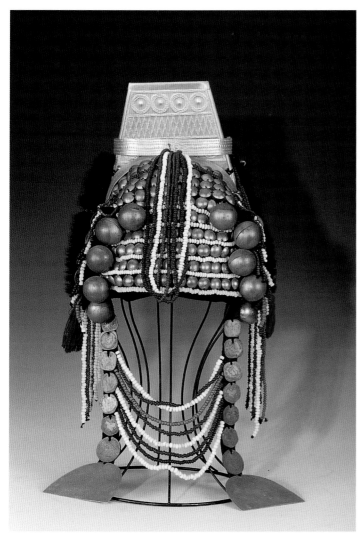

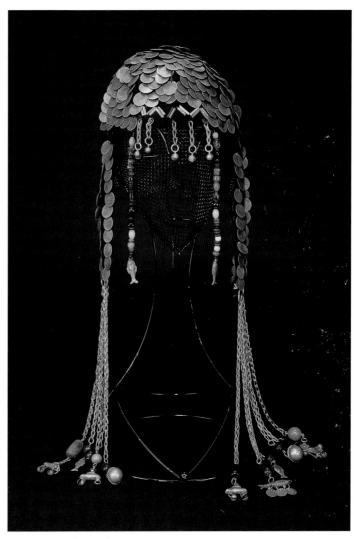

Antique tribal ceremonial cap from Thailand, with metal coins and balls and colorful strands of beads. *Courtesy of Barbara Bachman.* $100-200.

Antique tribal ceremonial cap from Thailand, with coins, metal streamers, beads, and charms. *Courtesy of Barbara Bachman.* $100-200.

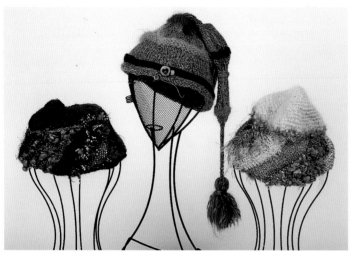

Hand knit caps, with stocking cap and tassel (*center*), embellished with colored yarns, and button. *By and courtesy of Liz Tekus, Fine Points.* $55-65; stocking: $75-85.

Detail.

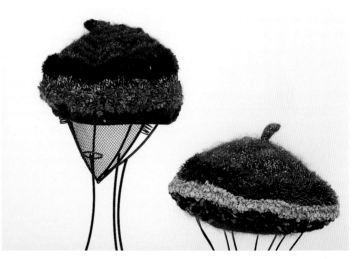

Hand knit beret and cap, both with fringe yarn. *By and courtesy of Liz Tekus.* $55-65 each.

Hand knit berets with textured yarns and chenille. *By and courtesy of Liz Tekus.* $55-65 each.

Opposite page:

Top left: Hand knit caps embellished with fringe yarn and beads. *By and courtesy of Liz Tekus.* $55-65.

Top right: Hand knit caps using alternating rows of variously textured yarns. *By and courtesy of Liz Tekus.* $55-65 each.

Bottom left: Hand knit berets with fringed and various other textural yarns. *By and courtesy of Liz Tekus.* $55-65.

Bottom right: Hand knit stocking cap made of variegated yarn, with applied fish charm. *By and courtesy of Liz Tekus.* $75-85.

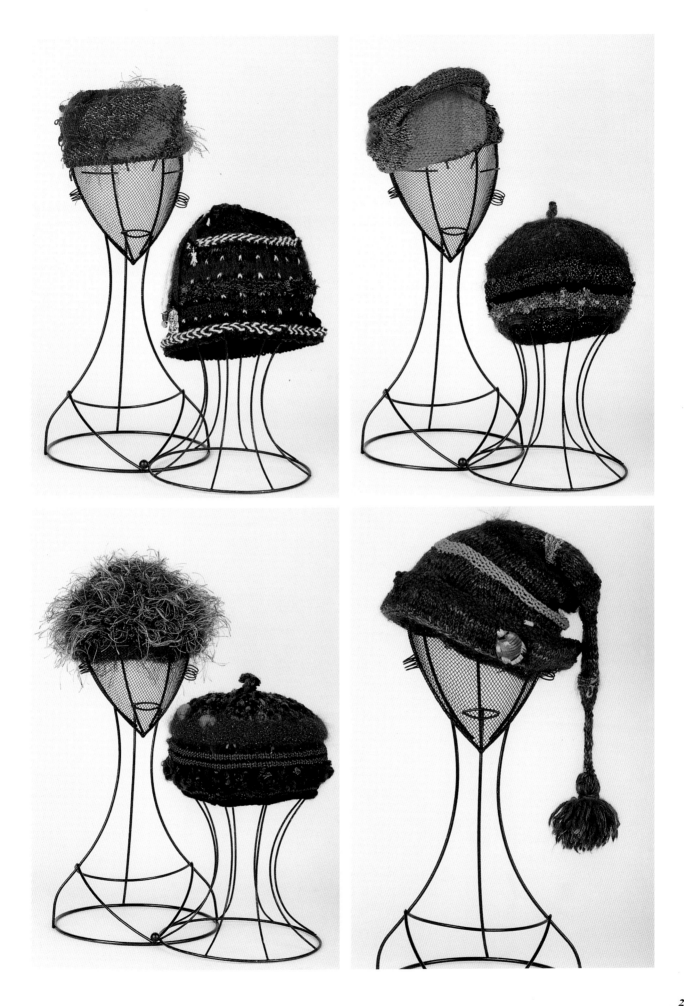

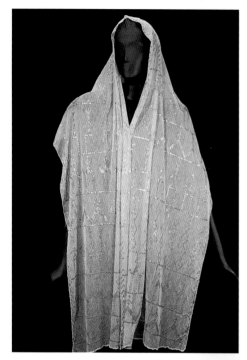

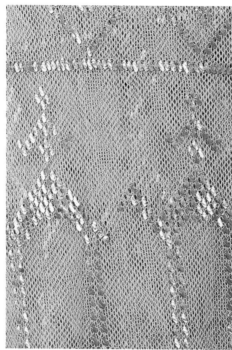

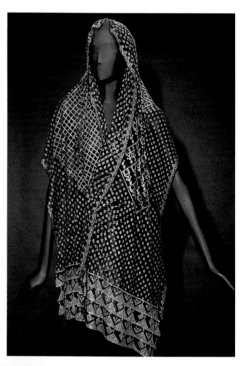

Cream color cotton mesh shawl/scarf with Egyptian metal decoration, c. 1920s. *Courtesy of Anna Greenfield.* $100-125.

Top center: Detail.

Black cotton and silk woven shawl/scarf with Egyptian metal decoration, c. 1960s. *Courtesy of Janet King Mednik.* $100-125.

Left: Detail.

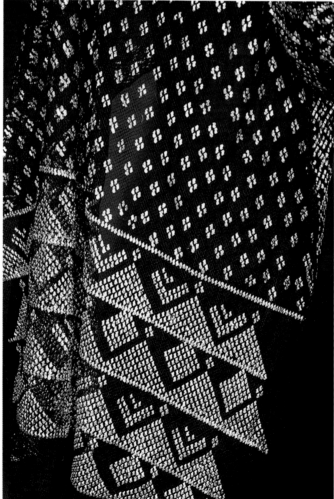

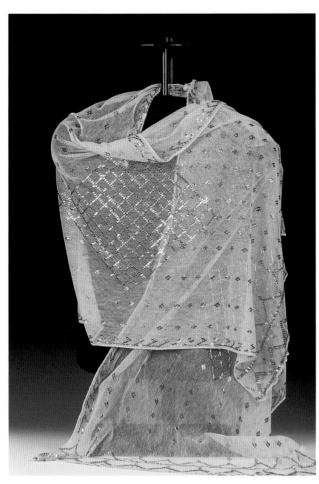

Cream color cotton mesh shawl/scarf with Egyptian metal decoration, c. 1920s. *Courtesy of Nancy Goldberg*. $100-125.

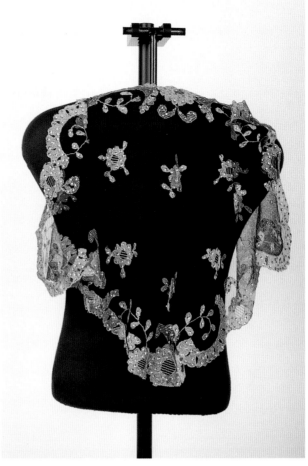

Black tulle scarf embellished with metallic embroidery and sequins, c. 1930s. *Courtesy of Nancy Goldberg*. $75-95.

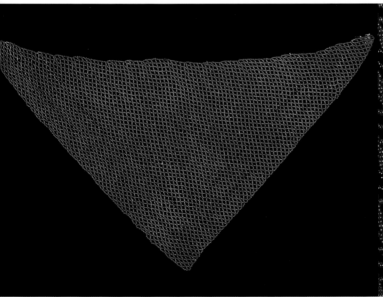

Art Deco red and gunmetal gray triangular scarf/bandanna of off-loom beading in netting or lattice pattern, c. 1920s. $150-200.

Detail.

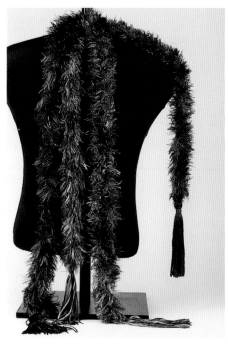

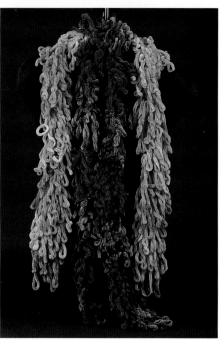

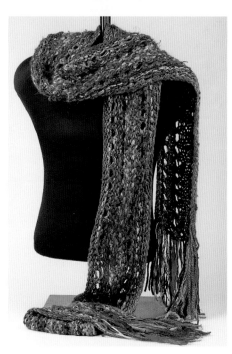

Hand knit boas of variegated and fringe yarns, 1990s. *By and courtesy of Liz Tekus.* $65-75 each.

Hand knit chenille yarn boas in hot tones, 1990s. *By and courtesy of Liz Tekus.* $50-60 each.

Hand knit scarf of multi-color and variegated yarns, 1990s. *By and courtesy of Liz Tekus.* $100-125.

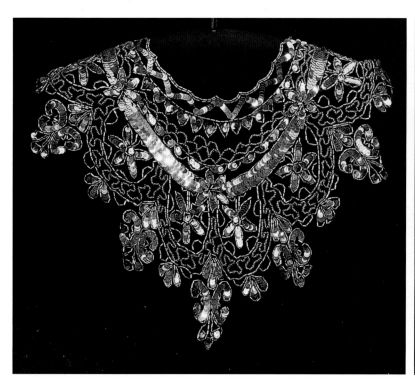

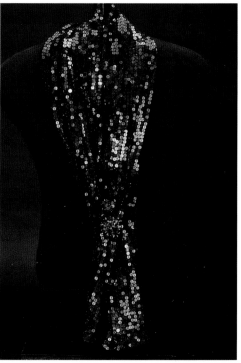

Openwork collar covered in gold sequins, with scallops of seed beads and bordering bugle beads, c. 1980s. *Courtesy Donna Kaminsky.* $50-75.

Multi-colored sequined scarf, c. 1980s. *Courtesy Donna Kaminsky.* $35-45.

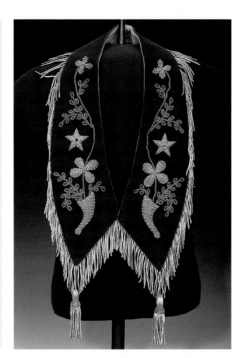

Neckline collar trim, hand tambour beaded on beige silk, with cream and taupe seed beads, and brown and white bordering bugle beads, c. 1930s. $75-125.

Red velvet lodge collar decorated with metallic embroidery, trim, and fringe, c. 1920s. *Courtesy Anna Greenfield.* $75-100.

Detail.

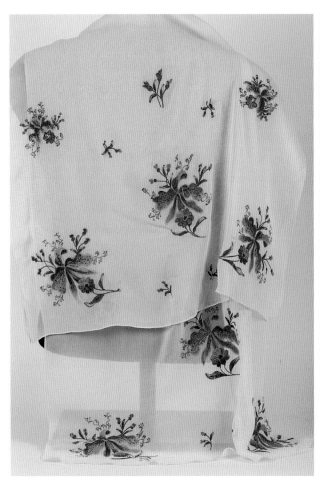

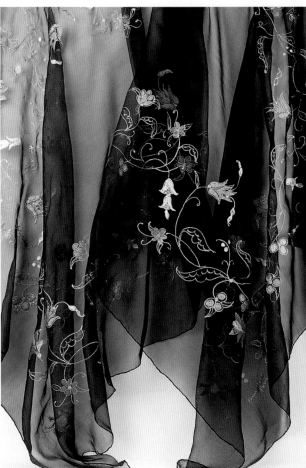

White silk chiffon, with hand painted orchids, unsigned, c. 1940s. *Courtesy of Marilyn Bennett.* $100-125.

Black silk chiffon, hand painted floral design outlined in various metallic colors, signed Irene Bors Pary, c. 1940s. *Courtesy of Marilyn Bennett.* $100-125.

Hand painted silk scarf with pomegranate motifs. $40-50.

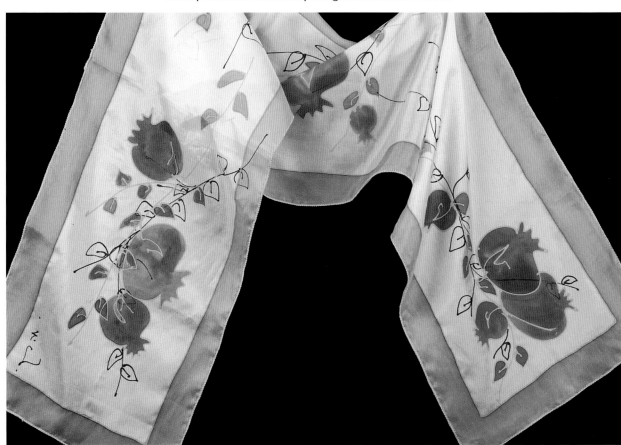

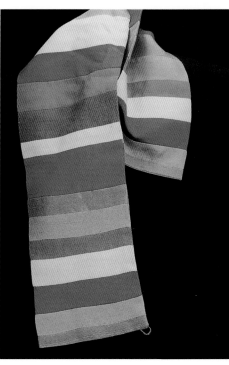

Scarf made from strips of brightly colored silk, 1960s. *By Shirley Friedland.* $40-50.

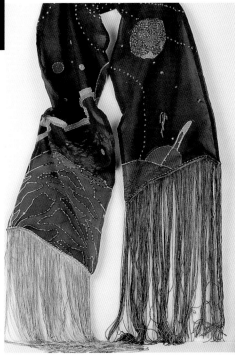

Hand painted and beaded silk scarf with long fringe, 1990s. *By and courtesy of Denise Newman of Isle of Beads.* $150-250.

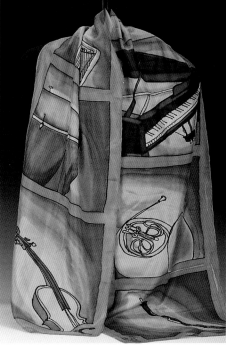

Hand painted silk scarf with musical motifs, by Gunter Schwegler, 1990s. *Courtesy of Paula Ockner.* $100-125.

The following hand painted silk scarves with hand-rolled edges are all from the late 1990s. *By and courtesy of Susanne Bodenger Skove.*

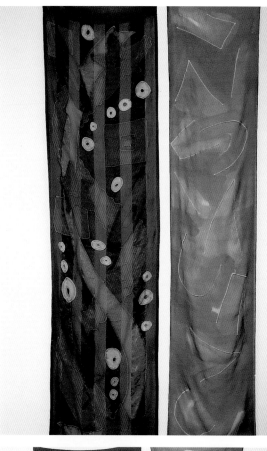
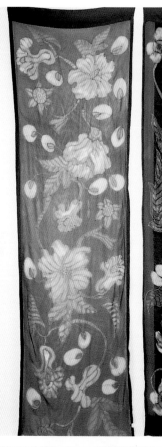

Top left: Silk jacquard with bold colorful abstract motif on black; silk chiffon version, in Gutta technique, average length two yards. $100-120 each.

Top right: Silk chiffon and silk jacquard scarves with floral motifs, in Gutta technique, average length two yards. $90-110 each.

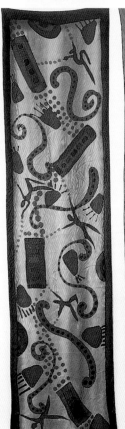
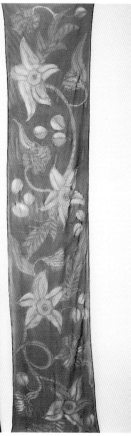
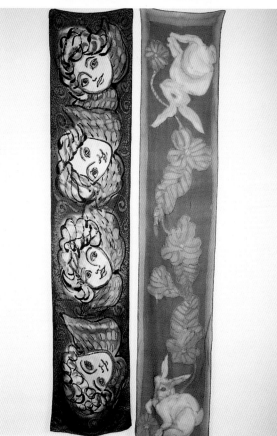

Bottom left: Silk with abstract pattern; silk chiffon scarf with floral motif, both in Gutta technique, average length two yards. $110-150 each.

Bottom right: Silk satin scarf with angel faces; silk chiffon with bunnies, in Gutta technique, average length two yards. $125-150 each.

Opposite page: Detail.

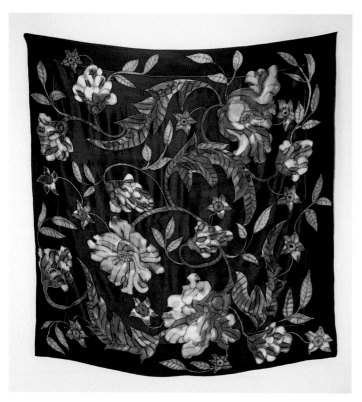

Large 43-inch square with hand painted floral motif. $240-260.

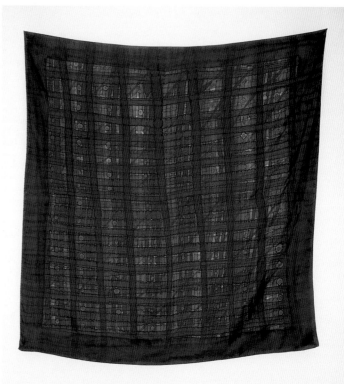

Large 43-inch square with hand painted blue and purple grid pattern. $150-175.

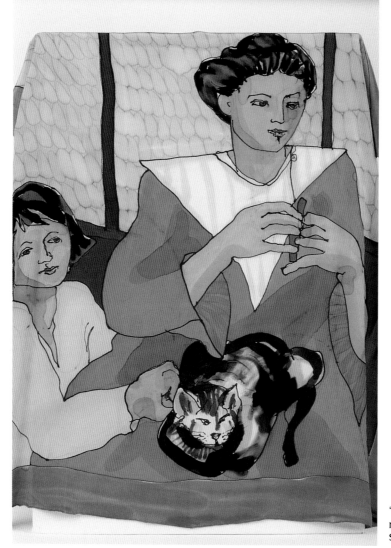

"Mother," large square with mother, child, and pet cat. $300-350.

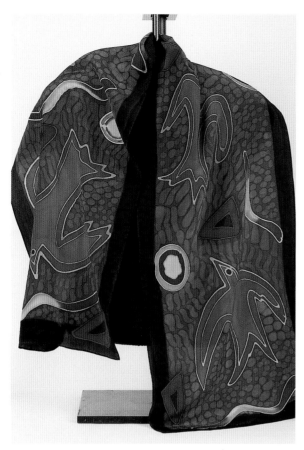

"Early Bird" of abstract birds in deep and subdued colors with black border. $140-160.

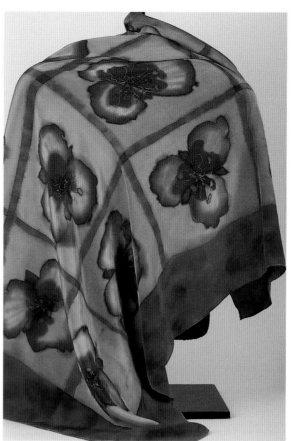

Gold background with mauve flowers in grid pattern. $240-260.

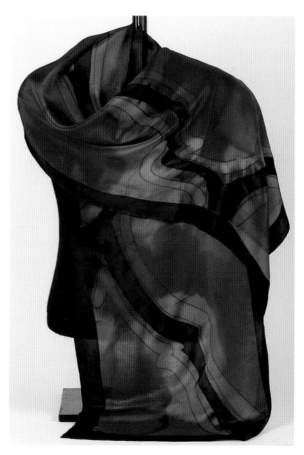

Vivid blue, green, purple, and magenta with black border. $135-150.

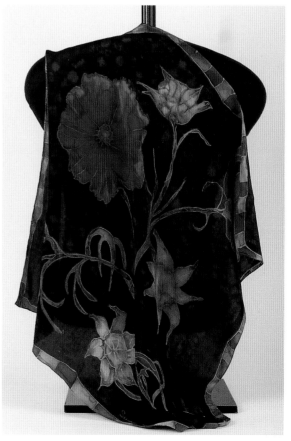

"Cosmos," black square with rust and muted chartreuse floral design. $115-135.

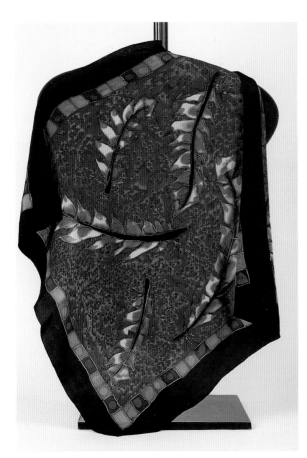

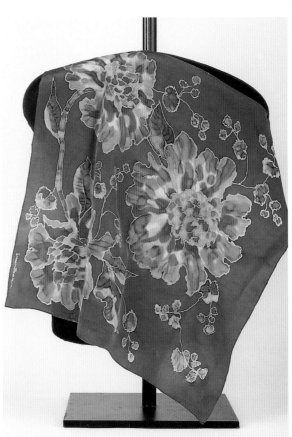

"Feathers," raspberry ground with checkered and black borders. $115-135.

"Peony," bright orange flowers on blue ground. $140-160.

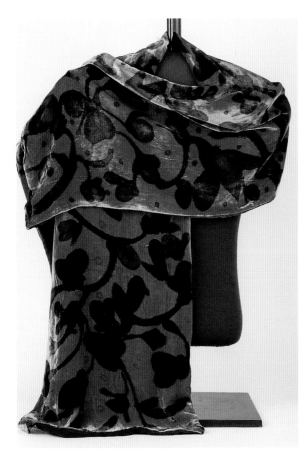

Silk velvet with silk jacquard lining, dark jewel tones on brown background. $200-220.

Silk velvet, unlined, clear jewel tones on black background (last Skove design). $100-120.

"Mashed Potatoes," hand painted silk charmeuse using gütta resist with fiber reactive dye, ready to be made into scarf or shawl. *By and courtesy of Lynn Benade.* $70-80 per yard.

Detail.

"Peacock Feathers," hand painted silk charmeuse using gütta resist with fiber reactive dye, ready to be made into scarf or shawl. *By and courtesy of Lynn Benade.* $70-80 per yard.

Detail.

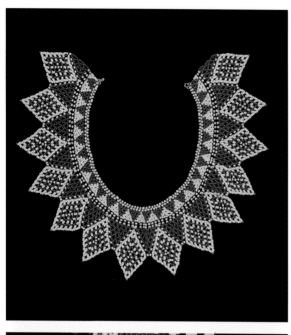

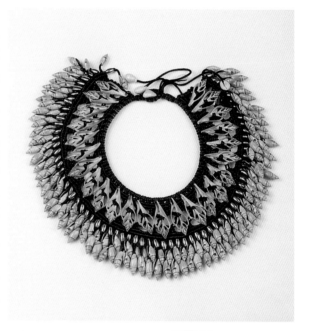

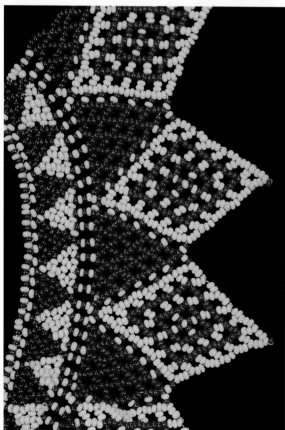

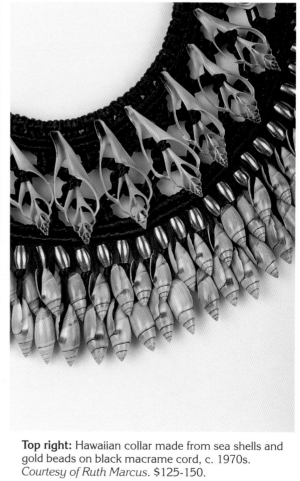

Top left: Red and yellow beaded collar in geometric pattern using off-loom method, c, 1970s. $75-100.

Bottom left: Detail.

Top right: Hawaiian collar made from sea shells and gold beads on black macrame cord, c. 1970s. *Courtesy of Ruth Marcus.* $125-150.

Bottom right: Detail.

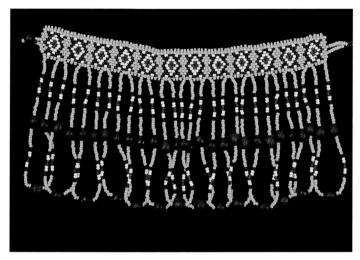

African collar of yellow, white, and red glass beads with black seeds, c. 1970s. $55-65.

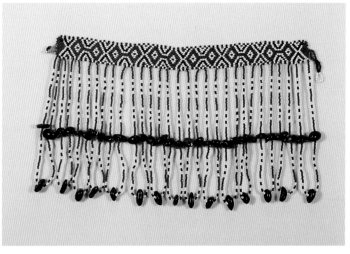

African collar of black, white, and red glass beads with black seeds, c. 1970s. $55-65.

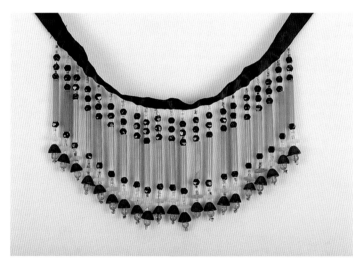

Collar of amber glass tubes and black jet faceted beads, on ribbon choker, c. 1920s. $65-75.

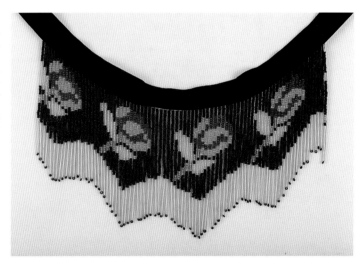

Fringe collar of glass seed beads strung in floral design, with amber glass tubes, on black ribbon choker, c. 1920s. $100-125.

African beaded fringe collar in blue, orange, and white, c. 1960s. $100-125.

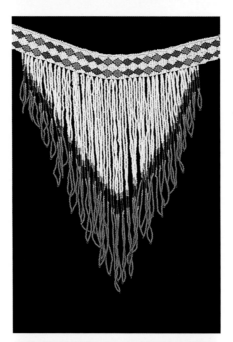

African beaded fringe collar in pale yellow and orange, c. 1970s. $100-125.

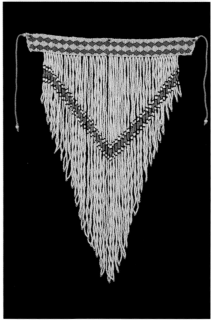

African beaded fringe collar in turquoise and off-white, c. 1970s. $125-150.

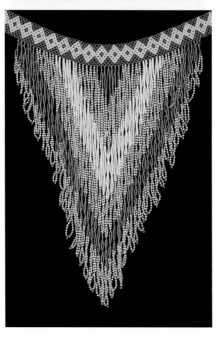

Opposite page:
Detail.

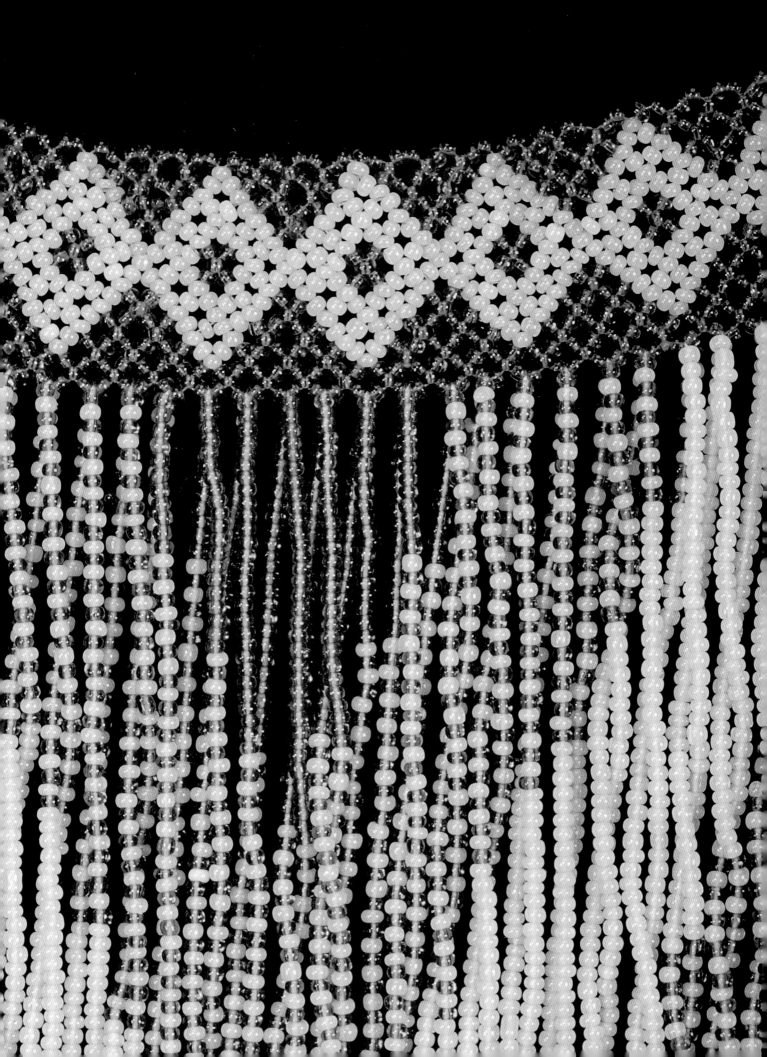

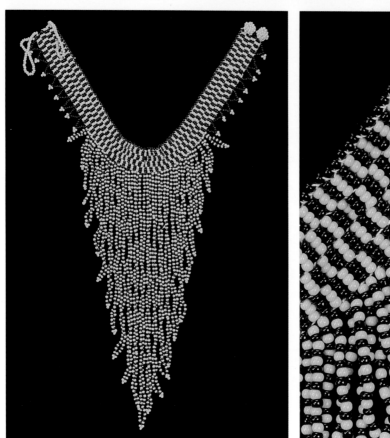

African beaded fringe collar of black and yellow glass beads, c. 1970s. $75-100.

Detail.

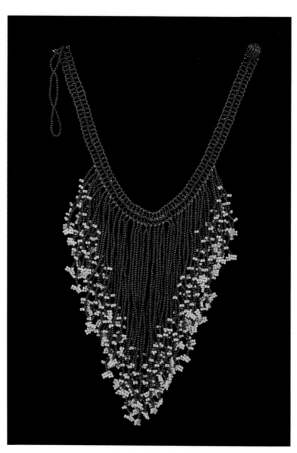

African beaded fringe collar in rust-brown and pearly white with clusters at the ends, c. 1970s. $100-125.

Opposite page: Detail.

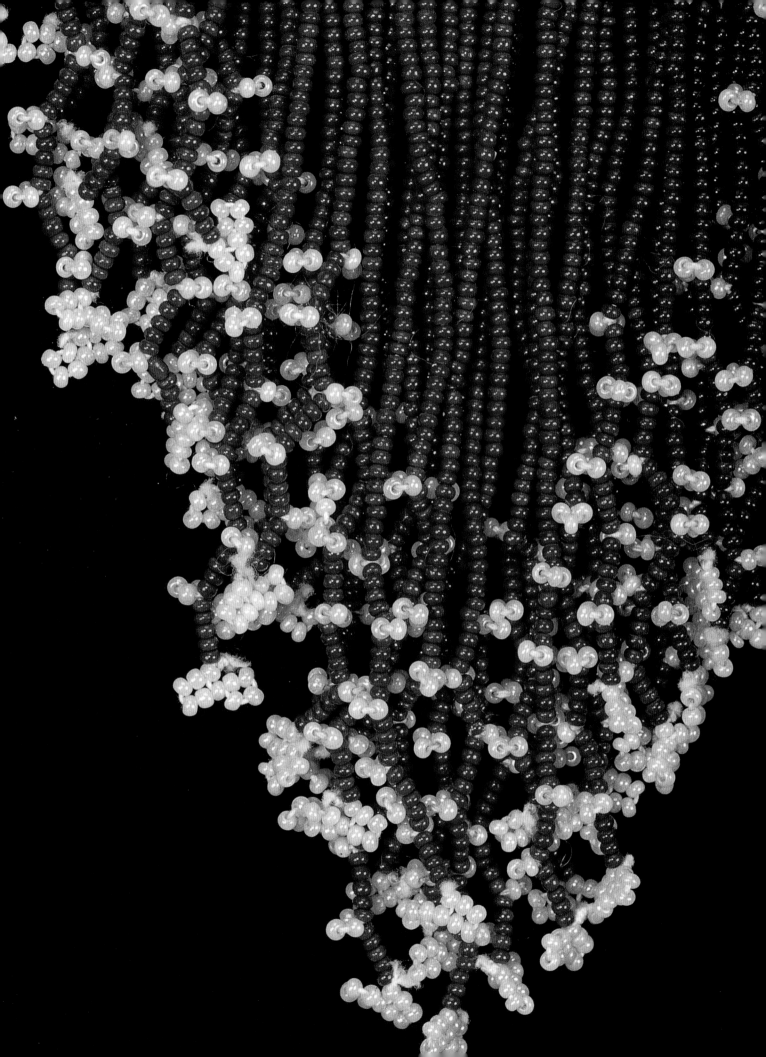

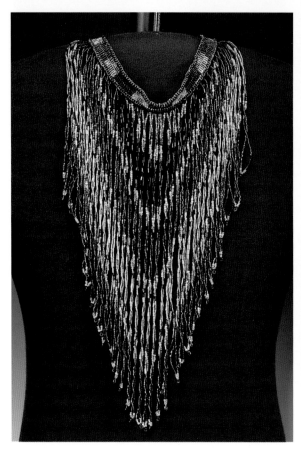

African beaded fringe collar in earth tones, c. 1980s. *Courtesy of Beverlee Rosenbluth.* $75-100.

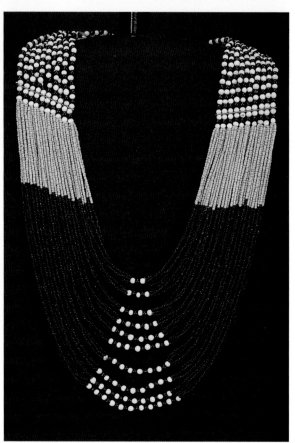

Strands of black glass and natural material beads, made in India, c. 1990s. $90-115.

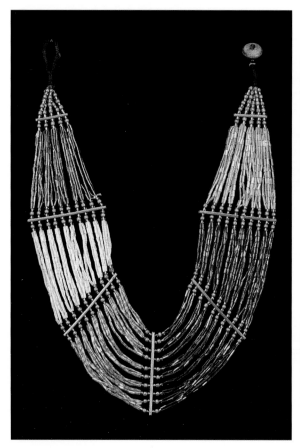

Multi-strand necklace of multi-color glass bugle bead separated with metal bars, c. 1970s. $75-95.

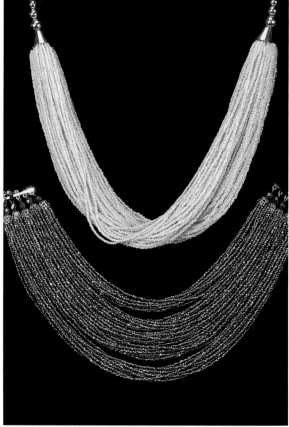

Multi-strand necklaces. *Top:* pastel glass beads, probably from India; *bottom:* bronzed glass beads, clasp stamped "Laguna." $50-60; $70-80.

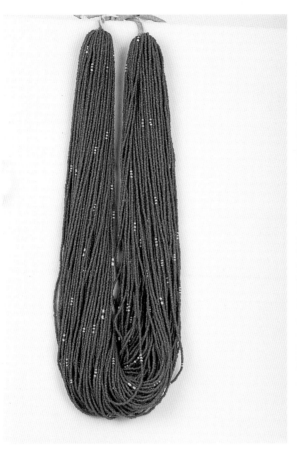

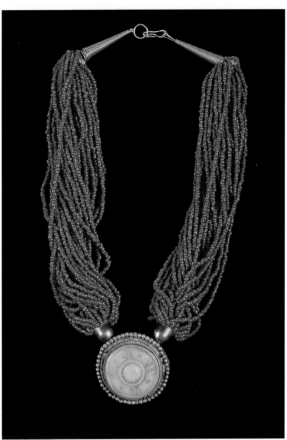

Seed bead necklace of 104 strands of primarily blue European beads, strung in Ghana. *Courtesy of Isle of Beads*. $250-350.

Strands of dark orange coral with silver and carved bone medallion. *Courtesy of Lorita Winfield*. $250-300.

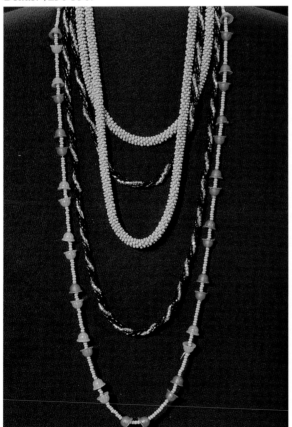

Seed bead necklaces. Turquoise beaded rope; black and gold strung and twisted; turquoise with glass caps. $35-40 each.

Assortment of beaded rope necklaces, c. 1950s. $35-45 each.

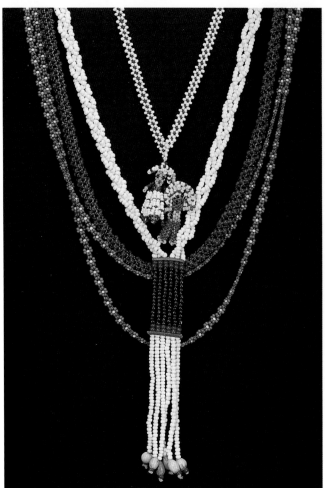

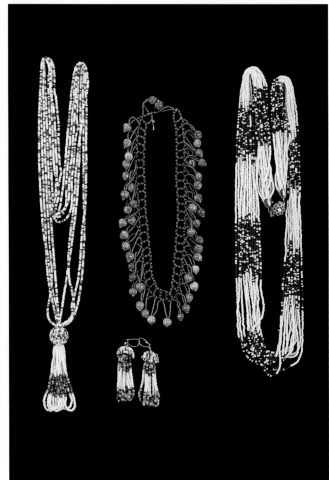

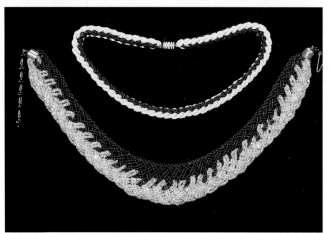

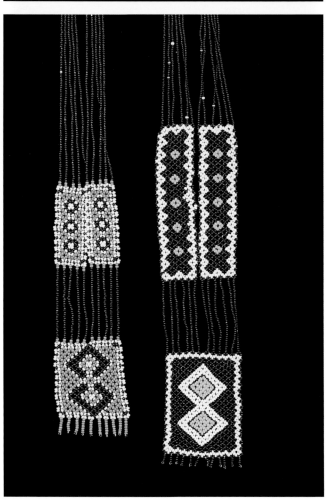

Top left: Assortment of red, white, and blue seed bead necklaces, one with figures. $15-25 each.

Bottom left: Twisted rope and woven seed bead chokers in black and white. *Top:* c. 1950s; *bottom:* c. 1980s. *Bottom: courtesy of Diana Papp Finn.* $50-60 each.

Top right: Seed bead necklaces, center has seeds, and earrings, c. 1980s. $20-25; earrings: $10-15.

Bottom right: American Indian off-loom beaded necklaces, c. 1960s. $45-55 each.

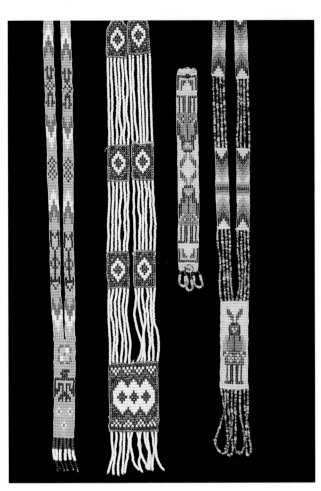

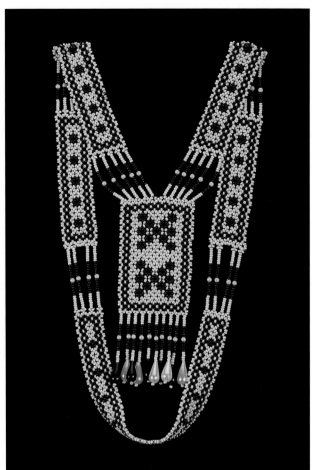

Assortment of American Indian loom beaded necklaces and a bracelet, c. 1970s. $30-40 each; bracelet: $20-25.

American Indian off-loom beaded necklace in black and white, c. 1970s. $45-55.

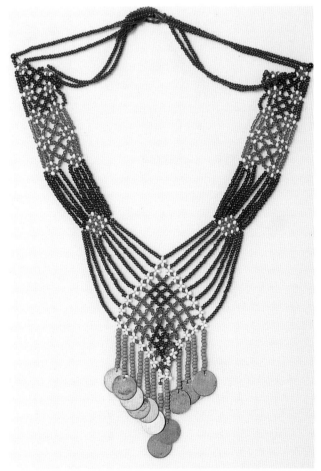

Off-loom multi-color seed bead necklace with metal discs. $75-100.

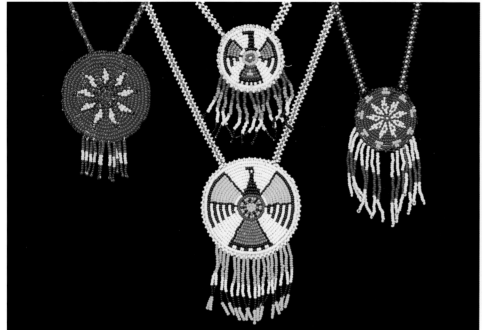

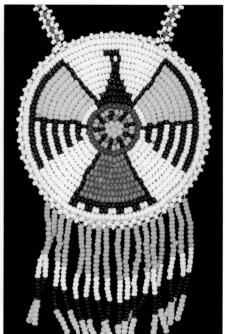

Assortment of American Indian beaded medallion necklaces.
$25-45 each.

Detail.

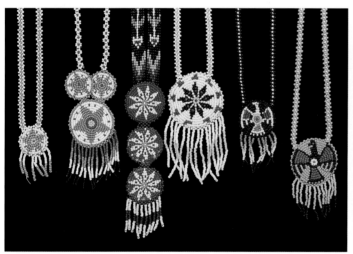

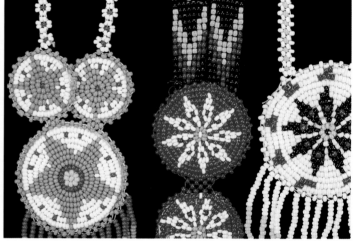

Assortment of American Indian beaded medallion necklaces.
$25-45 each.

Detail.

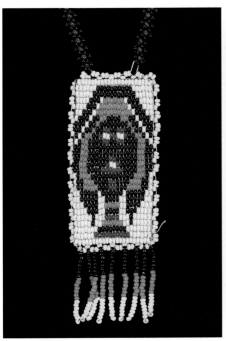

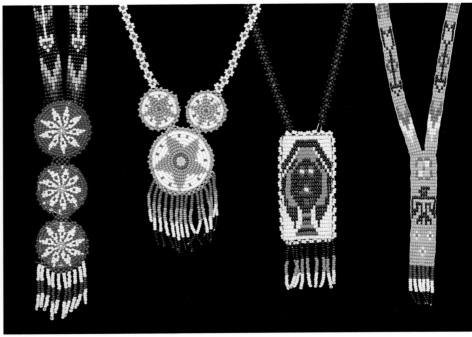

Detail.

American Indian beaded medallion necklaces and loom beaded necklace (*right*). $25-45 each.

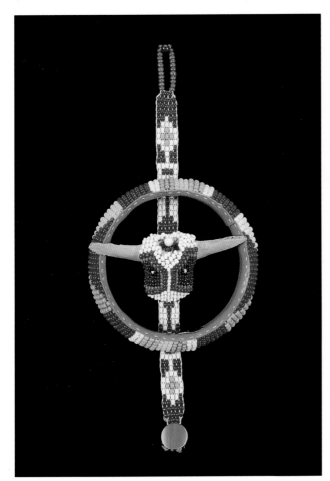

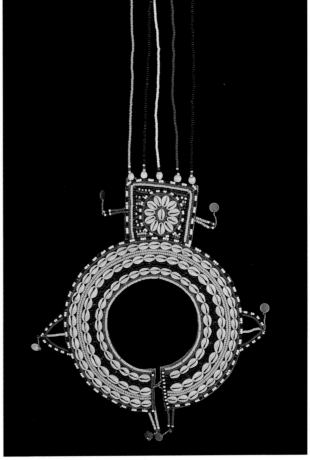

Beaded bracelets: circular on leather, and unmounted with cow head. $20-30 each.

Masai wedding medallion made from seed beads, shell, and metal discs. *Courtesy of Linda Cohen*. $40-50.

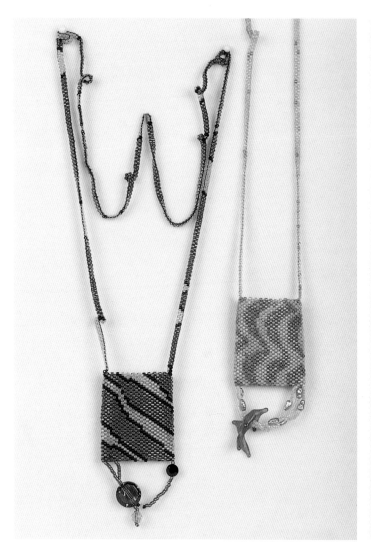

Two beaded amulet bags worn as necklaces, abstract design in the peyote stitch, 1990s. *By and courtesy of Denise Newman.* $145-195 each.

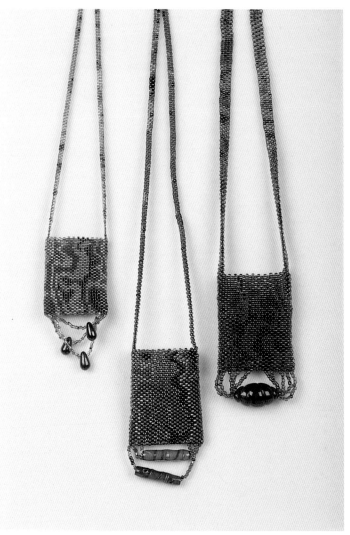

Three beaded amulet bags worn as necklaces, abstract design in the peyote stitch, 1990s. *By and courtesy of Denise Newman.* $145-195 each.

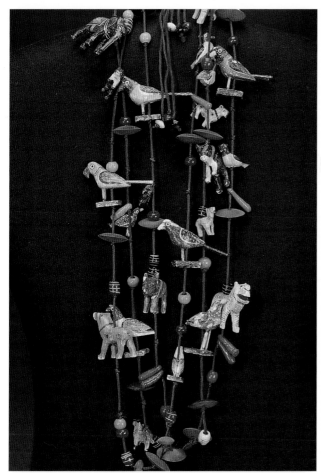

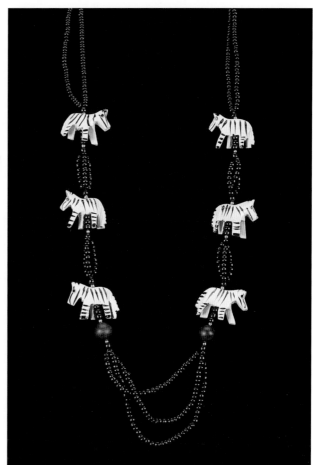

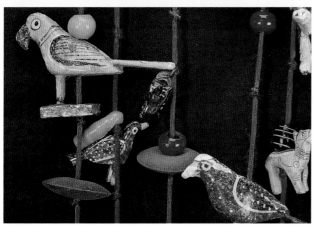

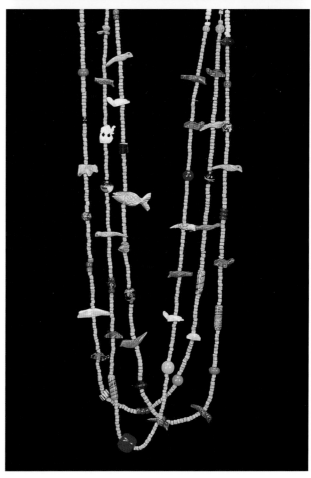

Top left: Hand-craved and painted wooden animals, strung on silk cord, made in India, c. 1990s. $75-100.

Bottom left: Detail.

Top right: Black painted wood beads with black and white painted carved zebras, made in Africa, c. 1990s. $25-35.

Bottom right: Group of necklaces with hand-craved American Indian and Hawaiian fetishes, of coral, turquoise, jade, and other natural materials, with heschi beads. *Strung by Shirley Friedland.* $200-250.

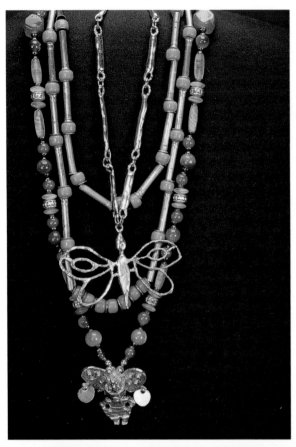

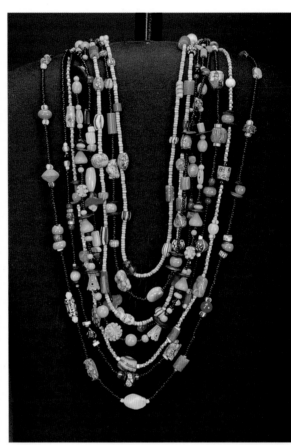

Top left: Necklaces with an assortment of Pre-Columbian style metal objects and glass beads. *Strung by Shirley Friedland.* $35-55 each.

Top right: Strands of glass beads, including African trade beads, plastic, and various natural materials. *Strung by Shirley Friedland.* $35-55 per strand.

Detail.

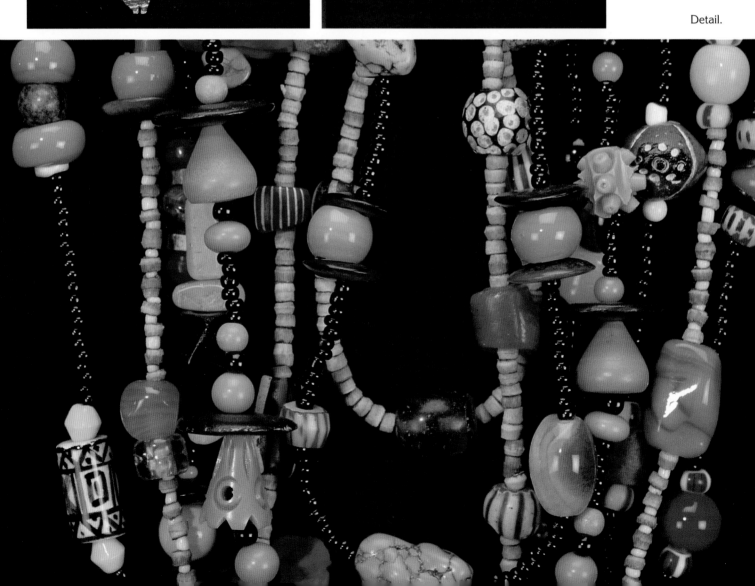

Top left: Strands of seed beads with hand made lamp-worked glass vegetables, one with black and white striped beads, 1990s. *By and Courtesy of Sandy Osborne.* $80-120.

Top right: Seven-strand necklace of glass and decorative metal beads, designed by Jay Feinberg. $300-350.

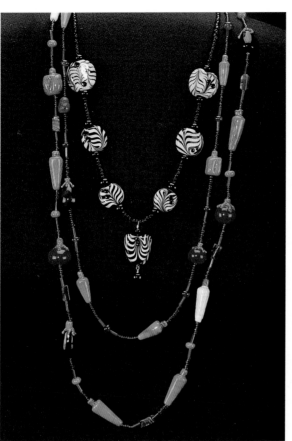

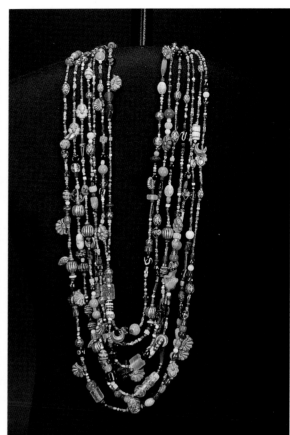

Detail.

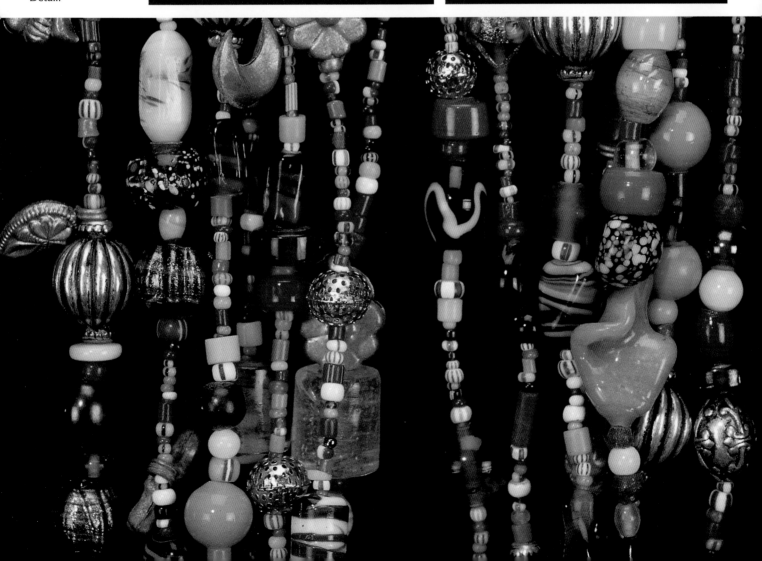

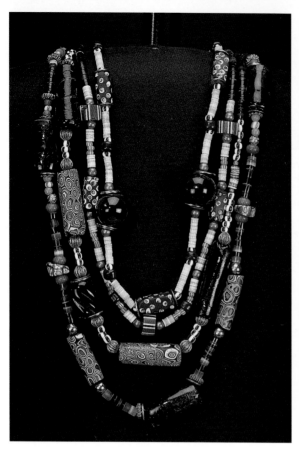

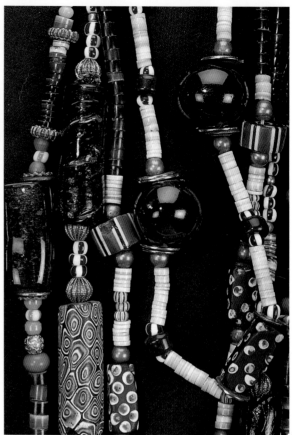

Necklaces of antique African trade beads mixed with other glass beads and various natural materials. *Strung by Shirley Friedland.* $75-85 each.

Detail.

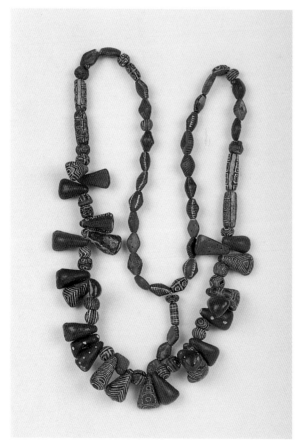

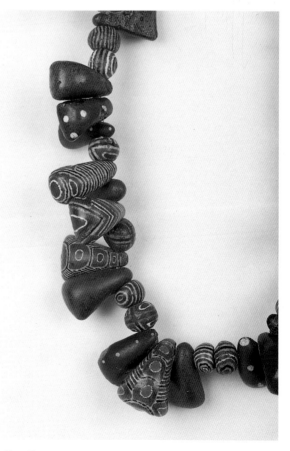

Kiffa bead necklace made by women of Mauritania, polychrome beads of varying shapes and sizes. *Courtesy of Isle of Beads.* $900-1,100.

Detail.

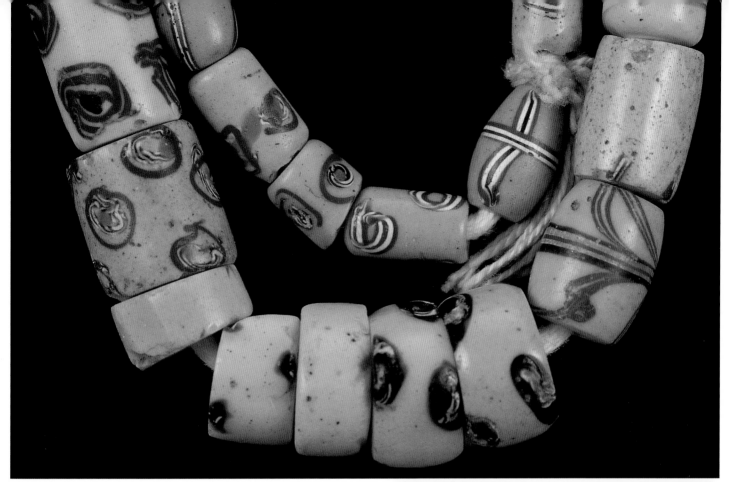

Detail.

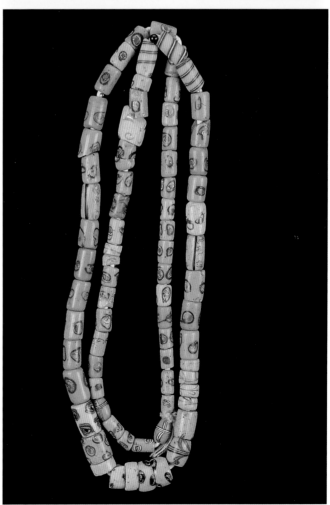

Strands of antique African trade beads with ochre and caramel backgrounds and various multi-colored canes. $75-100 each.

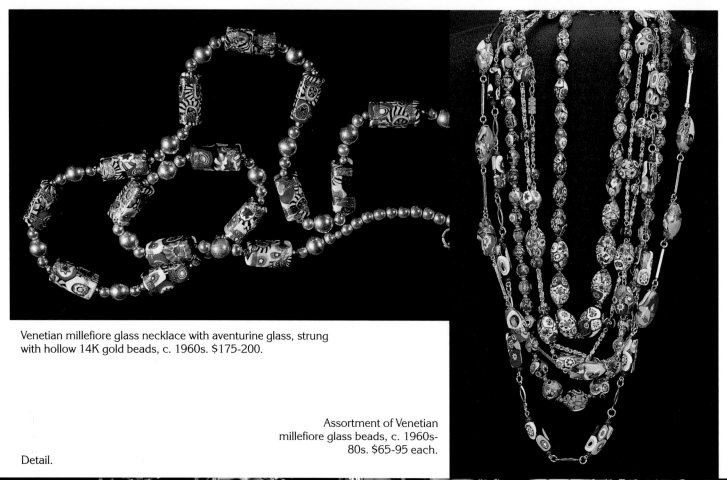

Venetian millefiore glass necklace with aventurine glass, strung with hollow 14K gold beads, c. 1960s. $175-200.

Assortment of Venetian millefiore glass beads, c. 1960s-80s. $65-95 each.

Detail.

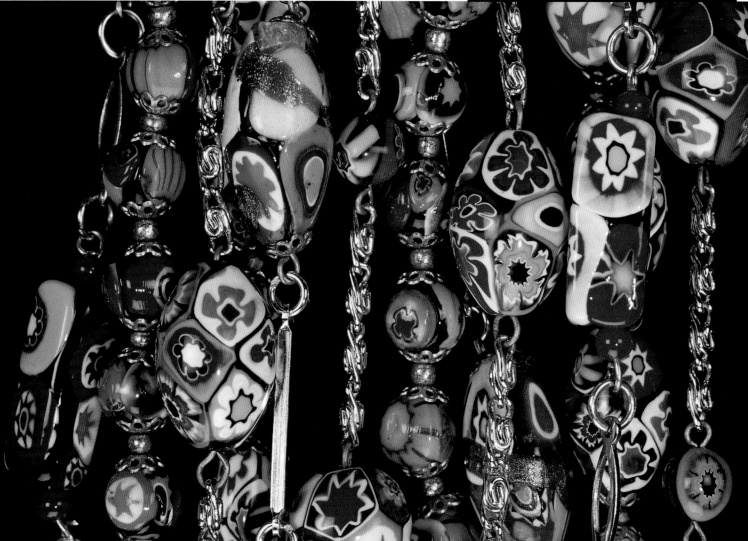

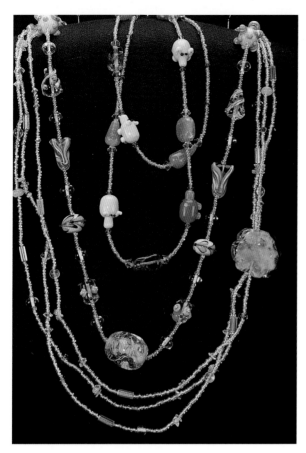

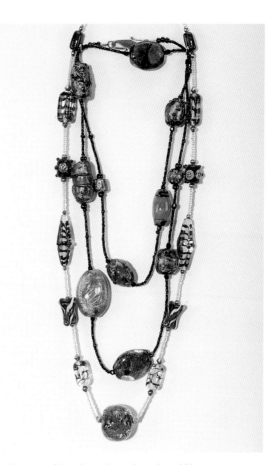

Strands of seed beads with hand made lamp-worked pink pigs and other shapes, 1990s. *By and Courtesy of Sandy Osborne.* $80-120 each.

Necklaces of hand made multi-colored Venetian style glass beads, 1990s. *By and Courtesy of Sandy Osborne.* $120-140 each.

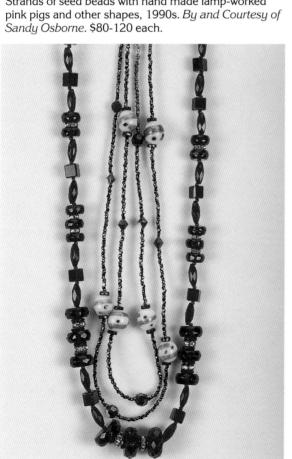

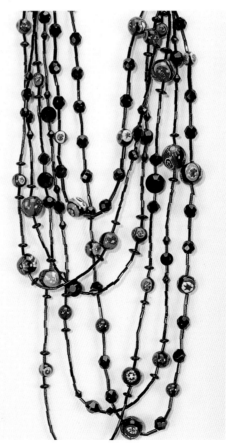

Necklaces of antique faceted red glass and Venetian red, white, and mica beads with cut steel beads. *Strung by Shirley Friedland.* $85-100 each.

Strands of antique jet and black-background millefiore beads with black glass bugle beads. *Strung by Shirley Friedland.* $65-85 each.

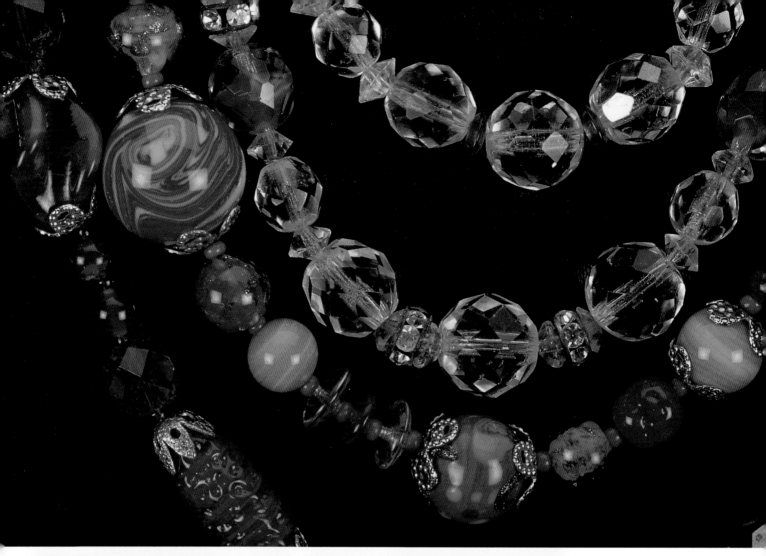

Detail.

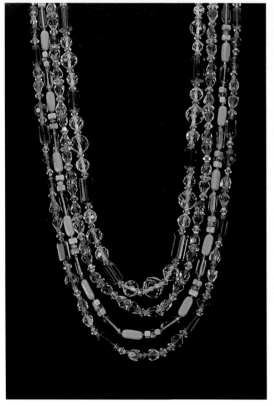

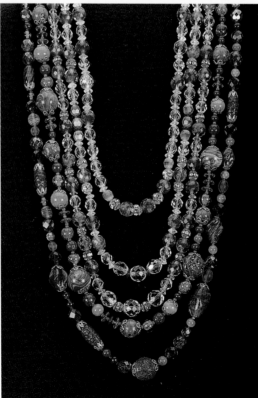

Bottom left: Multiple strands of cut crystal and blue glass beads in a variety of shapes, c. 1930-1950. *Strung by Shirley Friedland.* $40-50 each.

Bottom right: Multiple strands of crystal and orange cut glass beads in a variety of shapes and patterns, c. 1920s-1950s. *Strung by Shirley Friedland.* $35-55 each.

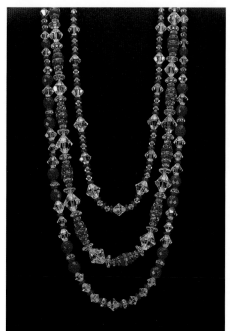

Strands of cut crystal and red glass beads in a variety of shapes and sizes, c. 1920-1940. *Strung by Shirley Friedland.* $50-60 each.

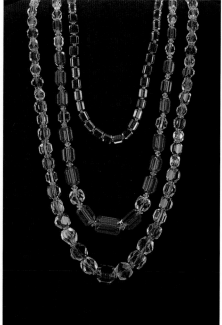

Cut crystal with internal red glass, log shaped beads; cut crystal with red casing in log shaped beads; cut crystal with internal colored glass decoration. c. 1930-1950. $50-75 each.

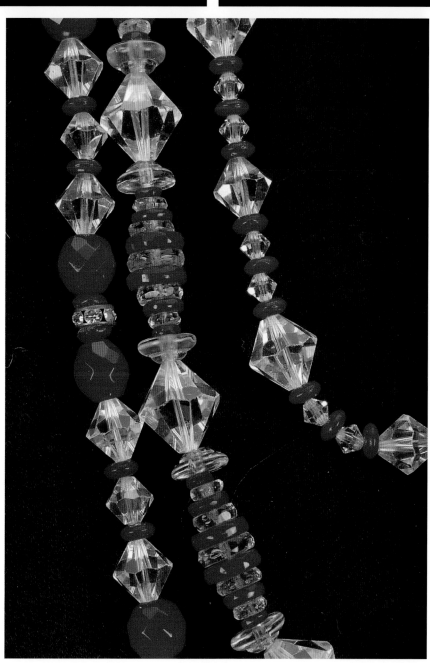

Detail.

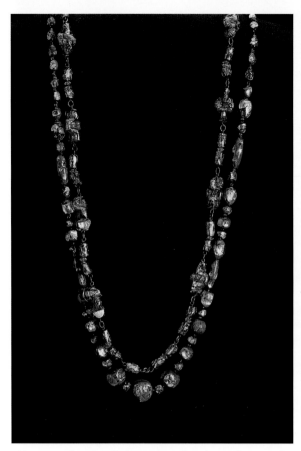

Venetian glass beads in green and amber with internal foil decoration. $50-60 each.

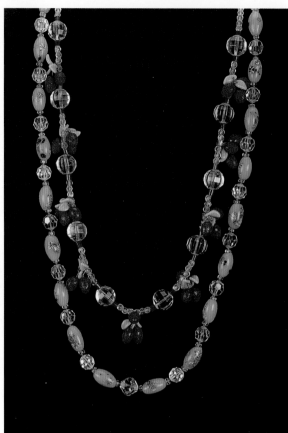

Venetian glass berries with leaves, strung with cut crystal beads; green Venetian glass beads with millefiore inserts. c. 1950s. $75-95 each.

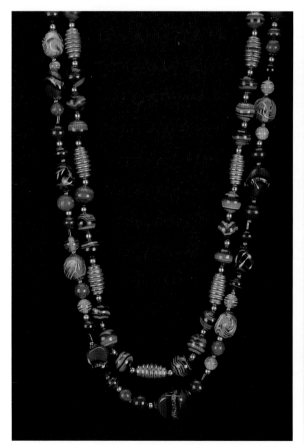

Malachite and gold beads; strand of malachite colored Venetian glass beads. c. 1950s. $100-125 each.

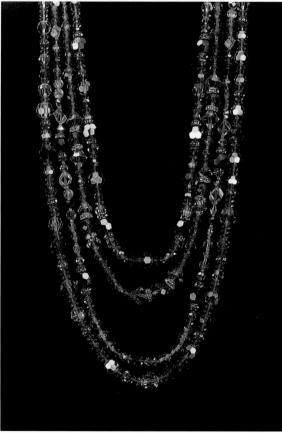

Strands of cut crystal in variety of pink shades, with rhinestone rondelles. $65-75 each.

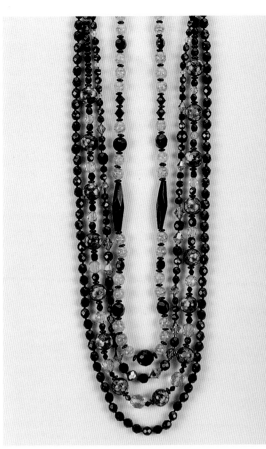

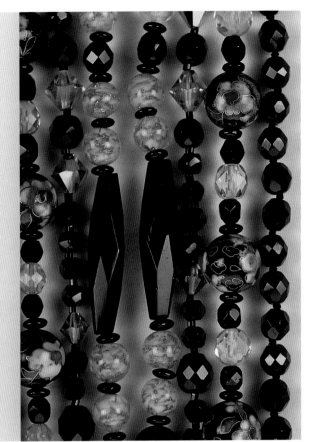

Strands of cut black, pink Venetian glass, cut crystal, and Chinese cloisonné beads, c. 1950s-1970s. Black: $40-50; Venetian & cloisonné: $100-125.

Detail.

Multiple strands of Venetian glass beads: watermelon seed shaped, mica filled, and tubular; with cut amber color crystal, metallic copper-colored glass beads, rhinestone rondelles. 1920-1970s. $50-85 each.

Detail.

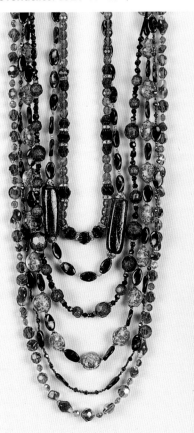

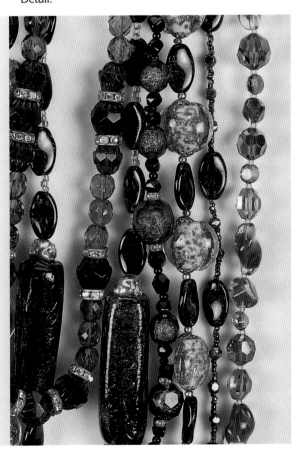

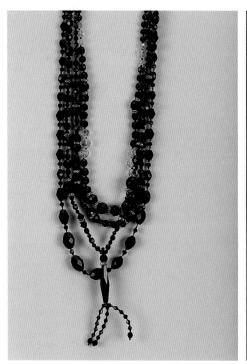

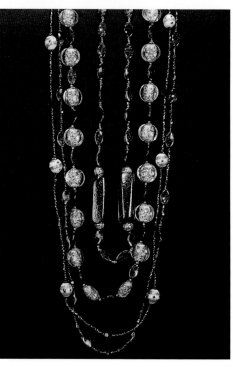

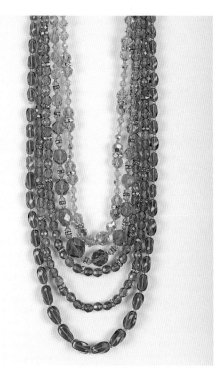

Strands of cut black glass beads in a variety of shapes, sizes, and vintage. $40-60 each.

Venetian glass mica-filled and watermelon-shaped beads, with cut copper color glass beads. $40-75 each.

Mixture of green and turquoise cut crystal, and shaped green glass beads. $40-60 each.

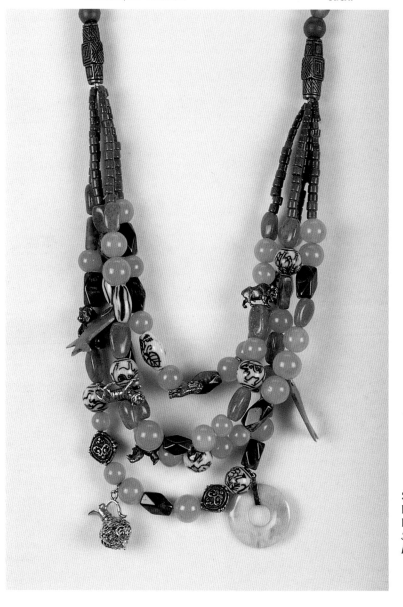

Strands of Chinese jade, lapis lazuli, and porcelain beads with metal charms. *Strung by and courtesy of Linda Cohen.* $300-350.

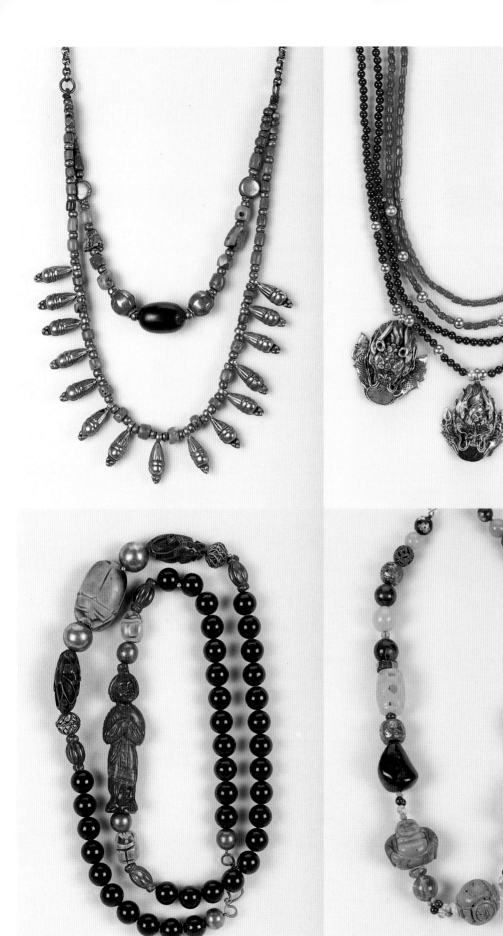

Top left: Metal beads with coral, turquoise, and amber beads, made in India, 1980. *Courtesy of Linda Cohen.* $100-125.

Top right: Tibetan silver masks with coral, lapis lazuli, and turquoise stones, strung on strands of lapis, coral, and silver beads. *Strung by Shirley Friedland.* $350-450 set.

Bottom left: Necklace of stone beads with ceramic scarabs, metal beads, carved animals, with carved stone figure. *Courtesy of Ruth Kyman.* $125-150.

Bottom right: Chinese necklace, 27-inch length, with oversized carved and polished beads of semi-precious stones, bone, and silver, 1998. *Courtesy of Paula Ockner.* $400-500.

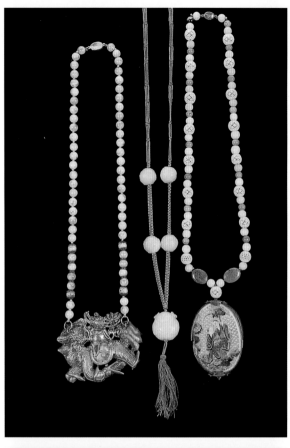

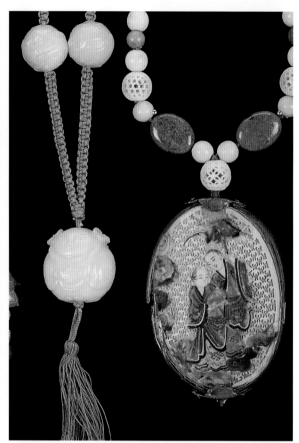

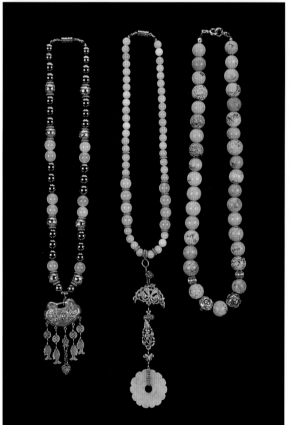

Chinese jade beads with antique silver pendant; Jade wheel and silver pendant on Chinese jade beads with silver spacers; necklace of African turquoise beads. *Courtesy of Ruth Kyman*. $135-155; $100-125; $150-175.

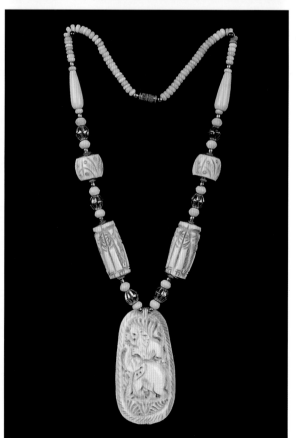

Carved bone beads and large bone pendant. *Courtesy of Ruth Marcus*. $45-55.

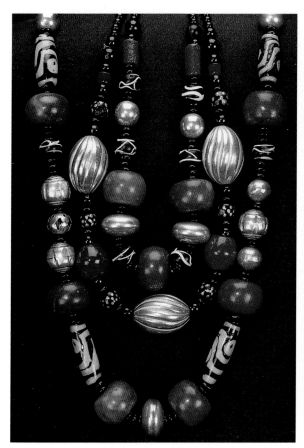

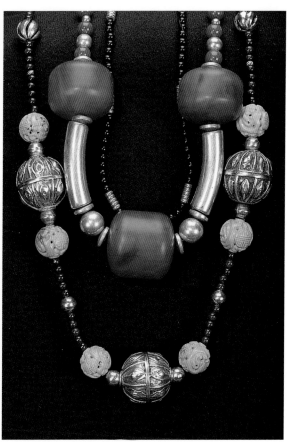

Strands of coral, silver, glass, and Iranian eye beads. *Strung by Shirley Friedland.* $75-125 each.

Strand of lapis lazuli and gold beads. $90-110. Silver and large African copal beads. $100-125. Carved turquoise beads with lapis and hand-wrought Yemenite silver. $200-300. *Strung by Shirley Friedland.*

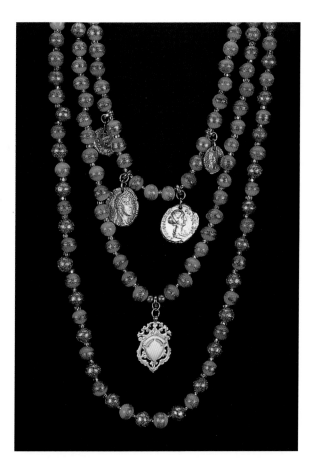

Triple strand of Venetian glass beads with mica, coins, and antique gold-filled medallion. *Strung by Shirley Friedland.* $275-325.

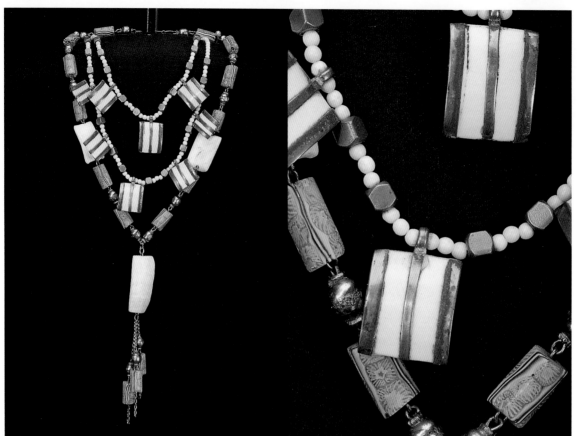

Top left: Double strand of bone squares inlaid with brass, made in Nepal, strung with small bone beads and copper cubes; strand of African trade beads, silver, and stone. $125-150 each.

Top right: Detail.

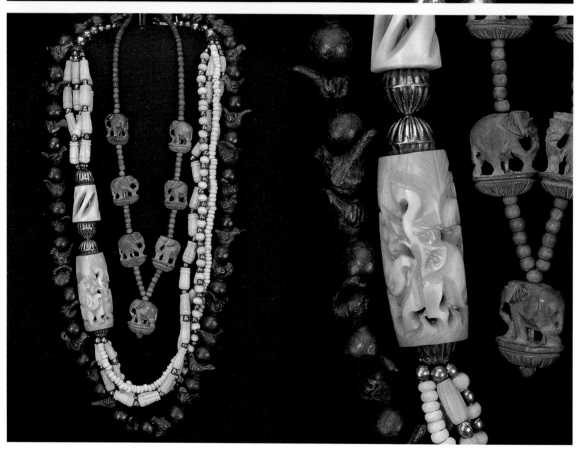

Bottom left: Necklace of carved sandlewood elephants from India, c. 1960s. $60-75. Carved bone feature bead with small bone beads, from India. $35-45. Mexican pottery birds and plain beads with black glaze. $40-50.

Bottom right: Detail.

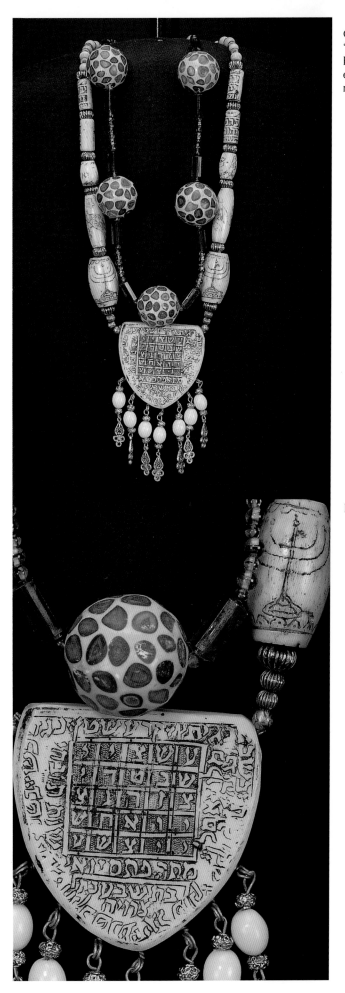

Cut glass beads with large inlaid "animal spot" beads. $75-95. Engraved bone beads with large engraved pendant with drops, made in Israel. $150-200.

Detail.

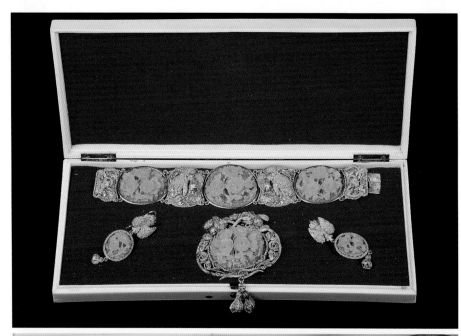

Antique Chinese marriage set consisting of earrings, bracelet, and brooch made of intricately carved carnelian cameos and 22 karat gold work. *Courtesy of Ruth Marcus.*

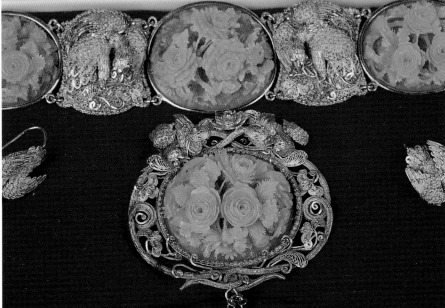

Detail.

Carved ivory box.

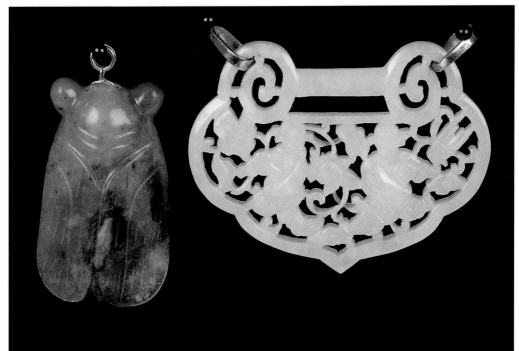

Antique Chinese carved jade pendants: brown cicada and white pierced and figural motif. $100-150; $200-250.

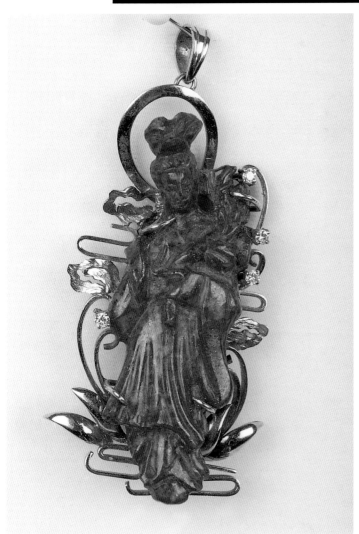

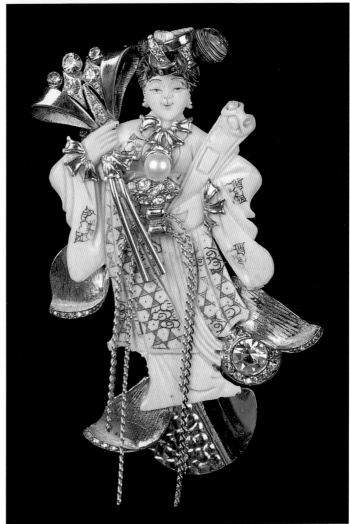

Chinese carved lapis lazuli Kwan Yin figurine, mounted in 14 karat gold setting with diamonds. $500-700.

Chinese carved ivory figural brooch embellished with pearls, gold, and rhinestones, by Meta Bleier, 1990s. *Courtesy of Ruth Marcus.* $125-175.

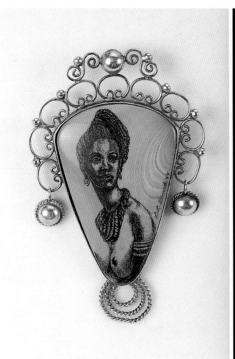

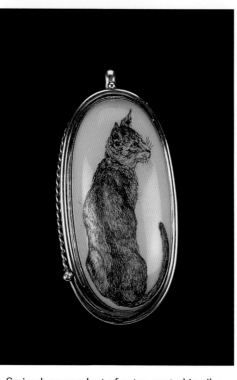

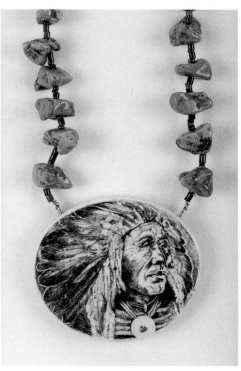

Scrimshaw brooch of female portrait in silver frame, 1990s. *By and Courtesy of Lynn Benade.* $200-250.

Scrimshaw pendant of cat mounted in silver, 1990s. *By and Courtesy of Lynn Benade.* $225-250.

Scrimshaw medallion of American Indian portrait, on strand of turquoise and heschi beads, 1990s. *By and Courtesy of Lynn Benade.* $350-400.

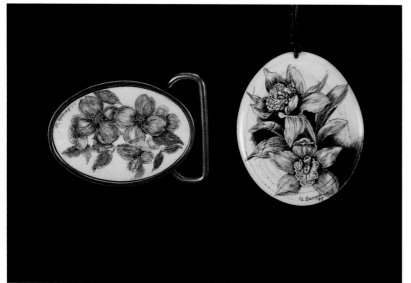

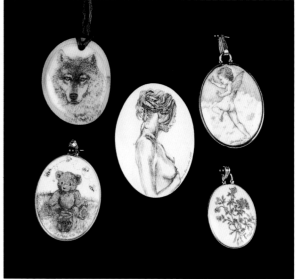

Scrimshaw belt buckle with rubbed-in color; pendant with scrimshaw floral design, 1990s. *By and Courtesy of Lynn Benade.* $150-175; $125-150.

Pendants of wolf, angel, teddy bear, and flowers, with unmounted nude, 1990s. *By and Courtesy of Lynn Benade.* $110-150 each.

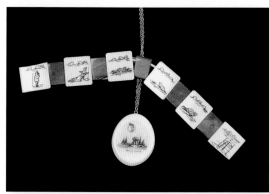

Scrimshaw bracelet, signed W. Okpowruk Shishak; pendant with indecipherable signature (Hamsh Muklask), c. 1970s. $60-80; $30-40.

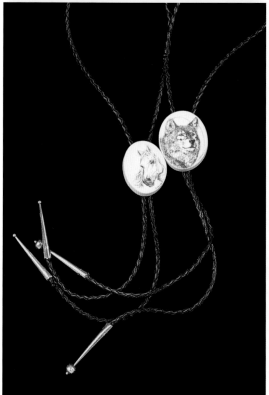

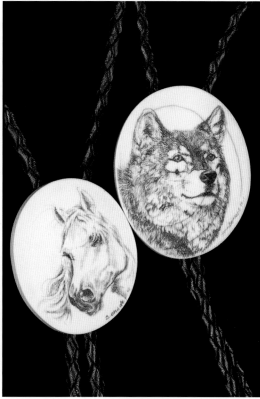

Center left: Scrimshaw bolos with horse and wolf portraits, 1990s. *By and Courtesy of Lynn Benade.* $250-300 each.

Center right: Detail.

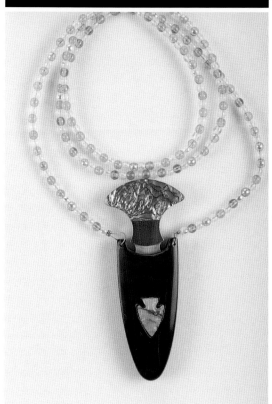

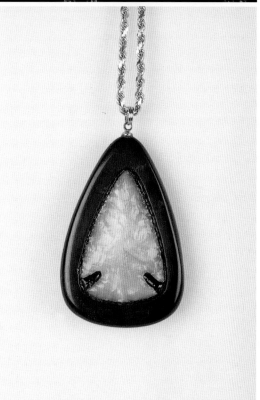

Bottom left: Labradorite beaded necklace, and steel dagger with abalone handle by John Smith; sheath of water buffalo horn by Martin Benade, with inset flint-napped gem-quality opal by Mike Cook, 1990s. *Courtesy of Lynn Benade.* $450-500.

Bottom right: Pendant of black stone set with carved opal arrowhead, by Mike Cook, 1990s. $325-375.

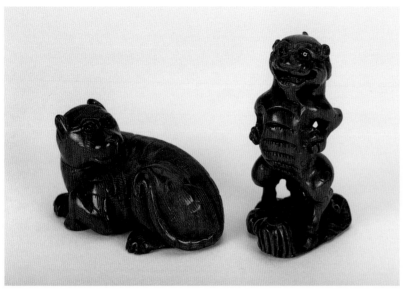

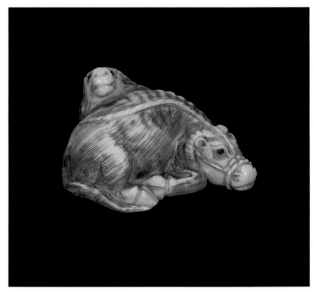

Japanese hand-carved wooden netsukes in the form of a female tiger and mythological kirin, signed Gyokuseki. $100-125 each.

Hand-carved ivory netsuke of mother and baby water buffalo, signed Gyokuseki. $125-175.

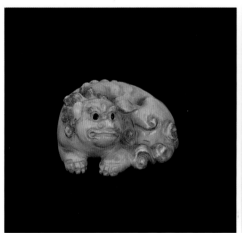

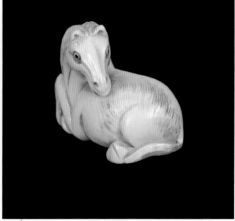

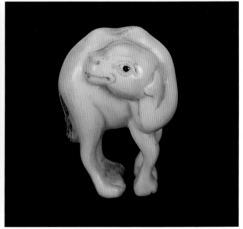

Hand-carved ivory netsuke of seated foo lion/dog, or temple guardian, signed. $125-175.

Hand-carved ivory netsuke of seated horse, signed. $125-175.

Hand-carved ivory netsuke of camel with head turned back, signed. $150-175.

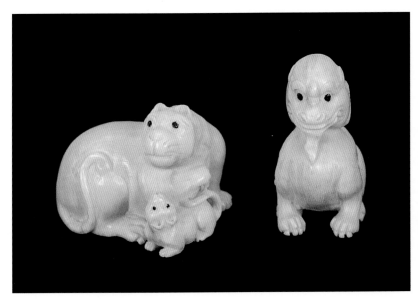

Hand-carved ivory netsukes of mother and baby lion with temple guardian, each signed Gyokuseki. $150-200 each.

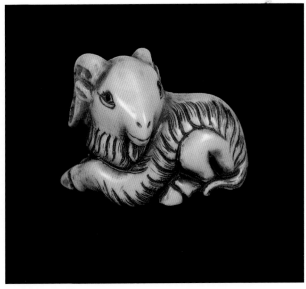

Hand-carved ivory netsuke of seated ram, signed. $125-175.

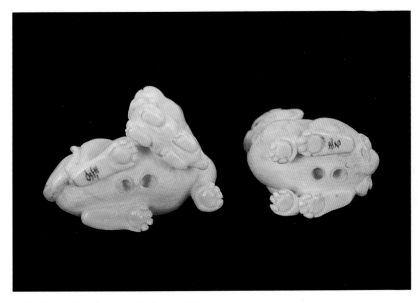

Bottoms showing cord holes and signatures.

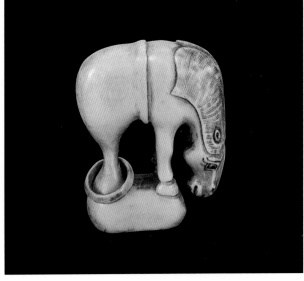

Hand-carved ivory netsuke of standing horse with loose ring around hind leg, signed. $150-175.

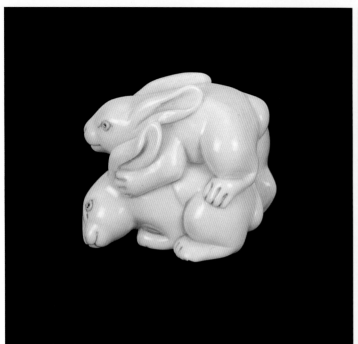

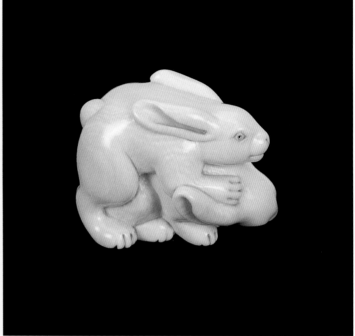

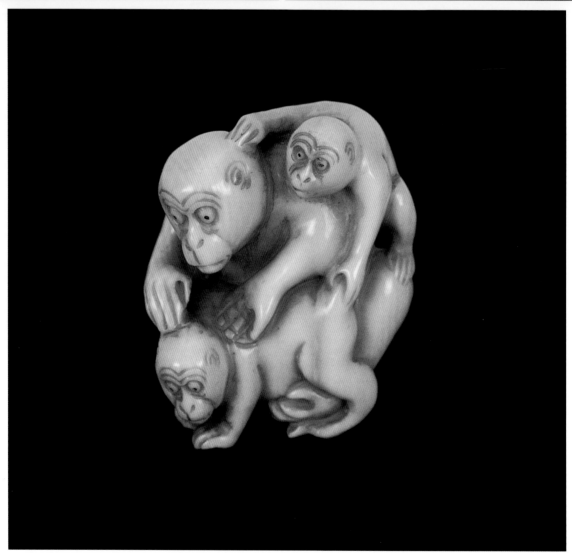

Top left: Hand-carved ivory netsuke of playful rabbits, signed. $200-225.

Top right: Different view.

Bottom: Hand-carved ivory netsuke of monkey family, signed Gyokuseki. $150-200.

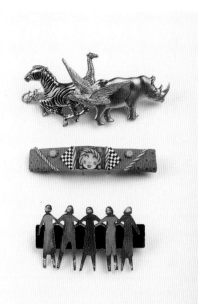

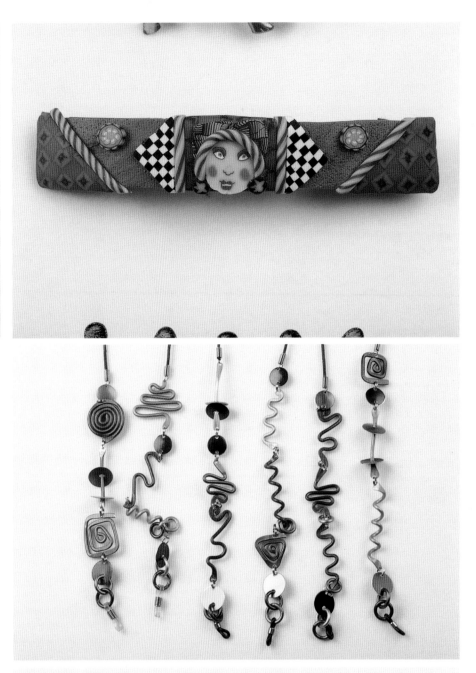

Above: Hair clips. *Top:* metal animals by Icis Co.; *center:* multi-color femo with face; *bottom:* metal figures by Gina Designs. *Courtesy of Fine Points.* $30-40 each.

Above right: Detail of femo hair clip with face.

Colored metal eyeglass leashes, by Sylvia Harwin Eclat, 1990s. *Courtesy of Fine Points.* $30-40 each.

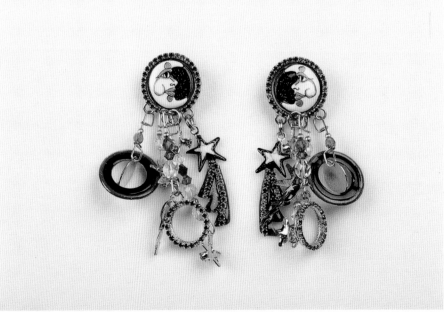

Enameled metal moon earrings with hanging chatskas, from Lunch at the Ritz, 1990s. *Courtesy of Fine Points.* $150-160.

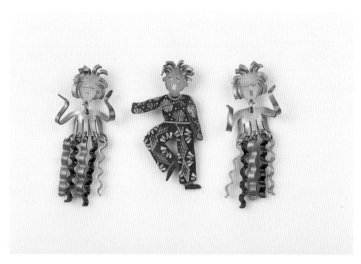

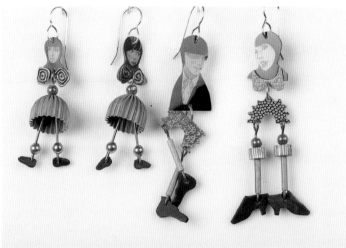

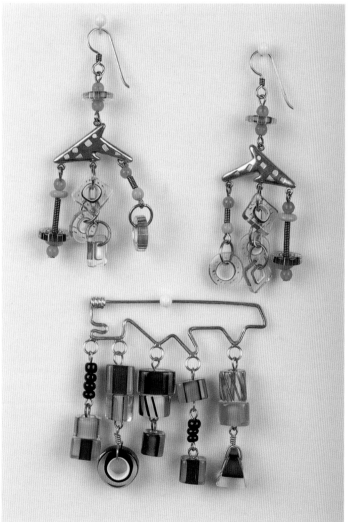

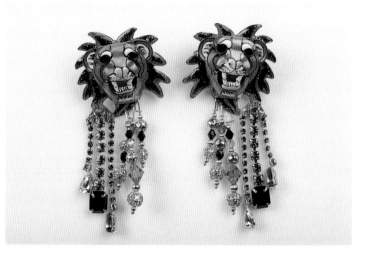

Top left: Brass and steel figural earrings with corrugated fringed skirts, with colorful pin, both by Catherine Butler, 1990s. *Courtesy of Fine Points*. $50-75 each.

Top right: Metal earrings of jointed people with laminated photo faces, by Kimberly Willcox, 1990s. *Courtesy of Fine Points*. $70-80 pair.

Bottom left: Earrings and pin of various colored cased glass beads on metal. $75-100 each.

Bottom right: Lion earrings of enameled metal with hanging mane, from Lunch at the Ritz, late 1990s. *Courtesy of Fine Points*. $125-150.

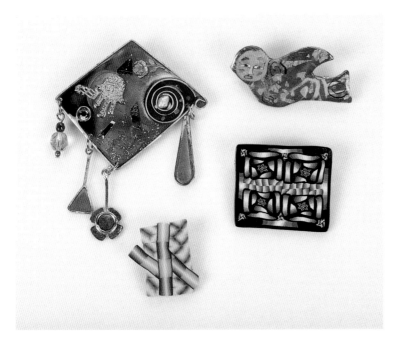

Pins, 1990s. *Top left:* plastic and metal collage with drops, from Israel; *right:* femo figure and black and white abstract by Lois Ockner; *bottom left:* femo by City Zen Cane. *Courtesy of Paula Ockner.* $75-100; $40-50 each; $60-70.

Femo pin of black and white checkerboards and hearts, c. 1990s. *Courtesy of Linda Cohen.* $40-50.

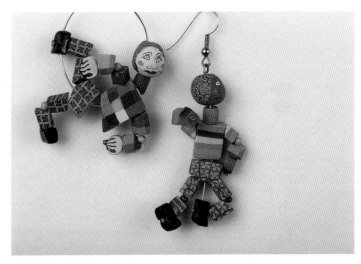

Japanese hand made paper fan earrings, c. 1980s. *Courtesy of Paula Ockner.* $15-20.

Colorful femo figural earrings, by C. Lue, 1990. $40-50 pair.

Femo buttons from Blue Moon and from Zecca, of face, flowers, and insect with leaves, 1990s. *Courtesy of Fine Points.* $6-12 each.

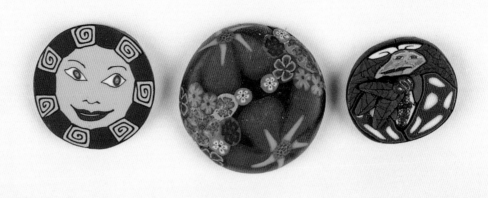

Femo buttons from Blue Moon and from Zecca, of figures, insect, and geometric design, 1990s. *Courtesy of Fine Points.* $6-12 each.

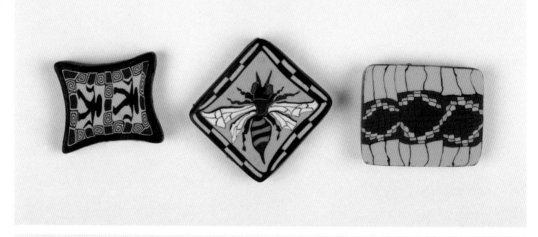

Femo buttons from Blue Moon and from Zecca, of checkerboard hearts and cat, 1990s. *Courtesy of Fine Points.* $6-12 each.

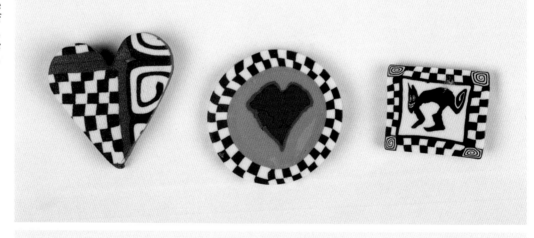

Femo buttons from Blue Moon and from Zecca, of Saturn, cup, and abstract design, 1990s. *Courtesy of Fine Points.* $6-12 each.

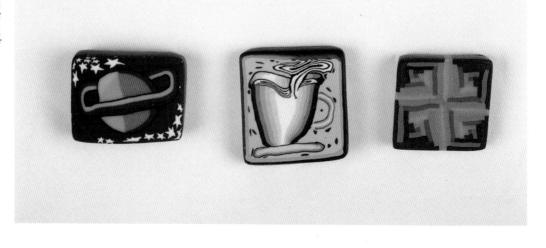

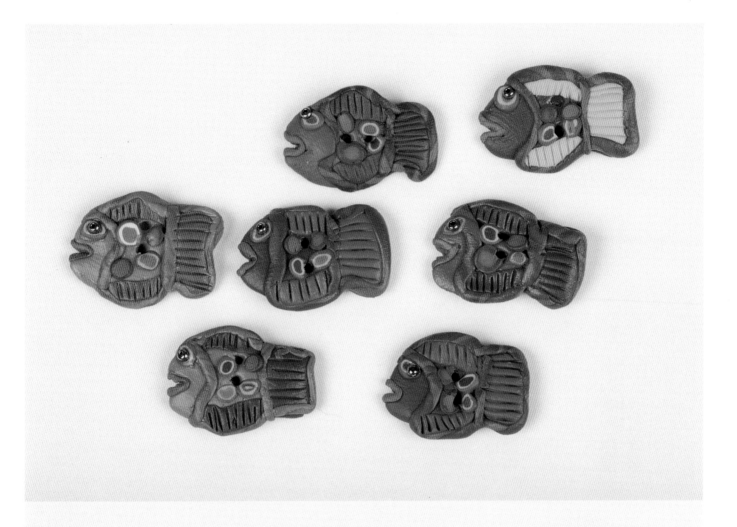

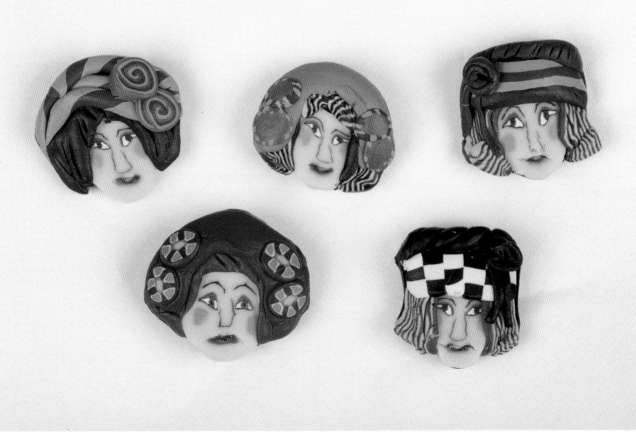

Top: Femo buttons from Blue Moon and from Zecca, of colorful fish, 1990s. *Courtesy of Fine Points*. $10-12 each.
Bottom: Femo buttons from Blue Moon and from Zecca, of female faces with hats, 1990s. *Courtesy of Fine Points*. $12-14 each.

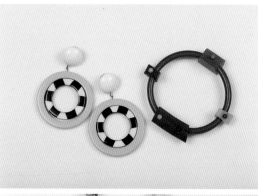

Left: Rubber bracelet with plastic earrings, 1990s. *Bracelet courtesy of Fine Points.* $20-25 each.

Center left: Necklaces of femo beads, one with wood beads, the other with black faux pearls, 1980s. *By and courtesy of Ruth Kyman.* $50-60 each.

Center right: Necklace of femo beads with black and white checkerboard pattern, 1980s. $50-60.

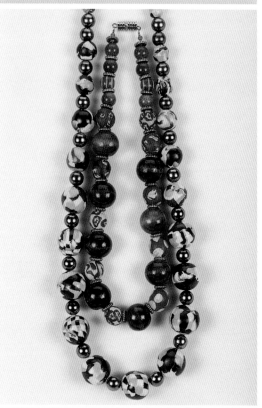

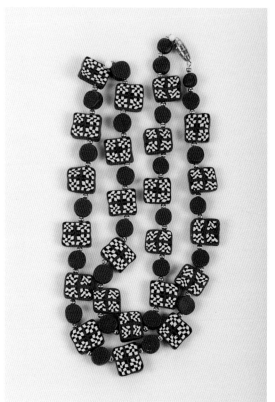

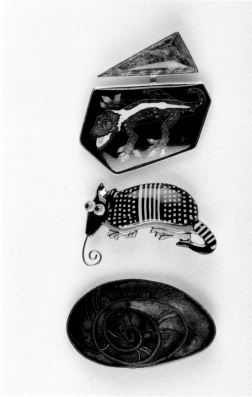

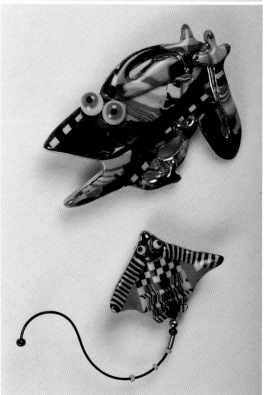

Bottom left: *Top:* pin of cloisonné enamel reptile in silver with purple stone also mounted in silver; *center:* porcelain pin of armadillo by Cynthia Chuang; *bottom:* enamel on metal pin by Linda Cohen. c. 1990s. *Courtesy of Linda Cohen.* $150-175; $80-100; $80-100.

Bottom right: Porcelain frog and manta ray pins, by Cynthia Chuang, c. 1990s. *Courtesy of Linda Cohen.* $150-200; $80-100.

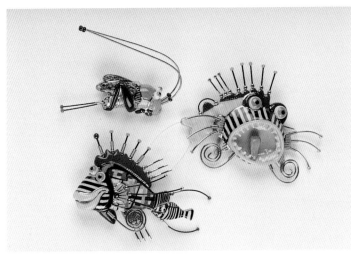

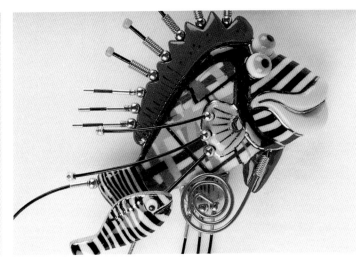

Fish with teeth, grasshopper, and smiling fish with baby, porcelain pins, by Cynthia Chuang and her husband, Erh-Ping Tsai, 1990s. *Courtesy of Cyndy Goodwin.* Fish: $150-200; grasshopper: $80-100.

Detail of fish.

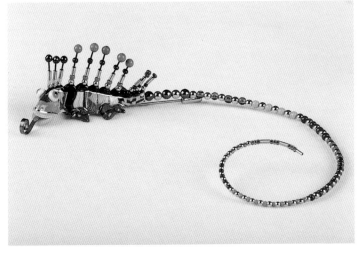

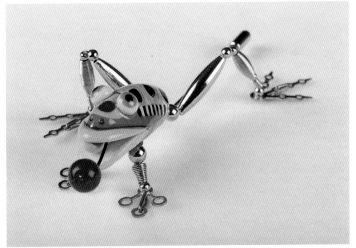

Porcelain and metal stick pin of fantastic reptile with beaded tail and spines, by Cynthia Chuang and her husband, Erh-Ping Tsai, 1990s. *Courtesy of Cyndy Goodwin.* $150-200.

Porcelain and metal frog pin by Cynthia Chuang and her husband, Erh-Ping Tsai, 1990s. *Courtesy of Cyndy Goodwin.* $150-200.

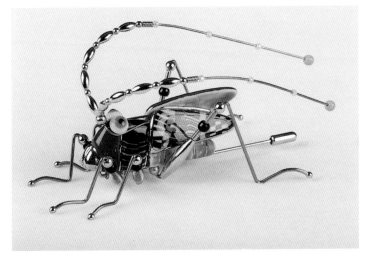

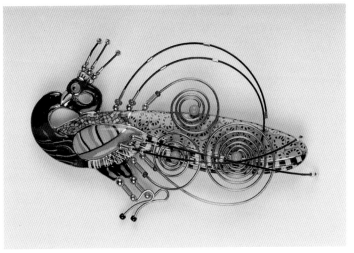

Porcelain grasshopper stickpin by Cynthia Chuang and her husband, Erh-Ping Tsai, 1990s. *Courtesy of Cyndy Goodwin.* $80-120.

Porcelain peacock pin by Cynthia Chuang and her husband, Erh-Ping Tsai, 1990s. *Courtesy of Linda Cohen.* $150-200.

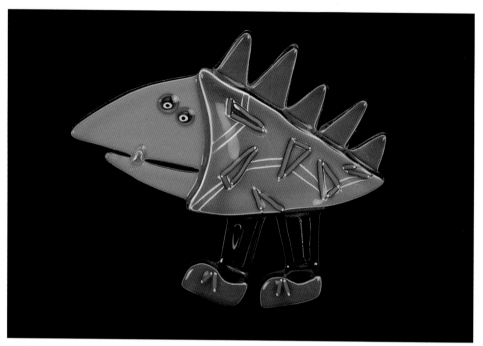

Glass pin of comical walking fish, c. 1990s. *Courtesy of Linda Cohen.* $50-75.

Glass pin of abstract face in blues with accents, 1980s. $50-75.

Purex glass bracelets by Ann Miller of Xeno Glass, Santa Fe, New Mexico, late 1990s. *Courtesy of Riley Hawk Galleries.* $40-75 each.

Dichroic glass and sterling silver necklace with pins and pendant, by Kroma, Santa Fe New Mexico, late 1990s. *Courtesy of Riley Hawk Galleries.* $220-230; $150-200 each.

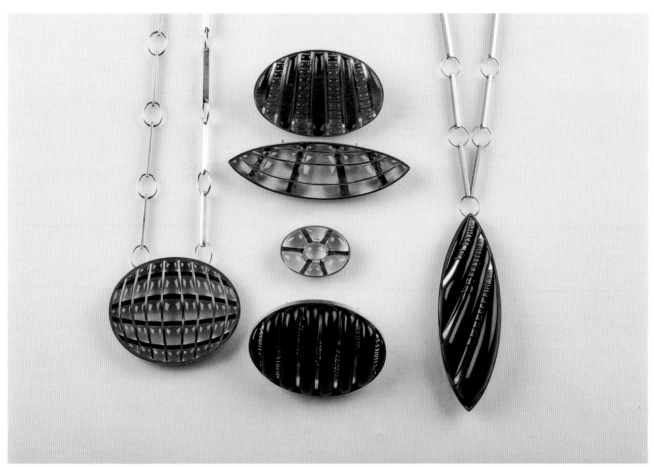

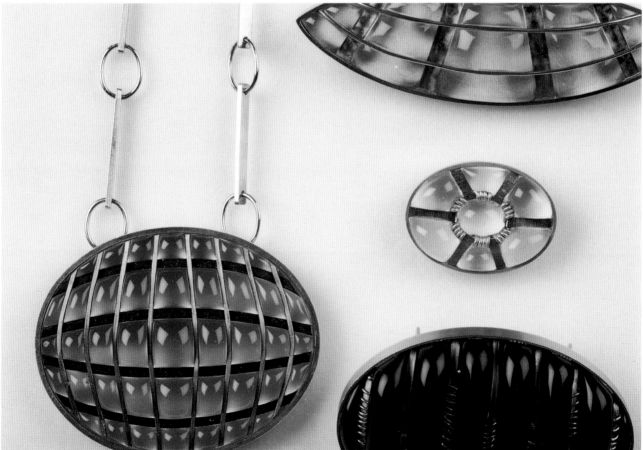

Top: Glass with 14 karat gold, sterling silver, and some with platinum, brooches and pendants by Julie Mihalisin, Seattle, Washington, late 1990s. *Courtesy of Riley Hawk Galleries.* $875-2,500 each.

Bottom: Detail.

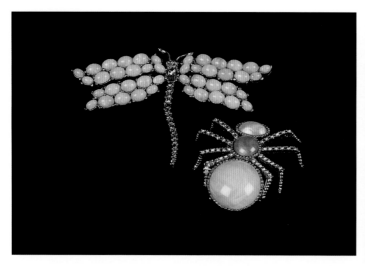

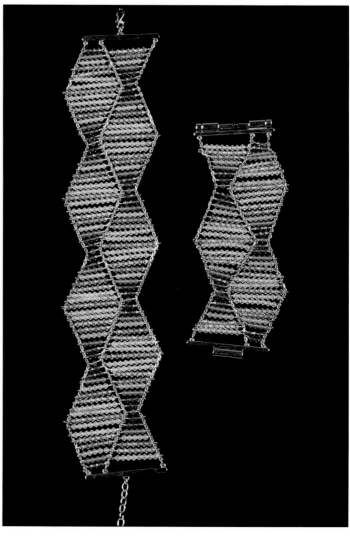

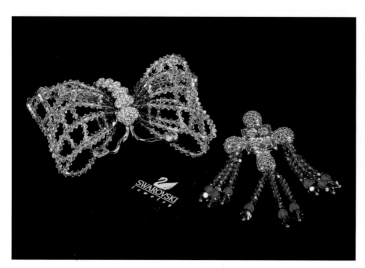

Top: Swarovsky dragonfly pin with wings of set stones and rhinestone body; spider pin with large cabochons and rhinestone legs, 1999. *Courtesy of Saks Fifth Avenue, Beachwood Place.* $190; $170.

Bottom: Swarovsky oversized butterfly pin with rhinestone body and crystal wings; rhinestone cross pin with hanging crystal strands, 1999. *Courtesy of Saks Fifth Avenue, Beachwood Place.* $395; $275.

Swarovsky crystal choker and matching bracelet made from strands of clear, blue, and green cut crystal, 1999. *Courtesy of Saks Fifth Avenue, Beachwood Place.* $700; $400.

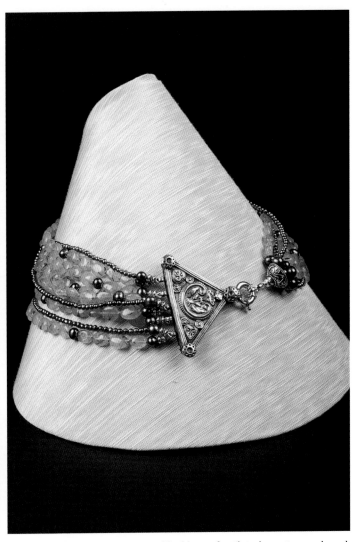

Necklace of citrine, serpentine, and sterling silver with both beads and clasp of the natural stone, by Sharon Meyer, Troy, Michigan, late 1990s. *Courtesy of Riley Hawk Galleries.* $1,000-1,100.

Necklace of rutilated quartz, pearl, and sterling silver by Sharon Meyer, late 1990s. *Courtesy of Riley Hawk Galleries.* $850-950.

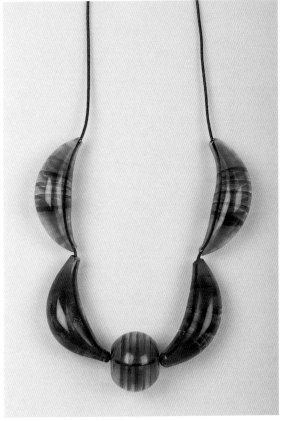

Necklace of large green and blue hollow blown glass beads, made in the Black Forest of Germany, c. 1990s. *Courtesy of Isle of Beads.* $70-80.

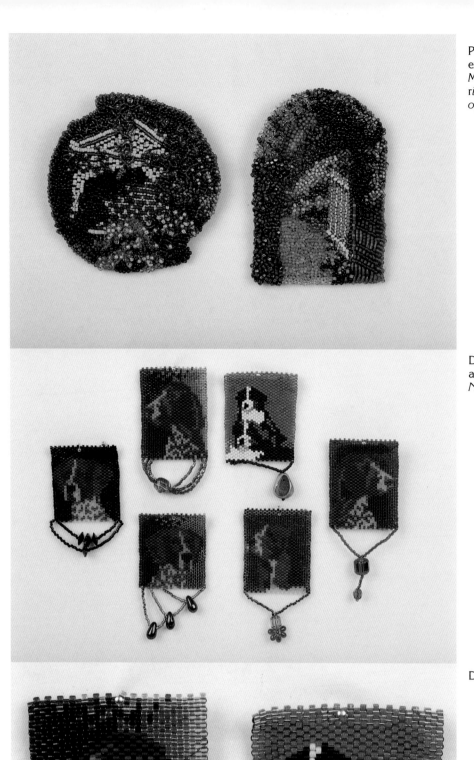

Pins of hand-sewn beads on leather, 1990s, exhibited at the Fiber Arts show of the Cleveland Museum of Art. *Left:* "Brick Wall:" $340-360; *right:* "Gated Path:" $275-300. *By and courtesy of Denise Newman of Isle of Beads.*

Dog portraits of peyote stitch beadwork, made as pins, late 1990s. *By and courtesy of Denise Newman of Isle of Beads.* $90-110 each.

Detail.

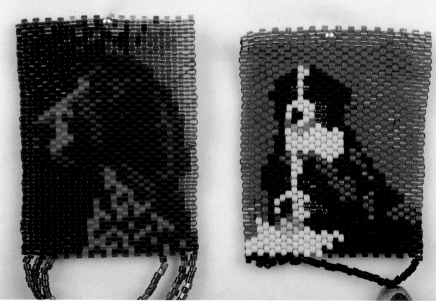

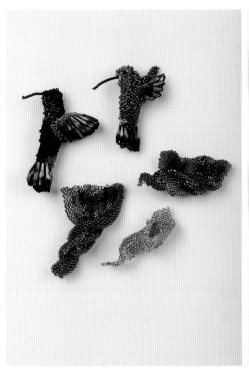

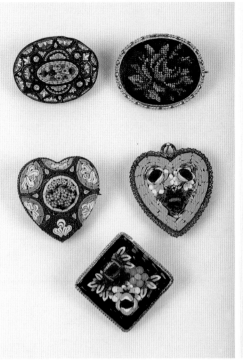

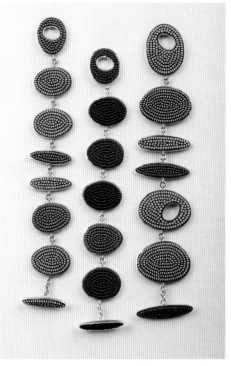

Hummingbird pins: soft sculpture with bead embroidery; peyote stitched beaded swirl pins, late 1990s. *By and courtesy of Denise Newman of Isle of Beads.* $90-110 each; $35-55 each.

Four Italian glass mosaic pins. *Top left:* fine mosaic, c. 1920s; others: c. 1950s. *Top right:* with Austrian needlepoint. Fine mosaic: $70-80; $30-40 each.

Bracelets of glass beads set in sterling silver, by Mary Kanda, late 1990s. *Courtesy of Riley Hawk Galleries.* $300-350 each.

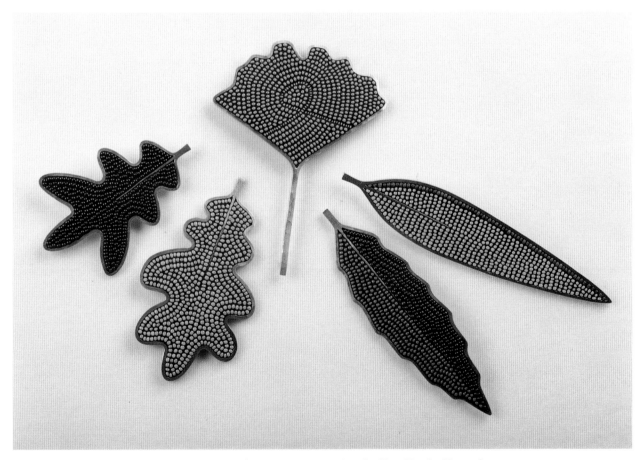

Leaf pins of glass beads set in sterling silver, by Mary Kanda, Massachusetts, late 1990s. *Courtesy of Riley Hawk Galleries.* $200-250 each.

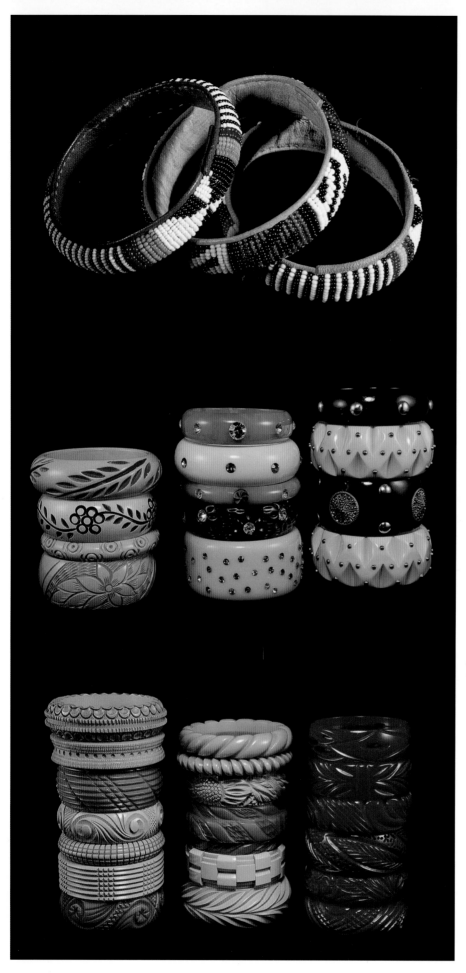

Examples of beaded leather bangle bracelets, made in Africa and the Philippines, c. 1970s. $20-30 each.

Assortment of Bakelite bracelets with applied rhinestones and metal, carving, and painting, c. 1930s. *Courtesy of Donna Wasserstrom.* $50-150 each; with metal: up to $300.

Assortment of deeply carved Bakelite bracelets, c. 1930s. *Courtesy of Donna Wasserstrom.* $200-350 each.

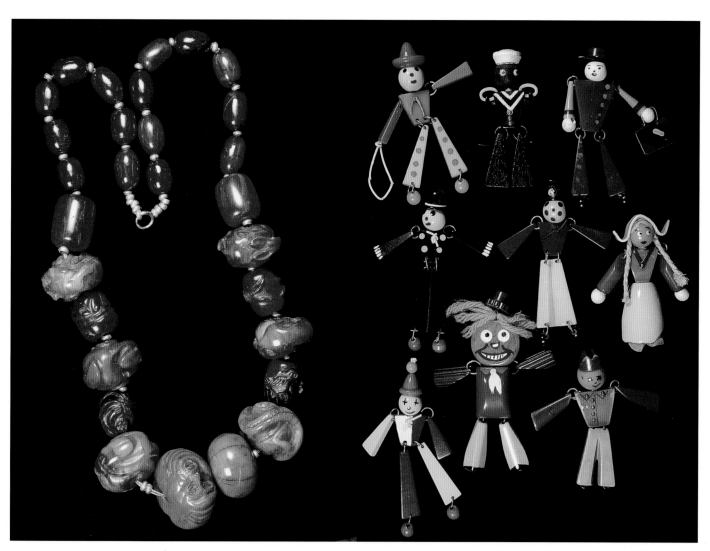

Rare carved Bakelite necklace of made to imitate amber, with beads in the form of faces and figures, c. 1930s. *Courtesy of Donna Wasserstrom*.

Jointed figural pins of Bakelite with yarn, paint, and metal rings, c. 1930s-1940s. *Courtesy of Donna Wasserstrom*. $400-900 each.

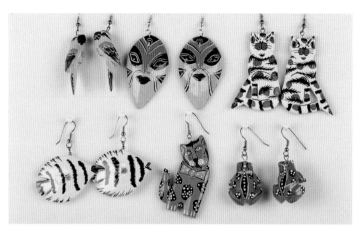

Hand painted wood earrings of birds, masks, cats, fish, and frogs, c. 1980s. $10-20 pair.

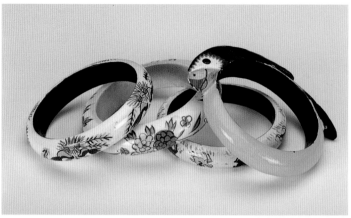

Assortment of hand painted wooden bracelets. $15-25 each.

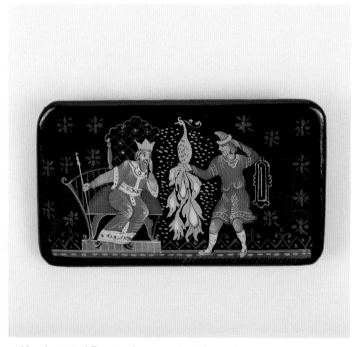

Hand painted Russian lacquer pin with royal court scene, c. 1960s. $50-75.

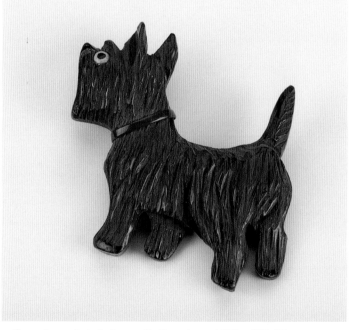

Carved wood pin in form of a Scottie, c. 1930s. $50-75.

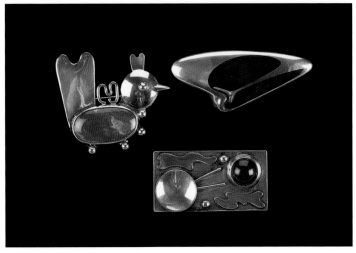

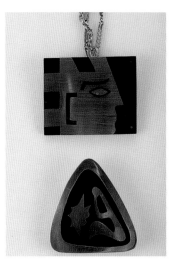

Two sterling silver pins, c. 1945, each signed "FB:" stylized bird with agate body and modernistic representation of sky; Georg Jensen (Denmark) freeform inlaid sterling pin (*top right*), designed by Henning Koppel, c. 1950s. $350-450 each.

Mexican three layered sterling inlaid pin, signed Codan; pendant/pin, the top layer inlaid with brushed silver, gold, and stone, c. 1940s-1950s. $150-200 each.

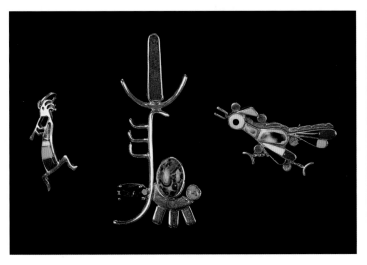

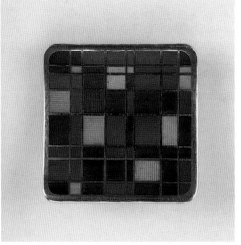

Zuni Indian sterling silver figural pins with inset colored semi-precious stones. *Courtesy of Linda Cohen.* $125-150 each.

Sterling silver pin with enameled silver grid, by David-Andersen, Norway, c. 1960. $200-250.

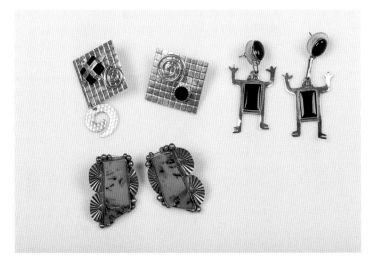

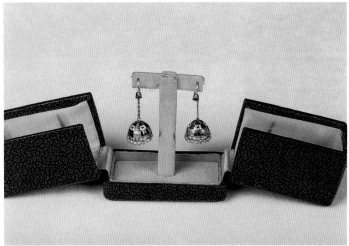

Earrings of semi-precious stones in sterling silver. *Courtesy of Linda Cohen.* $50-75 pair.

Antique coach earrings of 18 karat gold with enamel, hanging pearls, and hidden diamonds, shown with original box. *Courtesy of Ruth Marcus.* $2,500-3,500.

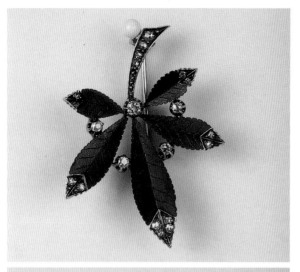

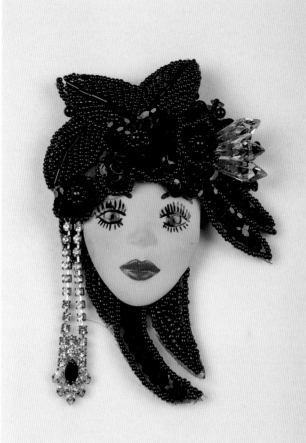

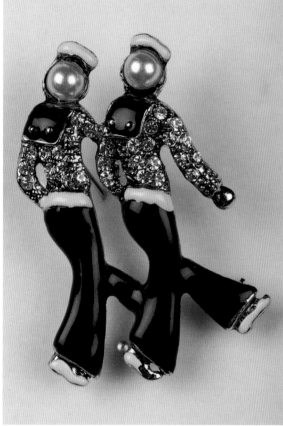

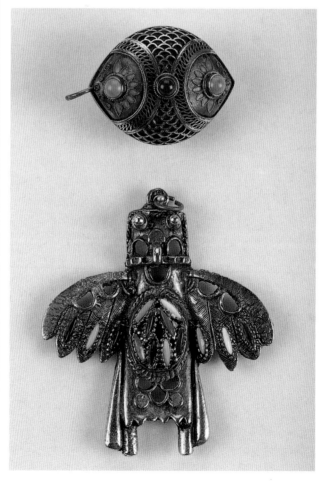

Top left: Antique leaf pin of carved smoky topaz with diamonds. *Courtesy of Ruth Marcus.* $1,000-1,500.

Center left: Figural pin depicting sailors of enameled metal with rhinestones, by Wendy Gell, c. 1970s. *Courtesy of Ruth Marcus.* $100-125.

Bottom left: Bucherer enameled watch with matching chain, c. 1950s; Art Deco cloisonné ball watch with matching chain, c. 1920s. $400-500 each.

Top right: Face pin of painted ceramic with black beaded hat and collar and long rhinestone earrings, c. 1980s. *Courtesy of Ruth Marcus.* $100-150.

Bottom right: Antique pendant converted from silver pill box with finely enameled feather pattern and stones; crude 1960s reproduction metal pendant in form of eagle with colored glass stones. $150-200; $20-25.

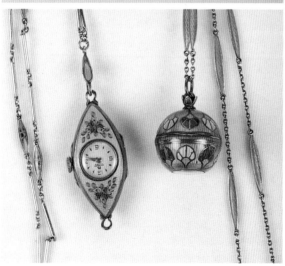

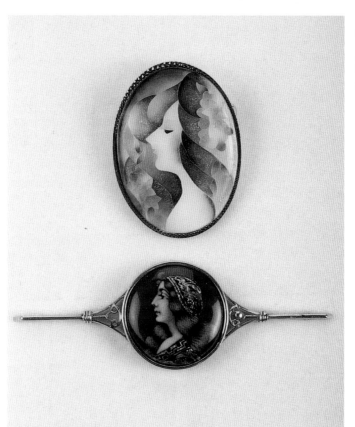

Cloisonné enamel portrait, c. 1960s; Camille Fauré enamel portrait in gold setting, marked "C. Fauré, Limoges," c. 1920s. $150-200; $1,000-1,200.

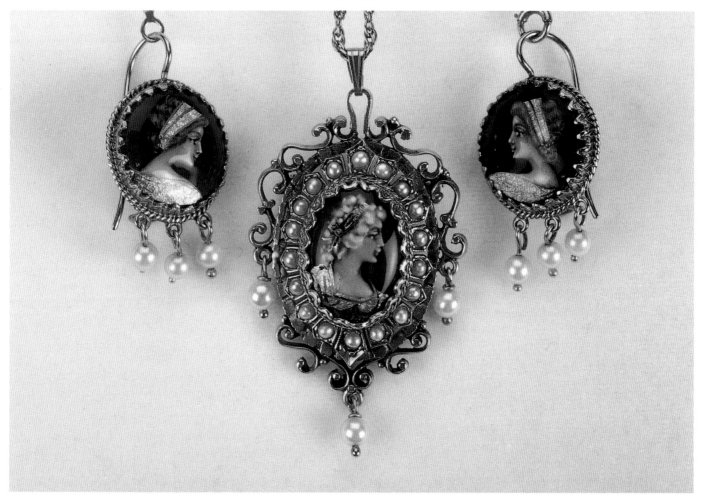

Pendant and matching earrings of 14k gold, with Limoges enamel portraits and hanging pearls, marked France, c. 1950s. $400-500 set.

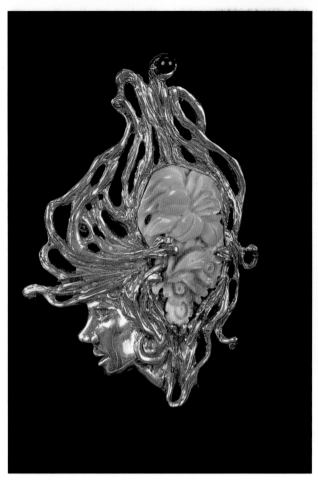

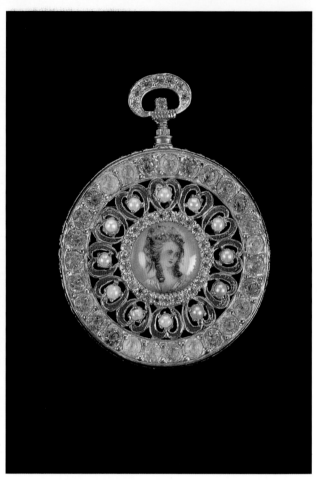

Sterling silver Art Nouveau revival pendant of female face with carved coral flower, c. 1970s. *Courtesy of Linda Cohen* $250-300.

Pin in pocket watch shape, sterling silver with gold wash and enamel, hand painted portrait, set rhinestones and pearls, by Nettie Rosenstein, signed, c. 1950. $500-700.

Eisenberg enameled pendant with modernist abstract design in orange and earth tones, signed, 1973. $200-250.

Eisenberg enameled pendant with multi-colored distorted checkerboard motif, signed, 1973. $250-300.

Large pendant of gold washed metal with enameled feather motif and American Indians circling red glass stone, marked "Castlecliff," c. 1960. $200-250.

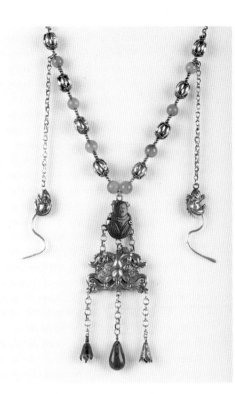

Antique Chinese necklace of silver, carnelian, and jade with silver animals. $350-400.

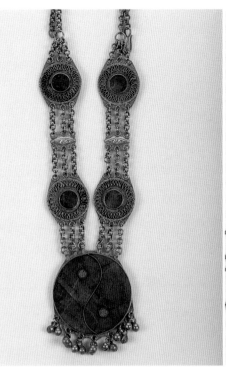

Silver metal necklace with lapis lazuli inset in a Yin-Yang design, made in Afghanistan, c. 1970s. *Courtesy of Anita Singer.* $100-125.

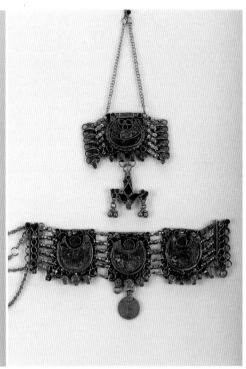

Silver metal pendant and bracelet, with lapis lazuli inset stones, made in Afghanistan, c. 1970s. $100-150 set.

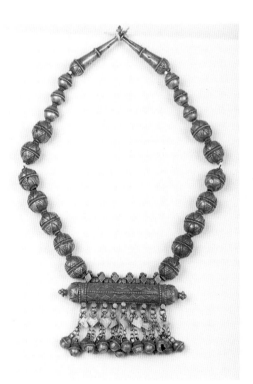

Yemenite coin silver necklace of large embossed hollow beads and decorative bar with bell drops, pre-1950. *Courtesy of Isle of Beads.* $450-550.

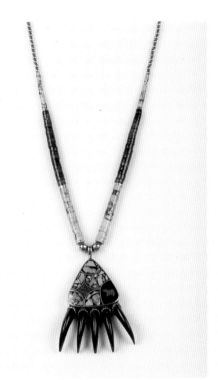

American Indian necklace of turquoise and palm nut beads, with silver pendant inlaid with turquoise and other natural stone, with five hawk claws, 1970s. *Courtesy of Ruth Marcus.* $250-350.

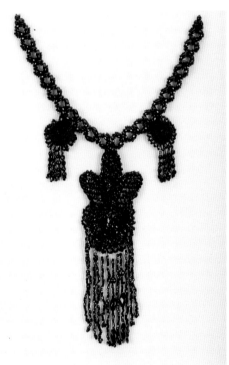

Remade necklace from antique jet and black glass beads and costume appliqués. $75-95.

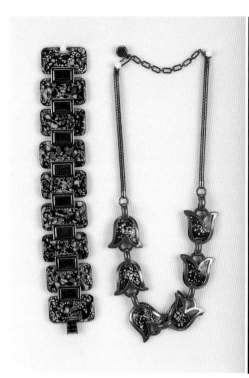

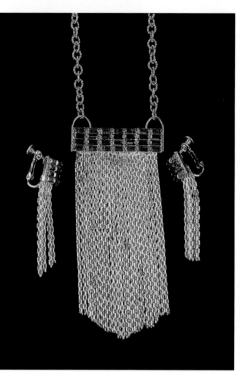

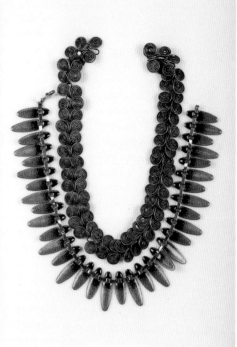

Enameled copper bracelet by Matisse; enameled necklace with red flowers by Rebajes. c. 1950s. $100-125 each.

Hobé fringed pendant and matching earrings with green and amber rhinestones, signed, c. 1960s. $150-175 set.

Necklace of spiral wound metal discs, c. 1940s; enameled copper necklace, c. 1950s. *Courtesy of Linda Cohen.* $50-60 each.

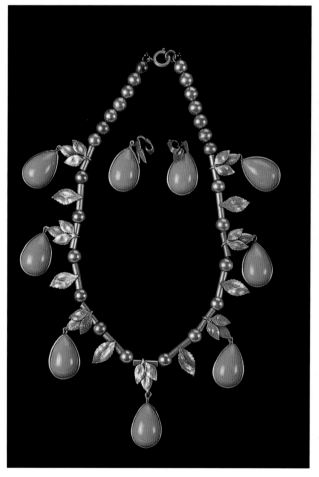

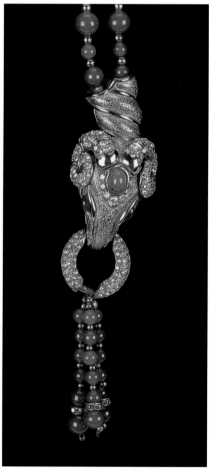

Joseff of Hollywood necklace and matching earrings of gold metal with leaves and pink plastic drops, signed metal disc on earring back, c. 1950s. $800-1,200 set.

Jomaz ram head pendant made from a belt buckle, gold metal with rhinestones and green glass stones, signed, c. 1960. $100-150.

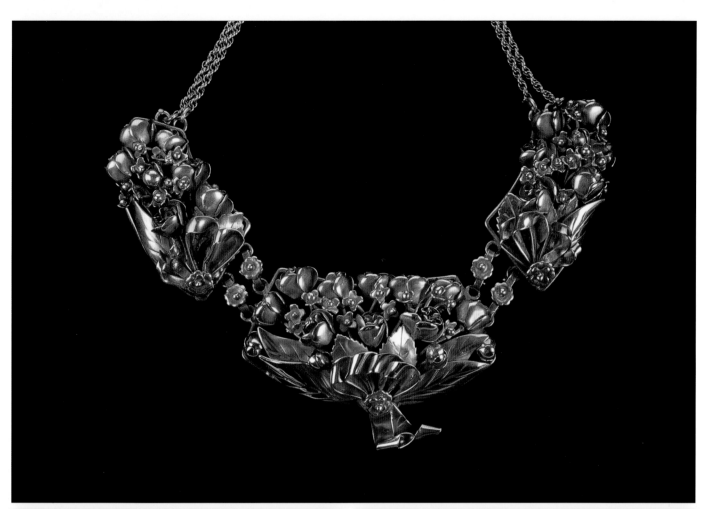

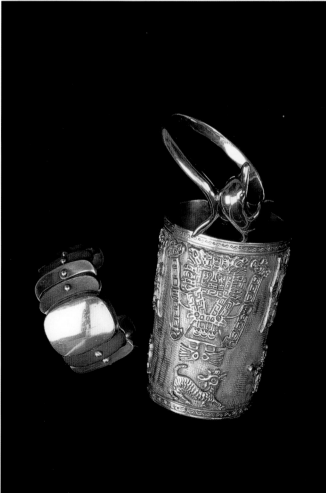

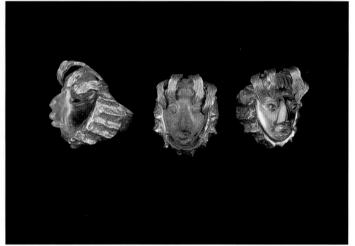

Top: Sterling silver Hobé necklace of elaborate formed flowers and ribbons, signed, c. 1950. $1,000-1,200.

Bottom left: Three sterling silver bracelets. Yaacov Heller design of dolphin with gold wash, Israel, c. 1980s; William Spratling design with stepped wood inserts, Mexico, c. 1940; 4-inch cuff with pictorial relief decoration, Peru, c. 1930s. $200-300; $1,200-1,500; $300-500.

Bottom right: Mexican sterling silver rings with carved turquoise stone and crystal Mayan portraits, 1970, marked "RJA." $125-150 each.

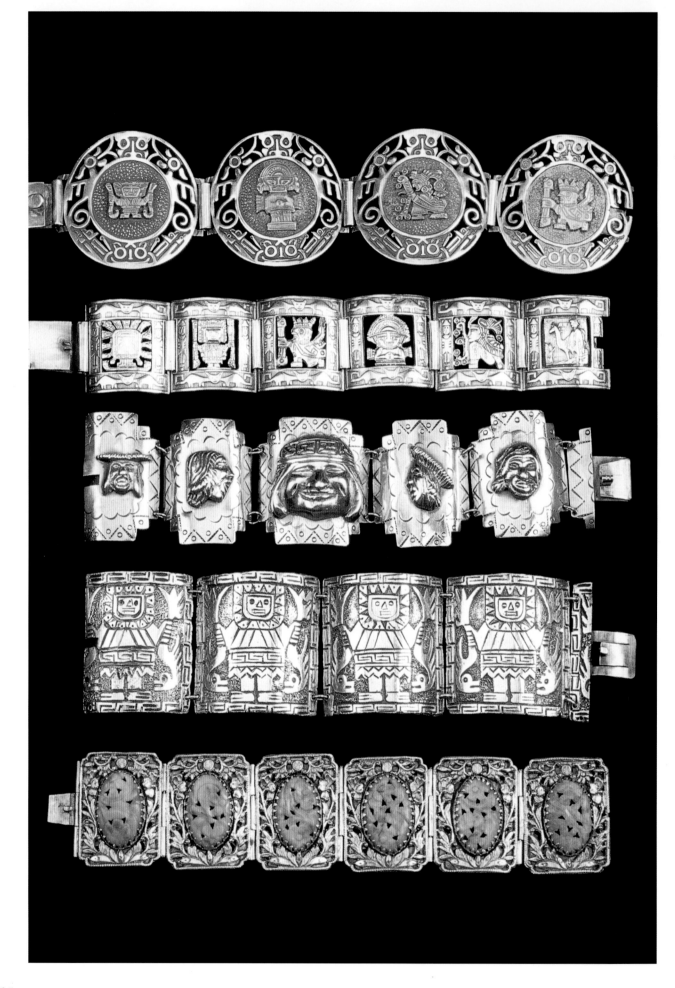

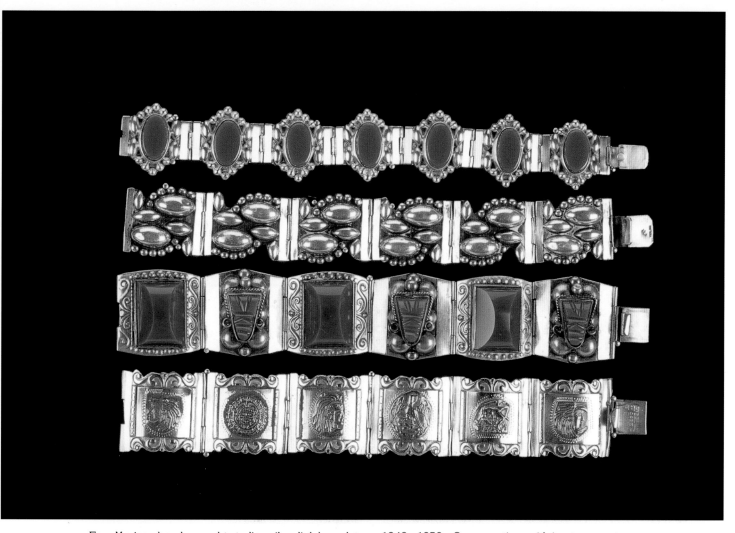

Four Mexican hand wrought sterling silver link bracelets, c. 1940s-1950s. Seven sections with inset green stone; six sections with high relief curvi-linear motif; six sections with green stone faces alternating with faceted stones; six sections of different gold Pre-Columbian motifs. $150-250 each.

Opposite page:
Peruvian hand wrought sterling silver link bracelets, c. 1930s-1940s. Four 3-7/8 inch medallions, with 18 karat gold Pre-Columbian figures; six square sections, each with different figural motif; five sections with high relief Inca Indian portraits, signed "JFM;" four 3-3/4 inch high sections with variations of the same Indian figure. One Chinese six-section bracelet with carved jade on ornate white metal. $200-350 each.

The following brass and stone pendant necklaces by Roberta and David Baird are *courtesy of Katharine Moore Coss.*

Top left: Pendant necklace of orange agate and African trade beads and brass, entitled "Toxicity," by Roberta Baird, Athens, Ohio, 1990s. $250-350.

Top right: Pendant necklace of light agate and brass with dragon, by Roberta Baird, 1990s. $200-300.

Bottom left: Pendant necklace of gray agate with intertwined brass dragons, by Roberta Baird, 1990s. $200-300.

Bottom right: Pendant necklace of red agate with asymmetrical dragon in brass, by Roberta Baird, 1990s. $225-325.

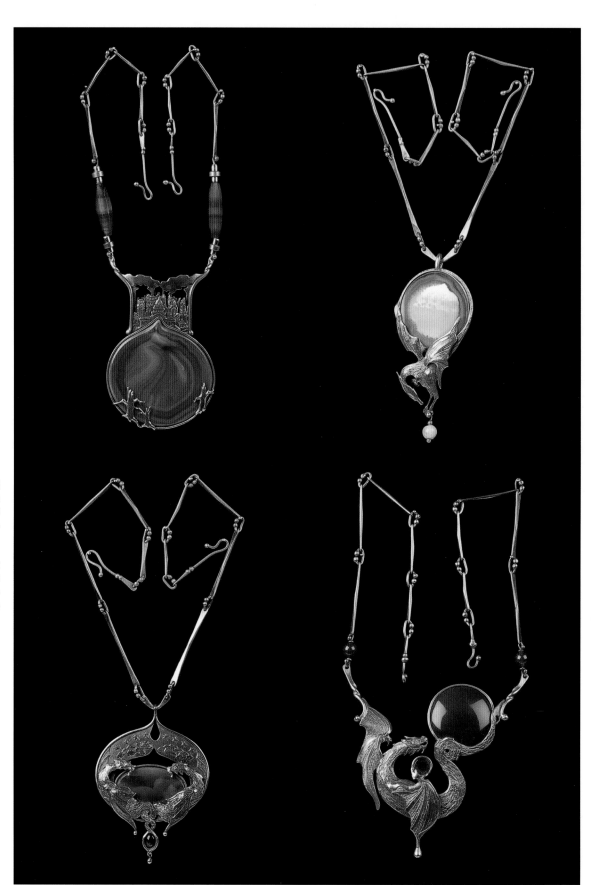

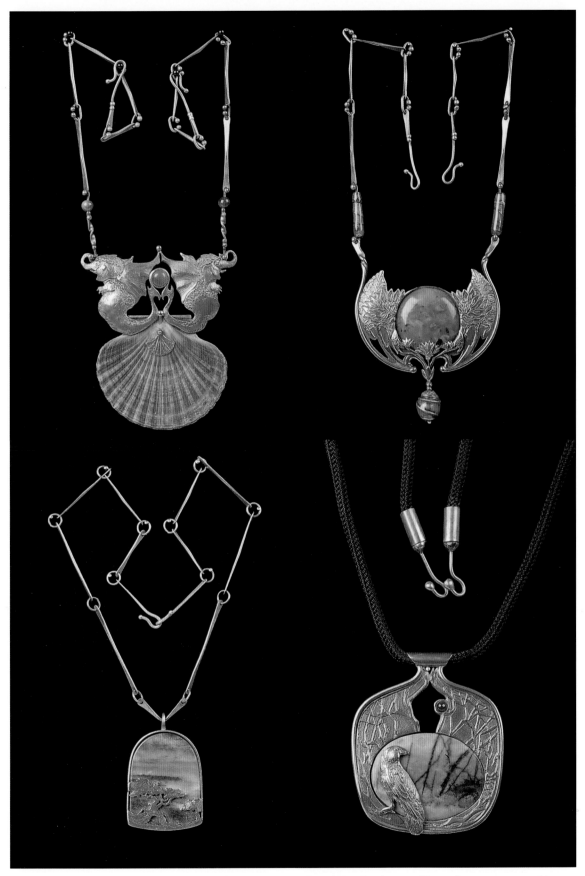

Top left: Pendant necklace with natural sea shell and brass dragons, by Roberta Baird, 1990s. $200-300.

Bottom left: Pendant necklace of striated green agate with brass wind-swept trees, by Roberta Baird, 1990s. $200-300.

Top right: Pendant necklace of green agate and brass water lily, by Roberta Baird, 1990s. $225-325.

Bottom right: Pendant of Picasso marble with crow mounted in brass, on braided silk cord, by Roberta Baird, 1990s. $150-250.

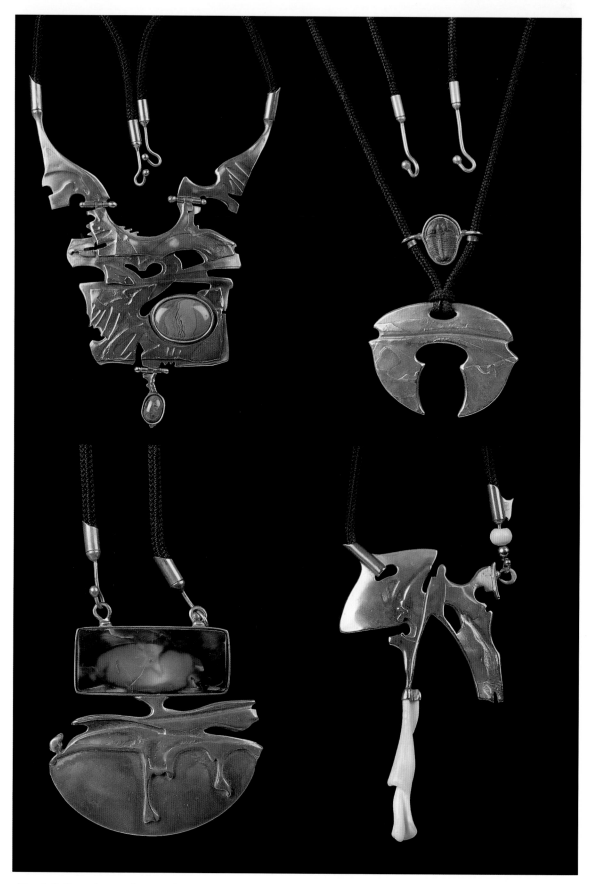

Top left: Brass breastplate pendant with green striated natural stone, on braided silk cord, by David Baird, Athens, Ohio, 1990s. $300-400.

Top right: Pendant of gray tribolite fossil with abstract brass pincers, on braided silk cord, by David Baird, 1990s. $275-375.

Bottom left: Pendant of greenish black stone with brown inclusions and abstract brass form, by David Baird, 1990s. $275-375.

Bottom right: Abstract pendant with white spiral shell suspended from brass, by David Baird, 1990s. $250-350.

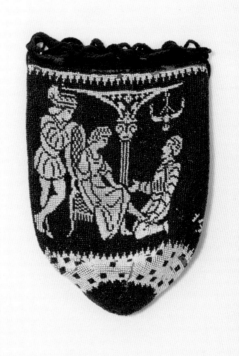

Top left: Beaded pouch style bag in black with apricot and blue design, draw string closure, c. 1900. *Courtesy of Anna Greenfield.* $150-200.

Top right: Black and white beaded bag with fairy tale scene, draw string closure, 7" h., dated 1916. *Courtesy of Veronica Trainer.* $200-250.

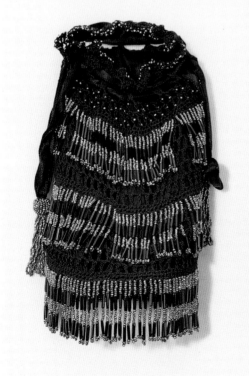

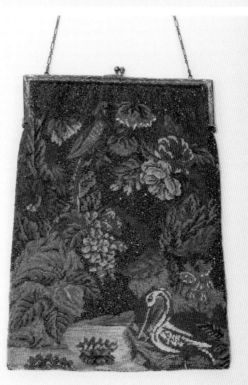

Bottom left: Rows of beaded fringe on crocheted black drawstring bag, 12" h., c. 1900. *Courtesy of Veronica Trainer.* $100-150.

Bottom right: Steel bead background with multi-color glass bead scene with birds and flowers, 10" h., c. 1920s. *Courtesy of Veronica Trainer.* $300-350.

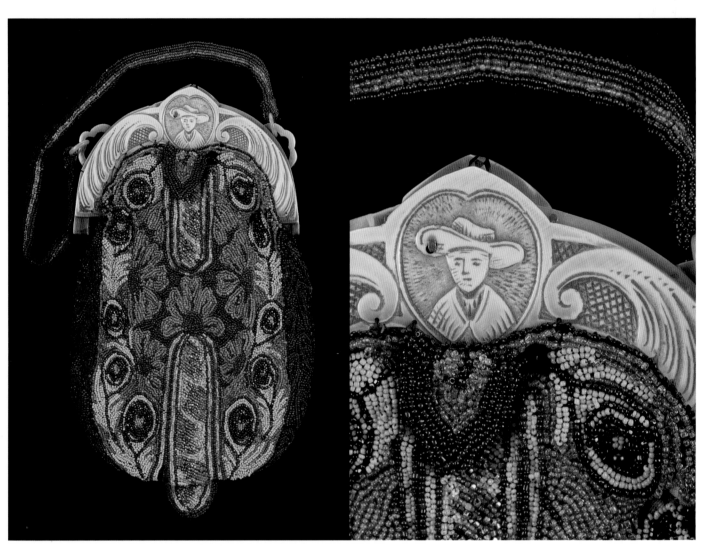

Czechoslovakian beaded bag in bold multi-color abstract floral motif, celluloid frame with man in hat, beaded handle, c. 1915. *Courtesy of Janet King Mednik.* $200-250.

Detail.

Czechoslovakian beaded bag in brightly colored Art Deco geometric design, celluloid frame with flowers, fringe, 11-1/2" h., c. 1920. *Courtesy of Paulette Batt.* $200-250.

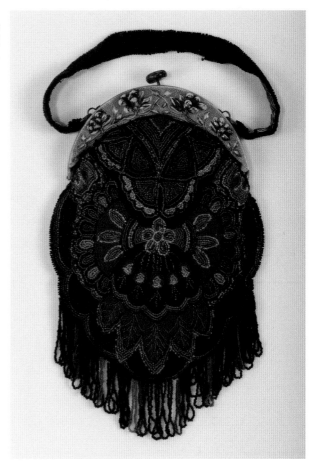

Detail.

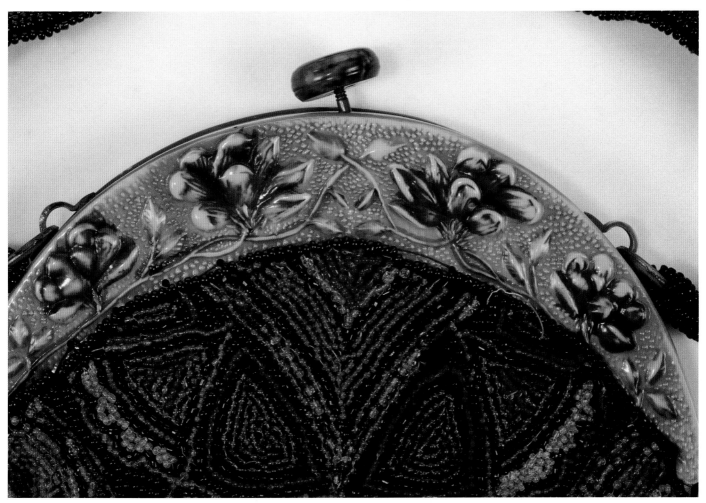

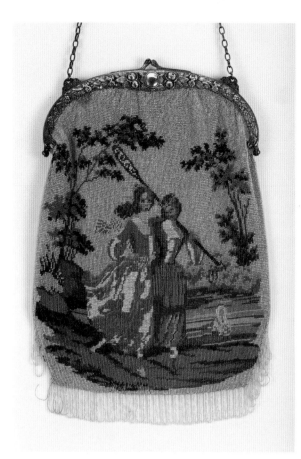

Pictorial finely beaded bag of girls carrying a canoe paddle with canoe in background, silver repousse frame, 13" h., c. 1920s. *Estate of Zelta Schulist Glick*. $500-700.

Detail.

Pictorial beaded bag with biblical scene, straight fringed bottom, sterling silver frame and chain, 9" h., c. 1920s. *Courtesy of Ruth Marcus*. $500-700.

Pictorial beaded bag with courting scene, elaborate silver frame, fringed bottom, 14" h., c. 1915. *Courtesy of Emma Lincoln*. $500-700.

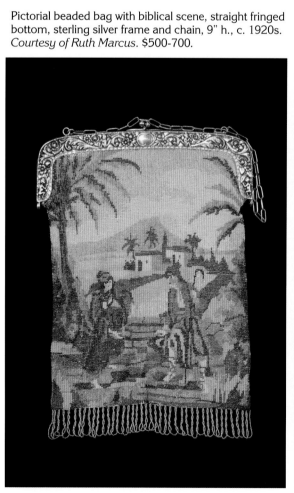

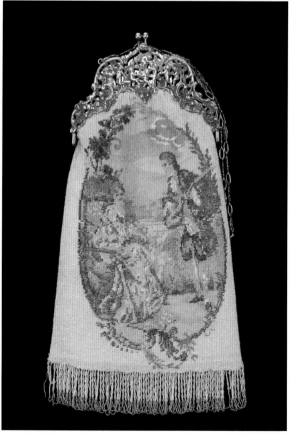

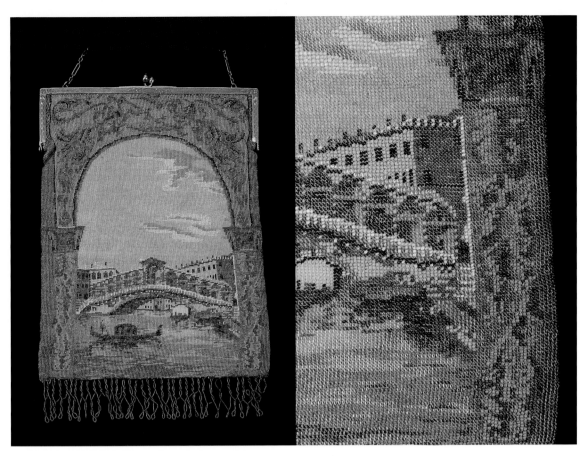

Venetian canal scene with gondola under a bridge, extremely fine beading, c. 1920. *Courtesy of Lorita Winfield.* $1,000-1,200.

Detail.

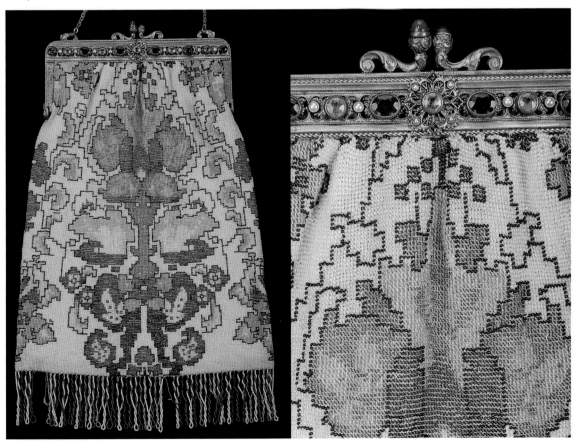

Multi-colored Art Deco geometric design of fine seed beads with jeweled frame. *Courtesy of Lorita Winfield.* $700-900.

Detail.

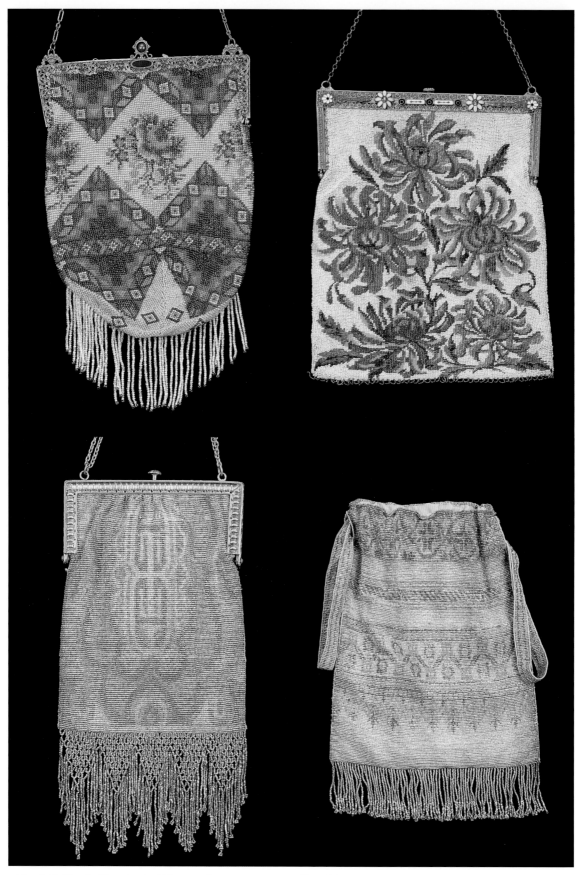

Top left: Beaded bag in vivid blues and orange geometric and floral pattern, with fringed rounded bottom and jeweled frame, c. 1920s. *Courtesy of Lorita Winfield.* $500-600.

Top right: Beaded bag with floral design on white background, enameled flowers and jewels on frame, 9" h., c. 1920s. *Courtesy of Veronica Trainer.* $350-400.

Bottom left: Steel bead bag with geometric design and complex fringe, c. 1920s. *Courtesy of Anna Greenfield.* $250-300.

Bottom right: Steel bead bag with soft closure, beaded handles, and fringe, c. 1920s. *Courtesy of Anna Greenfield.* $150-200.

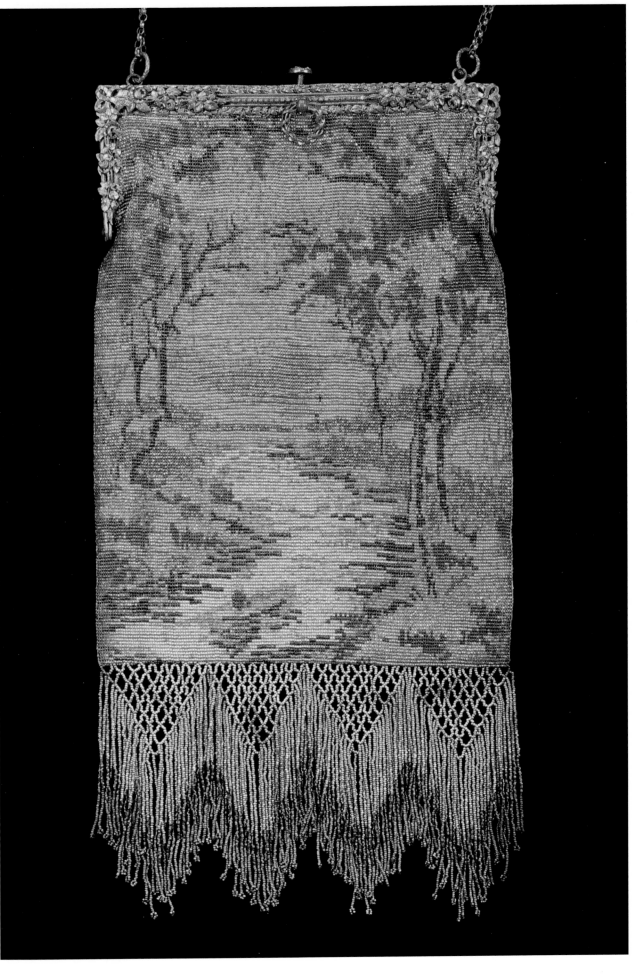

Pictorial French steel bead bag with landscape scene, elaborate molded floral frame, complex fringe, c. 1920s. *Courtesy of Lorita Winfield.* $400-450.

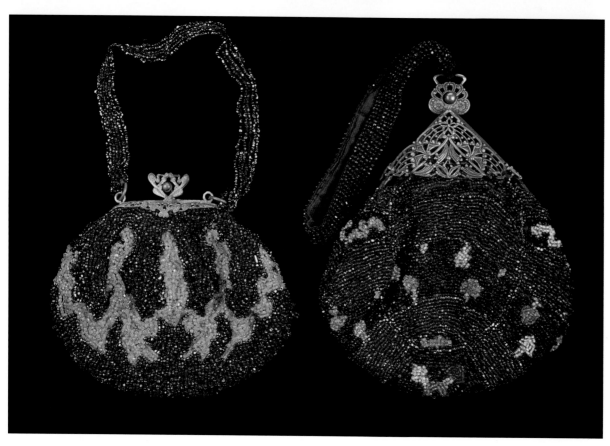

Czechoslovakian bags. *Left:* silver filigree frame, blue and gold beads; *right:* German triangular filigree frame with blue beaded floral pattern. *Courtesy of Anna Greenfield.* $75-100 each.

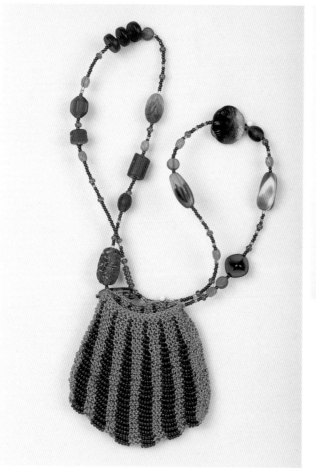

Amulet bag of plum seed beads on green knit, hanging on green and plum glass bead necklace. *By Mary Ann Weber, courtesy of Isle of Beads.* $125-150.

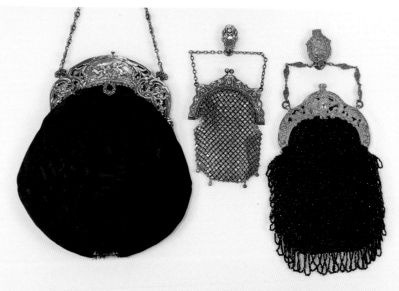

Left: black satin with ornate silver frame, 10-1/2" h.; *center:* German silver mesh chatelaine, 6" h.; *right:* black beaded chatelaine, marked "Pat. Feb. 22, 1900," 9-1/2" h. *Courtesy of Paulette Batt.* $75-125 each.

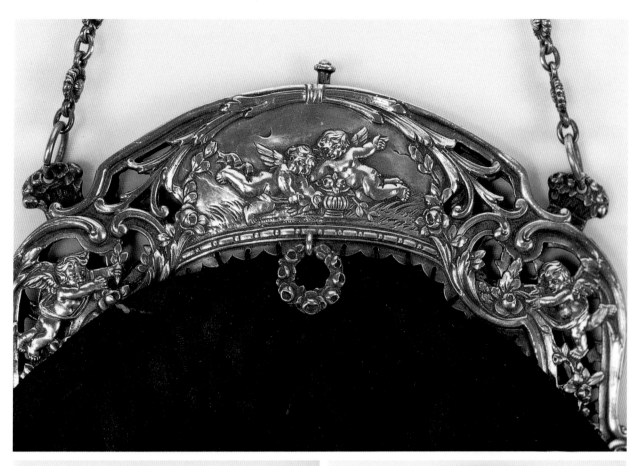

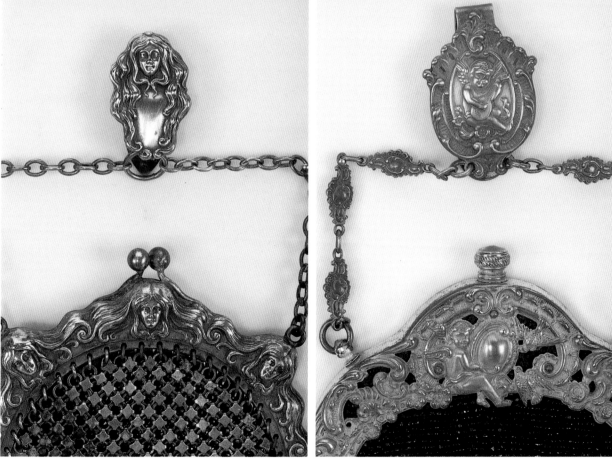

Top: Detail of left frame.

Bottom left: Detail of center chatelaine.

Bottom right: Detail of right chatelaine.

Top left: Seed beads and embroidery with finger loop handle, 7" x 7". *Courtesy of Paulette Batt.* $50-75.

Top right: Clutch evening bags in half moon shape with tiny seed beads, made in France, 8" w. *Courtesy of Paulette Batt.* $50-75 each.

Bottom left & right: Detail.

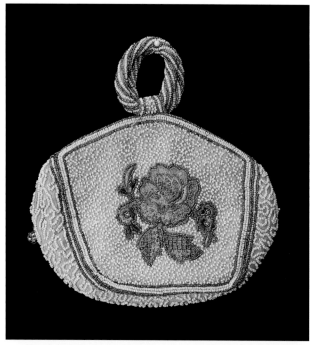

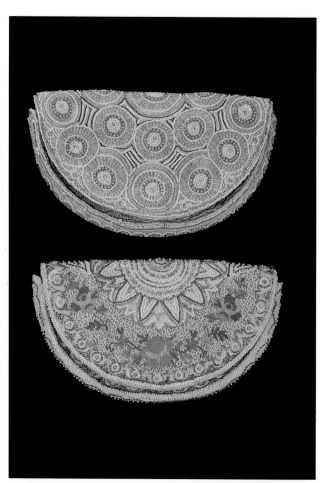

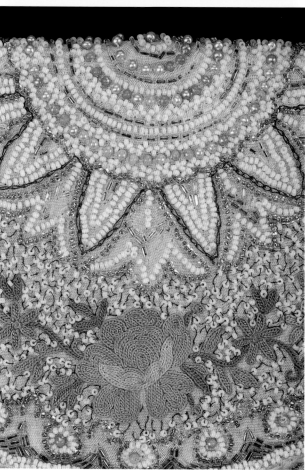

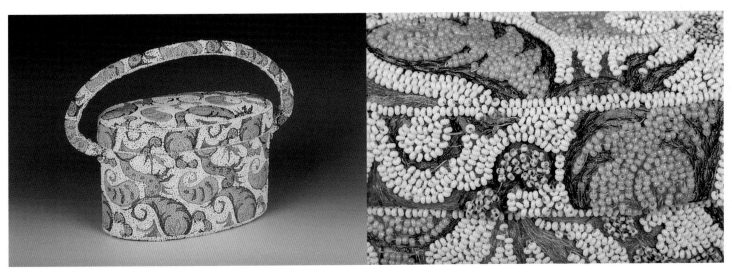

Oval box style handbag with soft handle, completely covered with seed beads and embroidery in a Persian style design, label: Delill, c. 1940s. *Courtesy of Nancy Goldberg.* $200-250.

Detail.

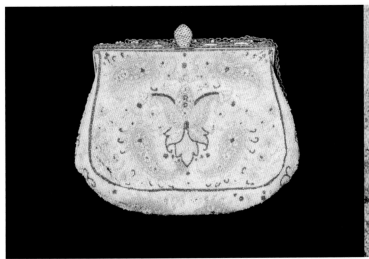

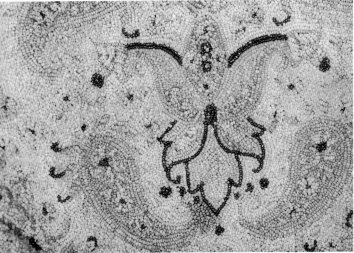

Pastel and white seed beads in paisley design, c. 1940s. *Courtesy of Barbara MacDonald Shenk.* $50-75.

Detail.

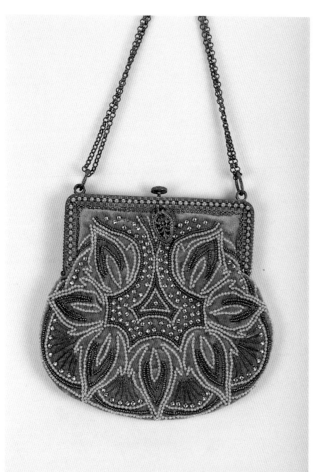

Orange velvet with metal beads, faux pearls, and rhinestones, 6-1/4" w. *Courtesy of Ruth Kyman.* $100-125.

Detail.

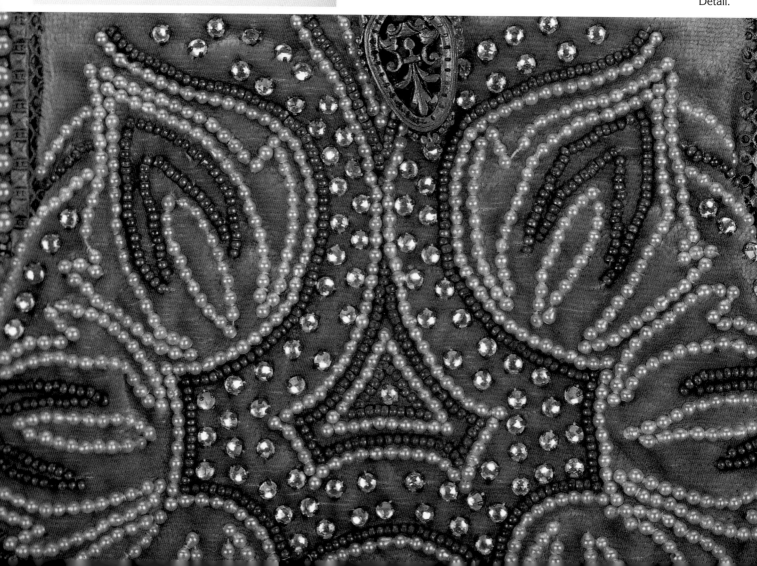

Black seed beads and floral embroidery with beaded frame, marked "Altman & Fils, Paris," c. 1950. $100-125.

Detail.

Needlepoint multi-color floral with black background, c. 1960. $50-70.

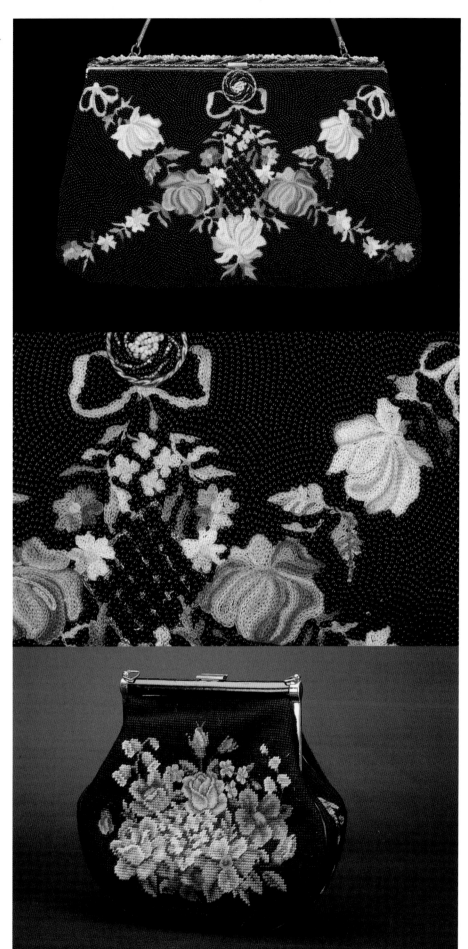

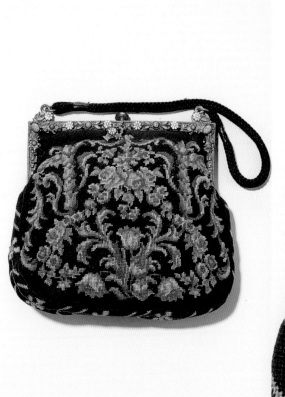

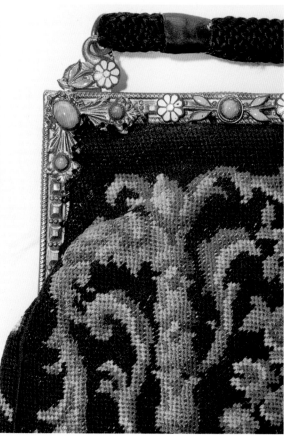

Black background with floral, petit point bag with fine enameled frame, c. 1940s. $150-175.

Detail.

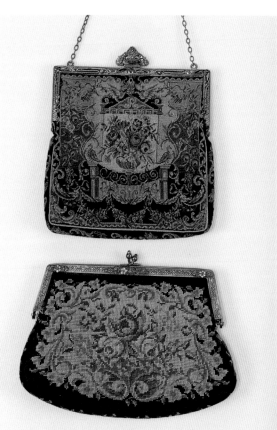

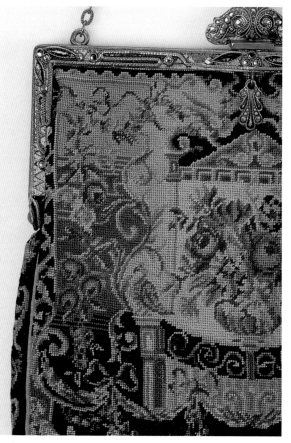

Top: minute petit point floral on black ground, ornate frame and clasp with marcasite, late 19th century, 5-3/4" h.; *bottom:* larger floral petit point, c. 1940s, 6-3/4" w. *Courtesy of Paulette Batt.* $200-250; $40-60.

Detail of top.

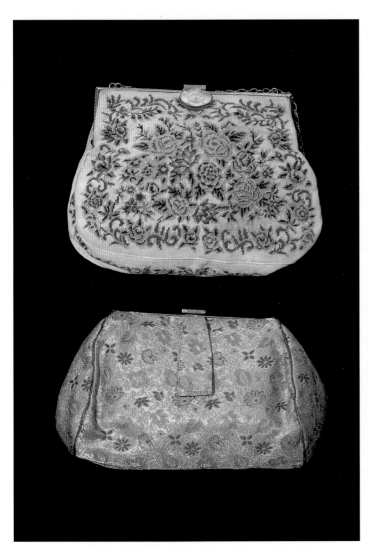

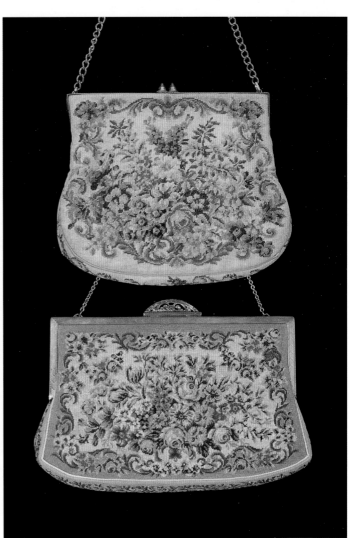

Top: fine petit point floral with carved jade clasp, c. 1930s; *bottom:* gold brocade Chinese floral, c. 1950s. *Estate of Rose Allen.* $150-175; $25-35.

Two very fine floral petit point bags, c. 1930s, 6-1/2" and 7-1/2" w. *Courtesy of Paulette Batt.* $125-150 each.

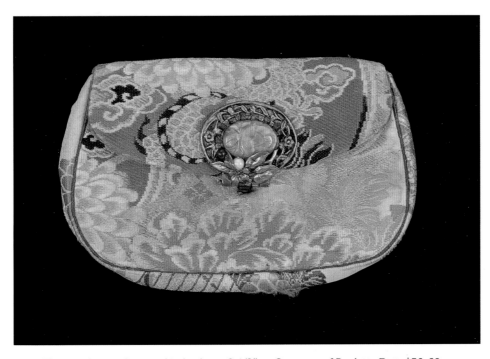

Tapestry bag with carved jade clasp, 6-1/2" w. *Courtesy of Paulette Batt.* $50-60.

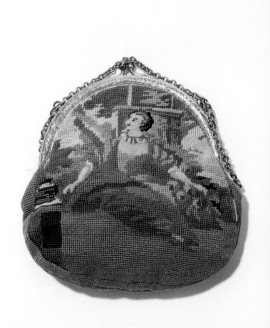

Petit point figural of seated lady, c. 1950s. $125-150. Detail.

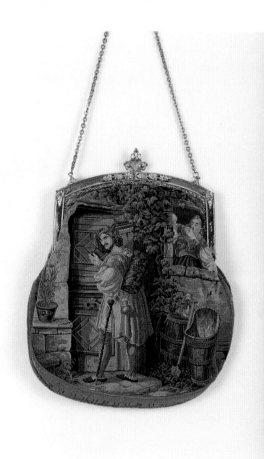

Extremely fine petit point 17th-century scenic figural,
c. 1930s. *Estate of Zelta Schulist Glick.* $300-400. Detail.

Very fine petit point compact with figure and building, c. 1930s. $100-150.

Detail.

Detail of frame.

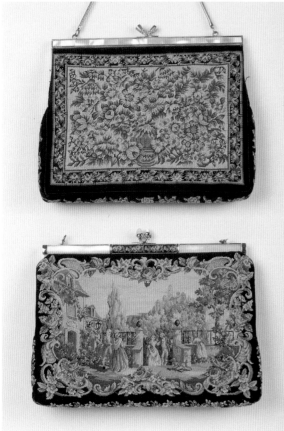

Top: very fine petit point evening bag with floral design on both front and back and mother-of-pearl frame; *bottom:* extremely fine scenic-figural petit point with front and back views alike; both purchased in Austria, c. 1960. *Courtesy of Lois Epstein from the estate of Rose Allen.* $250-300; $350-400.

Opposite page:
Top: Detail of floral.

Bottom: Detail of figural.

Unembroidered petit point canvas with fine petit point birds and flowers, overlaid onto cloth bag, metal filigree frame with blue beads, c. 1920s, 8-1/2" h. *Estate of Zelta Schulist Glick*. $200-225.

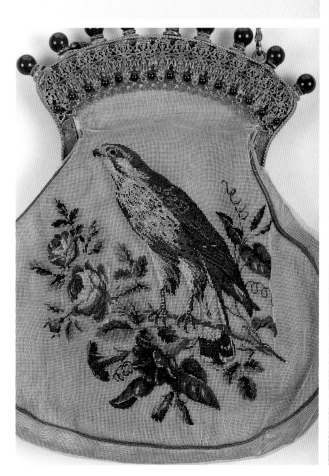

Reverse side.

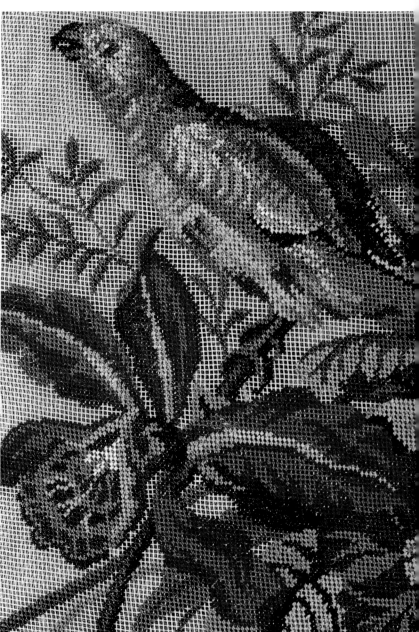

Detail showing petit point canvas.

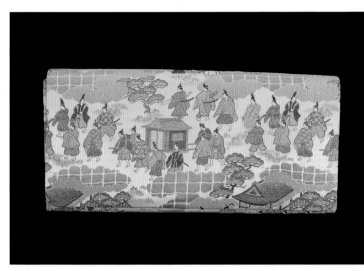
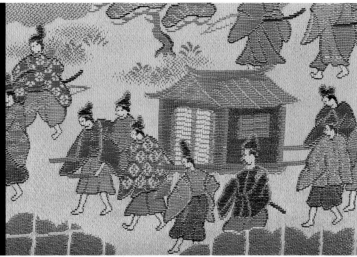

Chinese textile envelop bag with scenic and figural theme in pastel colors, 9-1/2" w. *Courtesy of Ruth Kyman.* $35-45.

Detail.

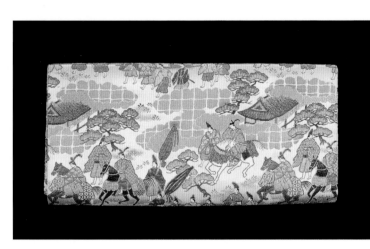

Reverse side.

Detail.

Top left: Chinese figural motif embroidered on white silk, frame with colored stones, 7" w. *Estate of Zelta Schulist Glick*. $75-100.

Top right: Colorful embroidered floral design on white silk, c. 1950s. *Courtesy of Ruth Kyman*. $40-50.

Bottom left: Detail.

Bottom right: Detail.

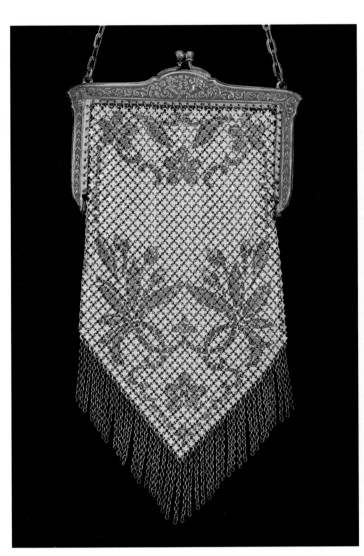

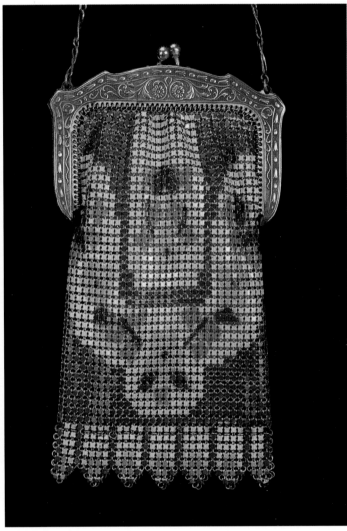

Mandalian enameled metal mesh purse, blue and yellow floral pattern, fringed pointed bottom, c. 1920s, 7-1/2" h. $125-150.

Whiting & Davis enameled metal mesh purse, green and orange geometric, zigzag bottom, c. 1920s, 6-1/2" h. $125-150.

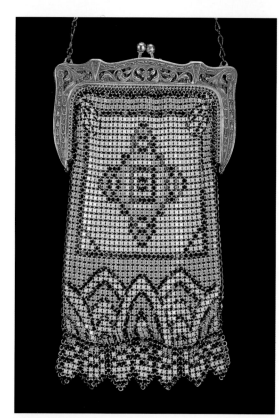
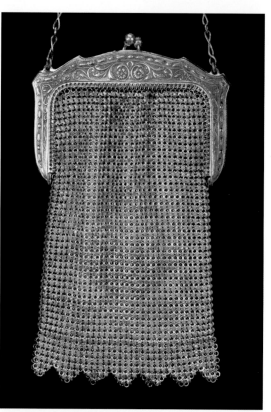
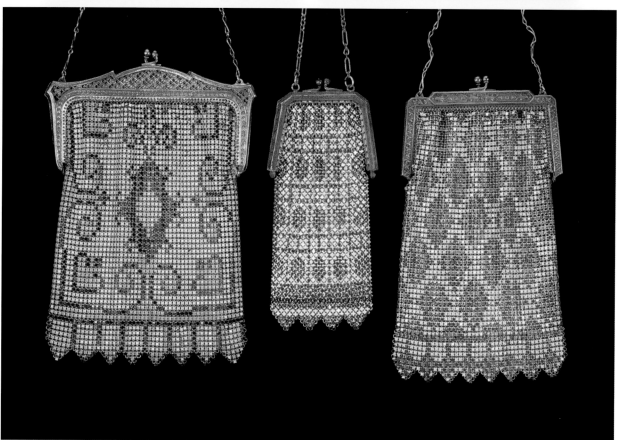

Top left: Enameled metal mesh purse, blue abstract, zigzag bottom, c. 1920s, 6-1/2" h. *Courtesy of Lorita Winfield.* $125-150.

Top right: Whiting & Davis raised bead-like mesh, enameled in pink, orange, and green, 6-1/4" h. *Courtesy of Paulette Batt.* $125-150.

Bottom: Enameled mesh purses with geometric designs and zigzag bottoms, c. 1920s. *Left:* Whiting & Davis (with tag) pink and gray, 7-3/4" h.; *center:* Mandalian blue and white, 6" h.; *right:* blues and brown, 7-1/2" h. *Courtesy of Paulette Batt.* $125-150; $90-110; $125-150.

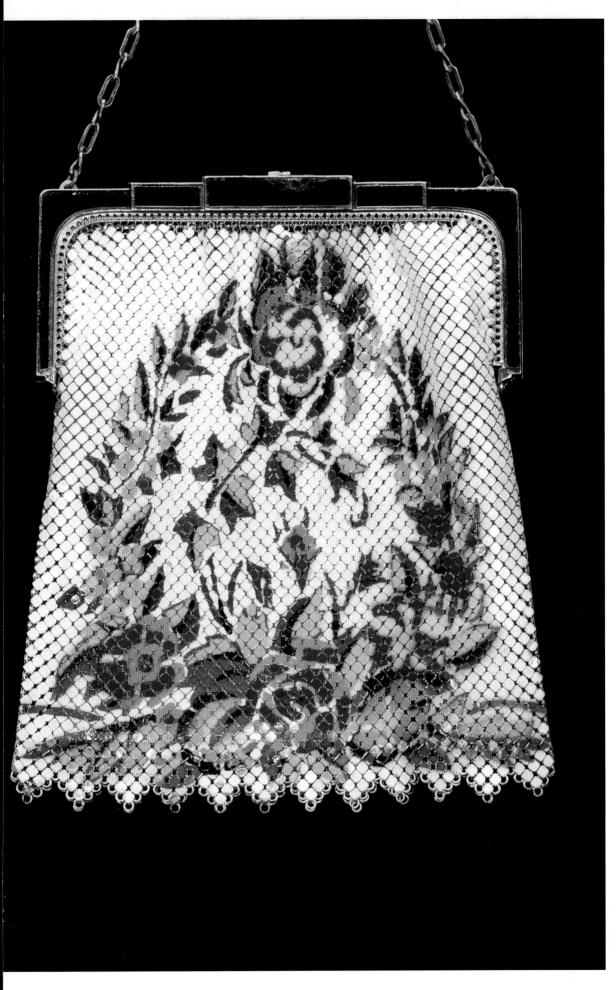

The following Whiting & Davis, Mandalian, and Evans enameled metal flat, armor style, and loop mesh purses are circa the 1920s. *Courtesy of Bunnie Union.*

Whiting & Davis, flat mesh, multi-color floral on white, zig-zag bottom, Art Deco frame, 6-1/4" h. $150-175.

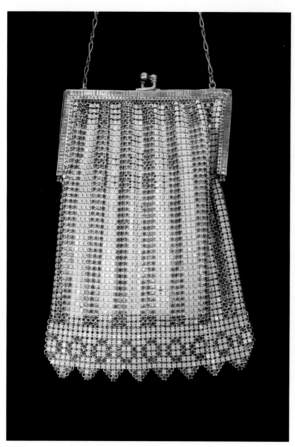

Unmarked green geometric, flat mesh, zigzag bottom, 6-1/4" h. $90-110.

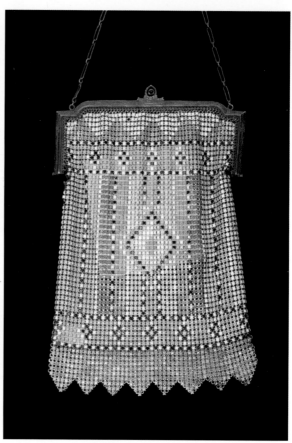

Whiting & Davis, flat mesh, Art Deco pastel stripe and geometric, zigzag bottom, 7-3/4" h. $100-125.

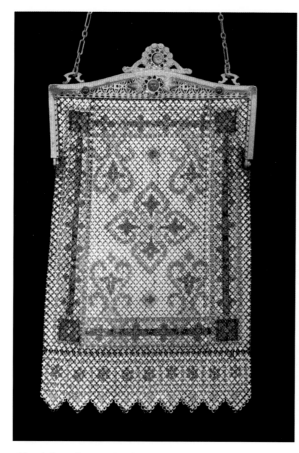

Mandalian, flat mesh, blue, tan, and white, zigzag bottom, jeweled frame, 9-1/2" h. $200-225.

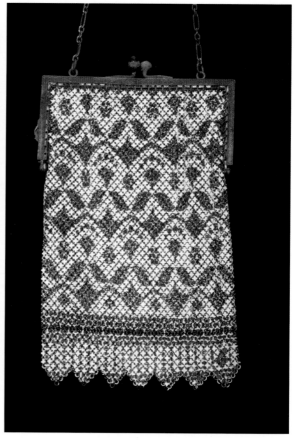

Mandalian, flat mesh, blue and white abstract, zigzag bottom, 7-1/8" h. $100-125.

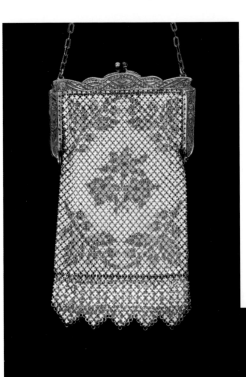

Mandalian, flat mesh, pink, yellow, and white floral, zigzag bottom, 6-1/2" h. $125-150.

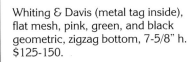

Whiting & Davis (metal tag inside), flat mesh, pink, green, and black geometric, zigzag bottom, 7-5/8" h. $125-150.

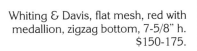

Whiting & Davis, flat mesh, red with medallion, zigzag bottom, 7-5/8" h. $150-175.

Whiting & Davis, flat mesh, geometric pattern in dark tones, Art Deco frame, zigzag bottom, 7" h. $200-225.

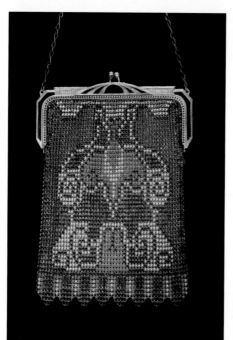

Detail.

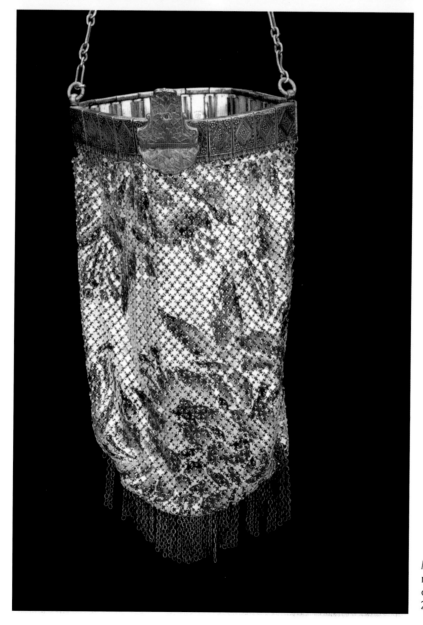

Mandalian (unmarked), flat mesh, unusual linked spring closing, fringed, 8" h. $225-250.

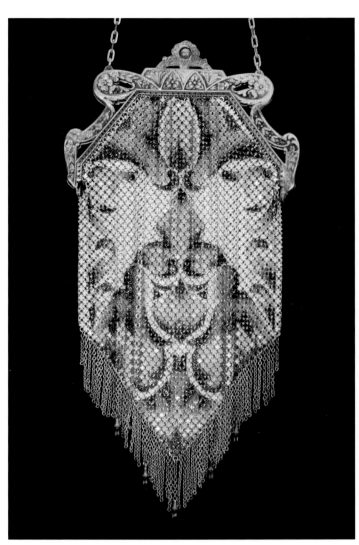

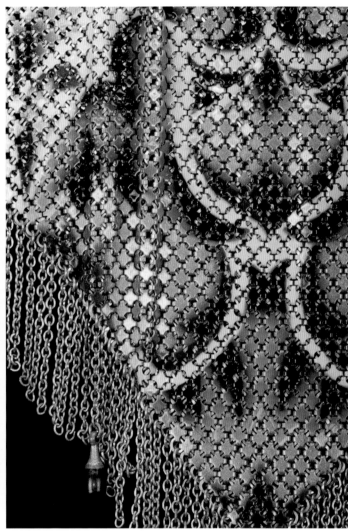

Mandalian, flat mesh, greens and yellows, pointed and fringed bottom with drops, ornate frame, 9-1/4" h. $250-275.

Detail.

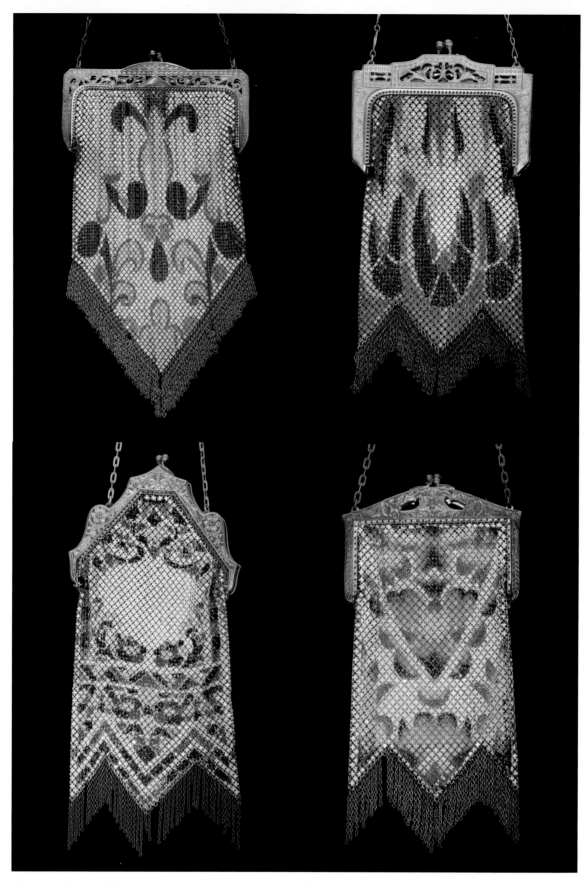

Top left: Whiting & Davis, flat mesh, dark green and pastels abstract floral, pointed and fringed bottom, 9-3/4" h. $150-175.

Bottom left: Mandalian, flat mesh, teal, black, and yellow, zigzag fringed bottom, 9" h. $150-175.

Top right: Whiting & Davis, flat mesh, turquoise, black, and coral geometric, zigzag fringed bottom, ornate frame, 7-1/2" h. $200-225.

Bottom right: Mandalian, flat mesh, coral, black, and gold, zigzag fringed bottom, 7-5/8" h. $150-175.

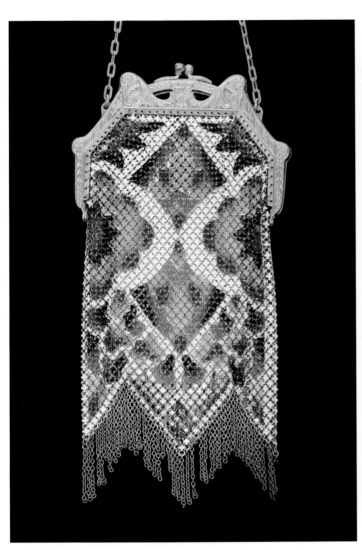

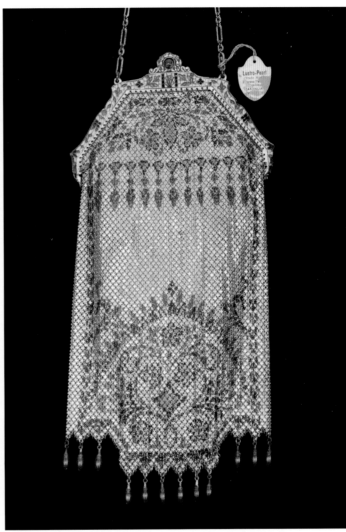

Mandalian, flat mesh, pink with earthtones geometric, zigzag fringed bottom, 7-1/4" h. $200-225.

Mandalian, flat mesh, delicate coral and turquoise design, stepped bottom with drops, ornate enameled frame, 9-1/2" h. $250-275.

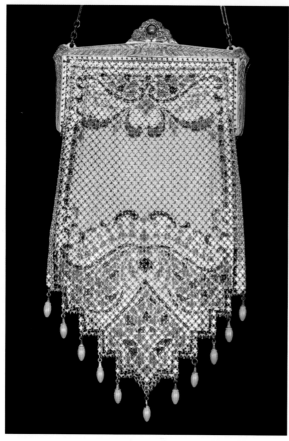

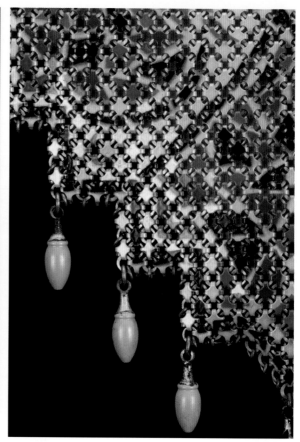

Mandalian, flat mesh, light yellow with multi-color pattern, pointed and zigzag bottom with drops, 8-1/2" h. $200-225.

Detail.

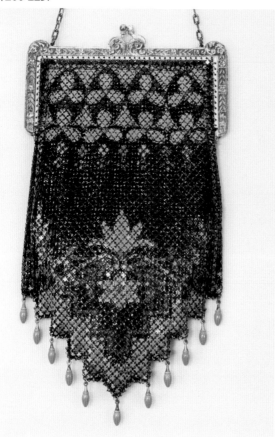

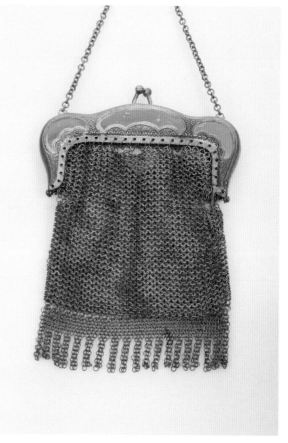

Mandalian, flat mesh, black and pink floral abstract, pointed and zigzag bottom with drops, 8-1/2" h. $175-200.

Child's purse, unmarked, Dresden loop mesh with painted pattern, fringed bottom, 4-3/4" h. $100-125.

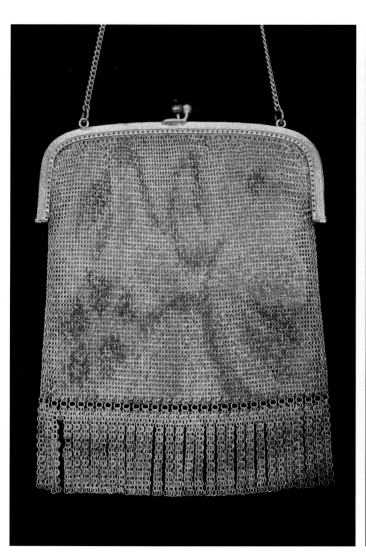

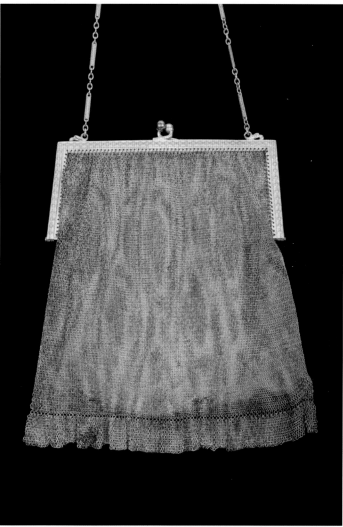

German Dresden loop mesh with painted pattern, fringed bottom, 6-1/2" h. $150-175.

Whiting & Davis, Dresden loop mesh painted in light magenta and multi-color abstract pattern, ruffled bottom, 6-1/2" h. $175-200.

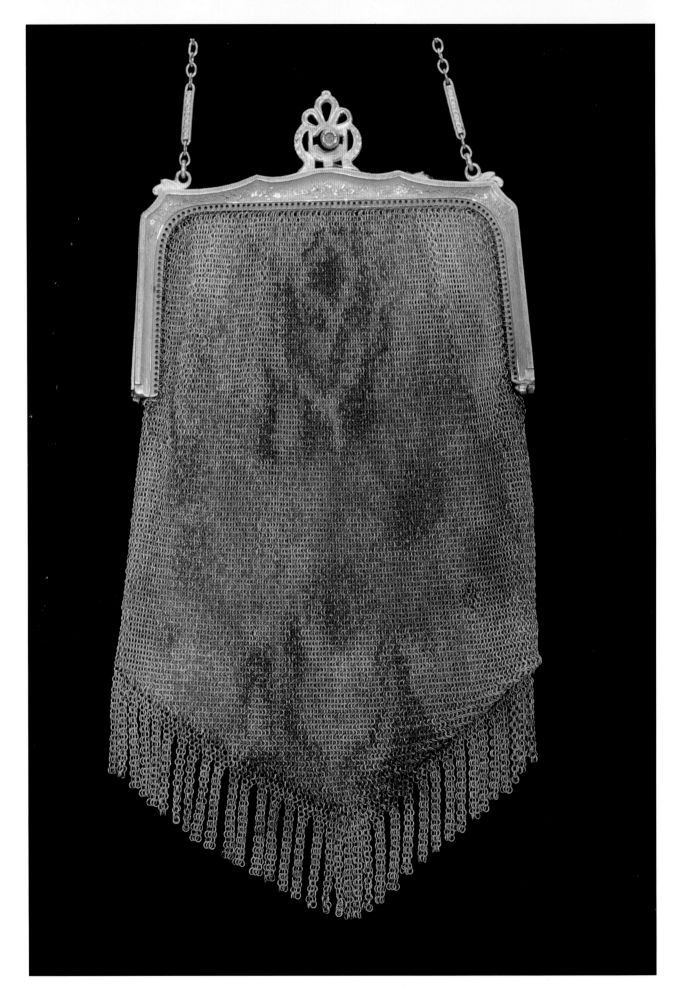

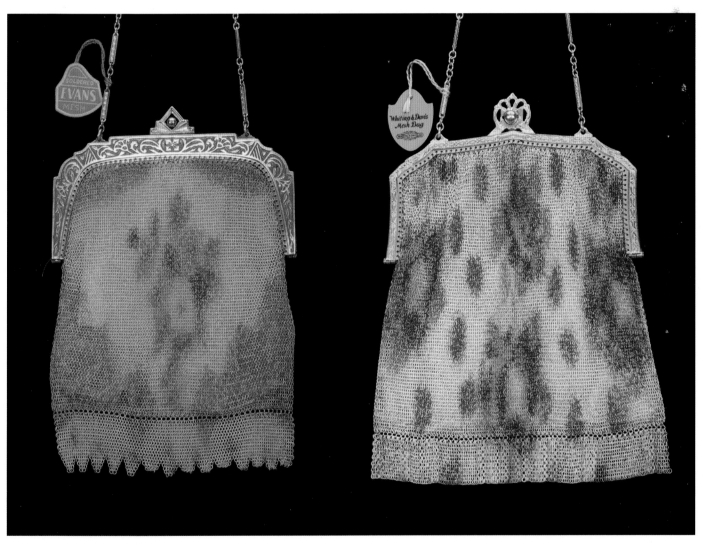

Evans (stamped plus paper label), pastels painted on Dresden loop mesh, zigzag bottom, 5-1/2" h. $200-225.

Whiting & Davis (stamped plus paper label), pink and red flowers painted on Dresden loop mesh, ruffled bottom, 5-3/4" h. $200-225.

Opposite page:
Whiting & Davis, Dresden loop mesh with bright warm colored floral painting, pointed and fringed bottom, 7-1/2" h. $200-225.

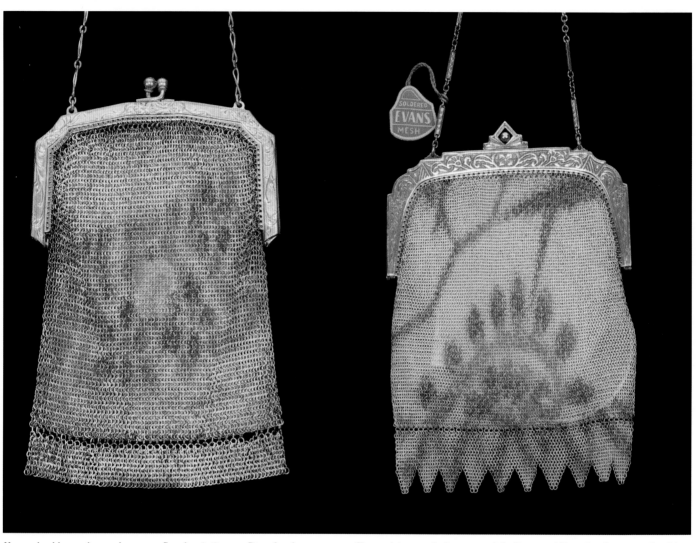

Unmarked lavender and orange floral painting on Dresden loop mesh, 6" h. $150-175.

Evans (stamped plus paper label), pastel Dresden loop mesh with pointed zigzag bottom, 5-1/2" h. $175-200.

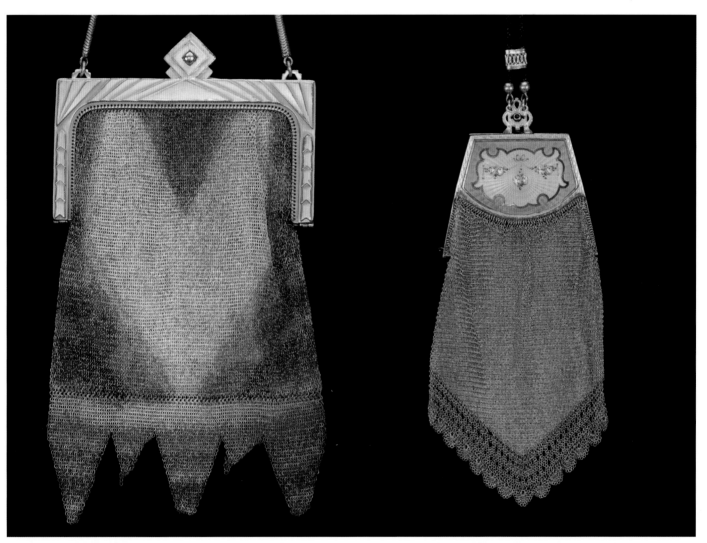

Whiting & Davis, multi-color Dresden loop mesh, with Art Deco frame and irregular zigzag bottom, 7-1/2" h. $200-225 (*last of Bunnie Union collection*).

Enameled powder compact made as part of purse frame, with fine brass mesh wire, 8-1/2" h. *Courtesy of Paulette Batt.* $175-225.

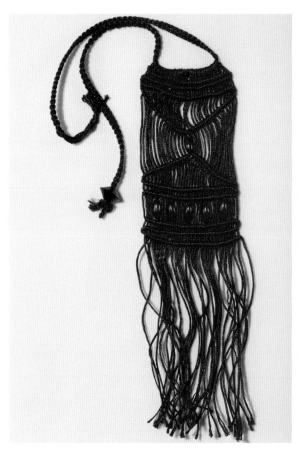

Small red macrame bag with red beads and long fringe, c. 1960s. $20-25.

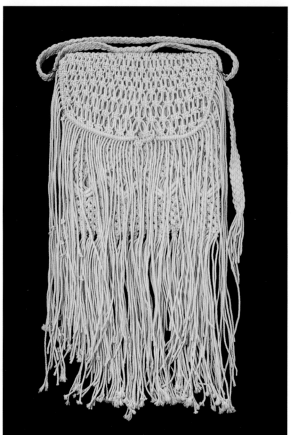

White macrame shoulder bag with long fringe on bottom, c. 1960s. $30-40.

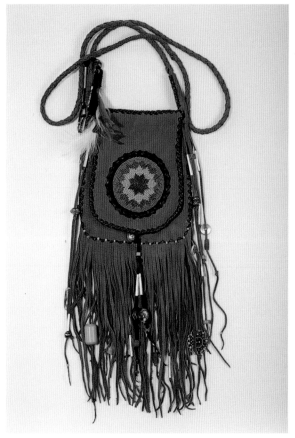

Deerskin saddlebag style Indian purse with braided shoulder strap, long fringe, and hand-beaded medallion on flap. *Courtesy of Arlene Schreiber.* $75-100.

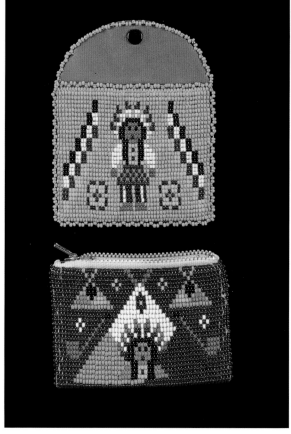

American Indian beaded coin purses, c. 1970s. $25-30 each.

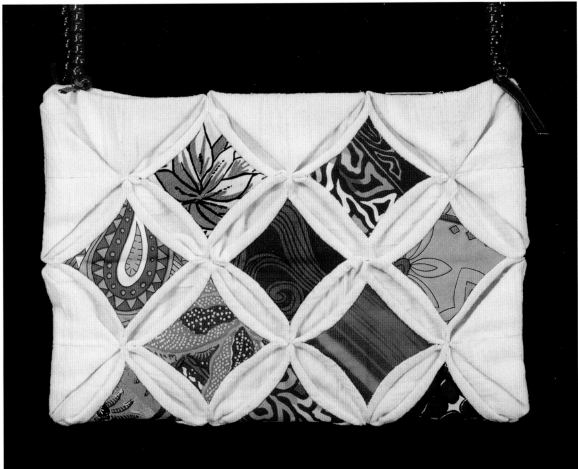

Top left: Patchwork handled bag in ikat and other Japanese fabrics. *Courtesy of Sharon Ramsay.* $40-50.

Top right: Cathedral patchwork of red, white, and blue prints on brushed denim shoulder bag, 1973. *By Shirley Friedland.* $60-80.

Bottom: White crinkle cotton shoulder bag with strung bead strap, cathedral patchwork of hot colored prints, 1974. *By Shirley Friedland.* $60-80.

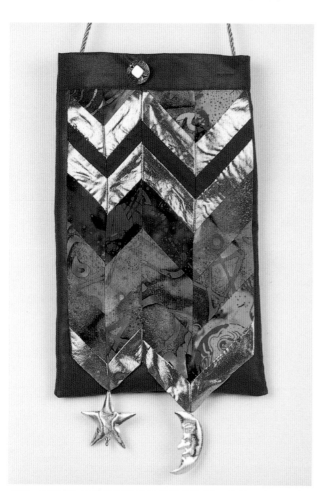

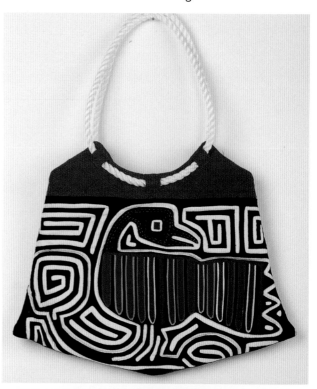

Left: Bag of seminole patchwork using hand-printed fabrics in blues, lavender, and metallic gold, with hanging soft metallic charms, 1999. *By Shirley Friedland.*

Below: Bag made of panel of Mola embroidery, of large multi-color bird on black and white background.

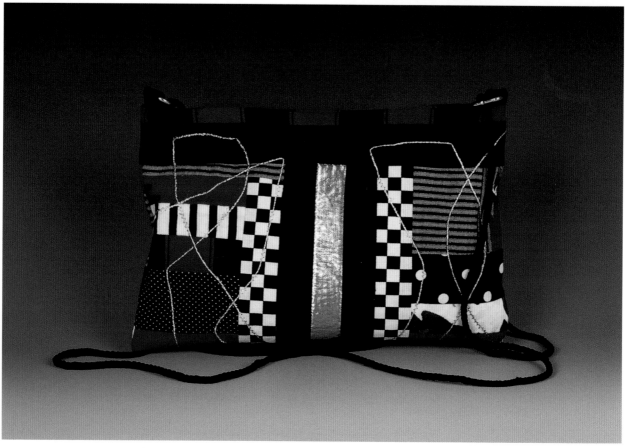

Bag of strip pieced patchwork in black, red, white, and metallic silver fabric, 1999. *By Shirley Friedland.*

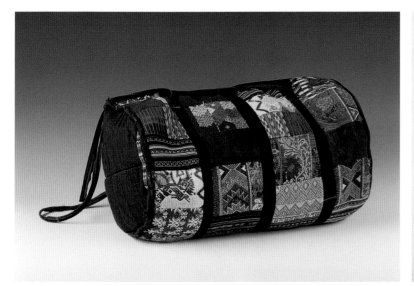

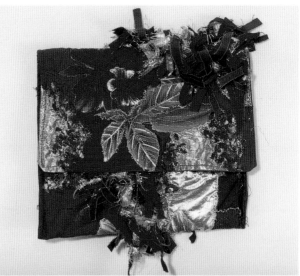

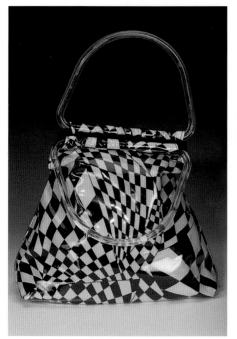

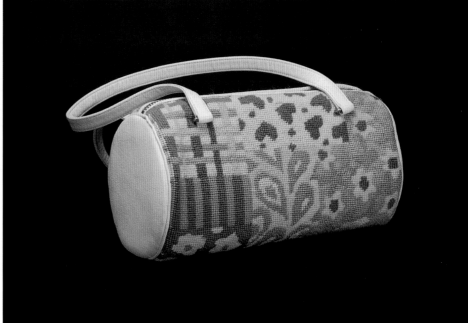

Top left: Navy blue cylindrical carry-all with Guatamalan textile patchwork, c. 1980. *Courtesy of Linda Cohen.* $30-35.

Top right: Clutch bag with machined appliquéd flowers and leaves and loose ribbons, 1990s. *By Joan Goulder.* $25-35.

Bottom left: Plastic handbag with Op Art checkerboard pattern, c. 1960s. *Courtesy of Anna Greenfield.* $25-35.

Bottom right: Cylindrical shaped needlepoint of brightly colored abstract patchwork design, on white leather, c. 1970s. $75-100.

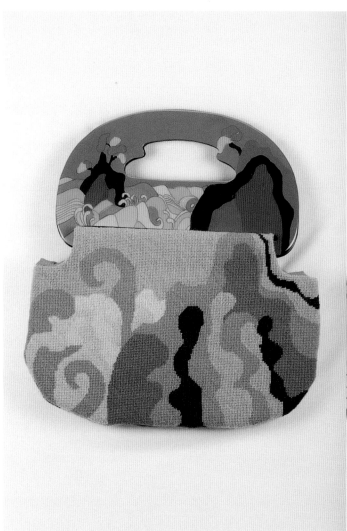

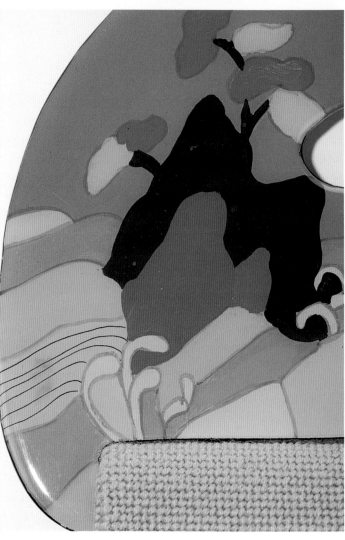

Needlepoint snap-off handbag in multi-color Art Deco revival pattern, with hand painted plastic handle, 14" x 14", c. late 1960s. $200-250.

Detail of handle.

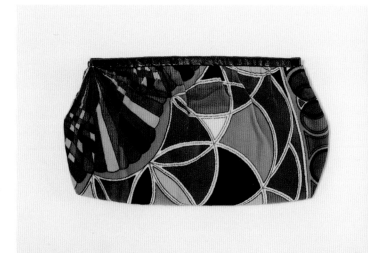

Emilio Pucci print velvet clutch, c. 1970. *Courtesy of Sue Hersh*. $100-150.

Detail.

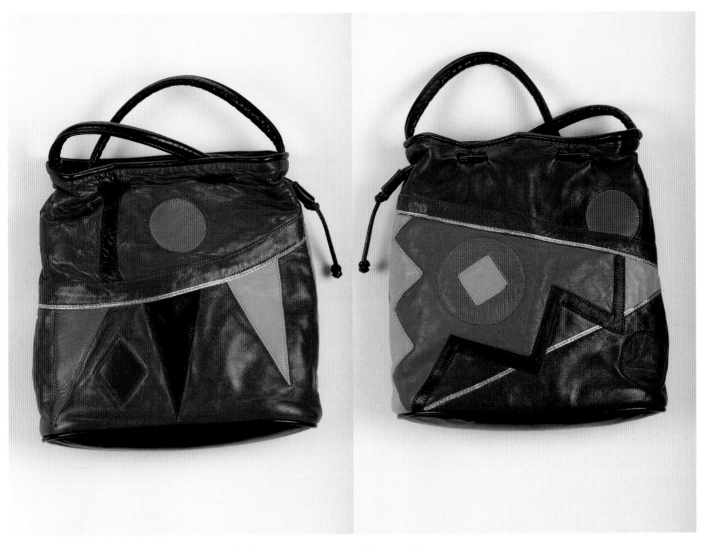

Pieced leather drawstring shoulder bag in vivid colors,
1980s. $75-100.

Reverse side.

Embossed and painted suede purse with silver frame, c. early
1900s. *Courtesy of Anna Greenfield.* $100-125.

Back view.

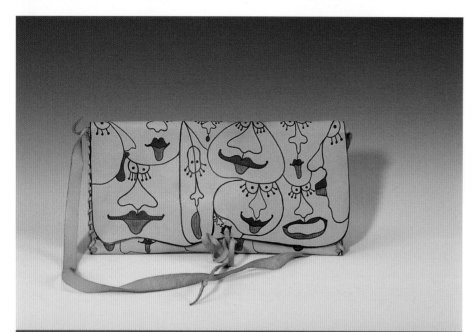

Leather handbag, hand painted faces by Barbara Cohen Ismoloff, c. 1984. *Courtesy of Lillian Horvat.* $50-60.

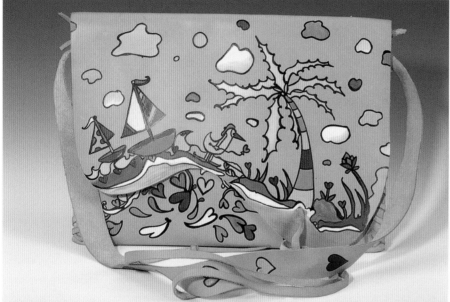

Leather handbag with hand painted tropical island scene by Barbara Cohen Ismoloff, c. 1984. *Courtesy of Lillian Horvat.* $85-100.

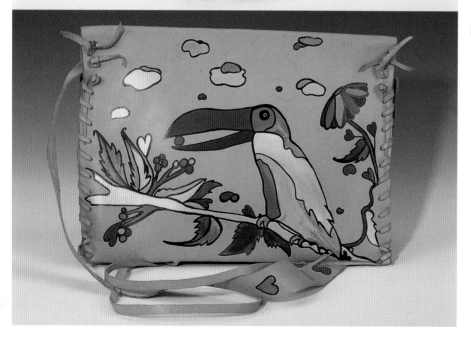

Reverse with toucan.

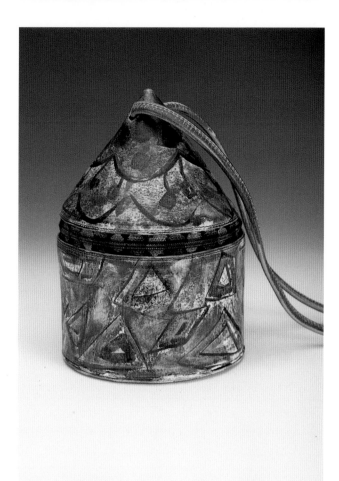

Leather shoulder bag with cylindrical base and cone shaped cover, hand painted in abstract design, by Jane Yoo, c. 1990. *Courtesy of Lorita Winfield.* $100-150.

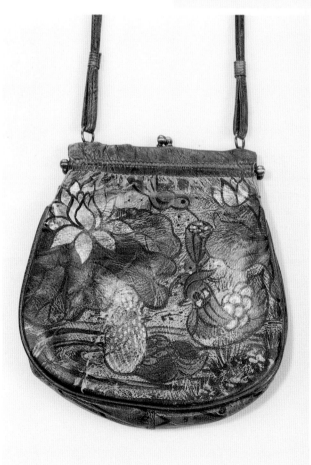

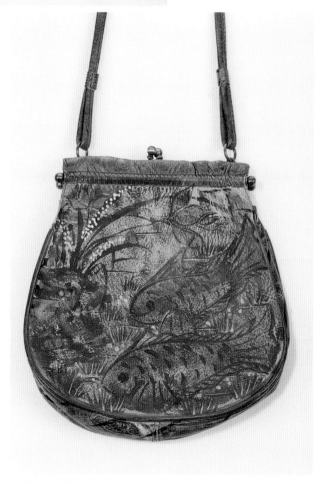

Leather shoulder bag with hand painted birds and flowers, hand signed "Jane Yoo," c. 1980s. *Courtesy of Lorita Winfield.* $100-125.

Fish motif on reverse side.

The following collection of small bags are of hand knit construction using a variety of embellishment techniques including embroidery, appliqué, piecing, quilting, braiding, wrapping, and use of beads and charms. Each is a one-of-a-kind original made by the artist in 1998. Prices range from $125 to $450, depending on size and amount of work involved. *By and courtesy of Susan Cavey.*

Top left: "Al-Lat," named after Ancient Persian lunar deity, with metal embroidery and metallic fabric triangles.

Top right: "Downtown Venus," with dangling beads and charms, African cross bead, and Venus symbol.

Bottom left: "Sappho and the Hetaerae," with accents of gold and sea greens using fabric, buttons, and dangling beads.

Bottom right: "Mercato Giorno," with inset printed fabric, applied gold charms, and dangling beads.

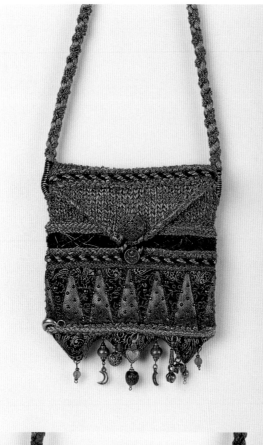
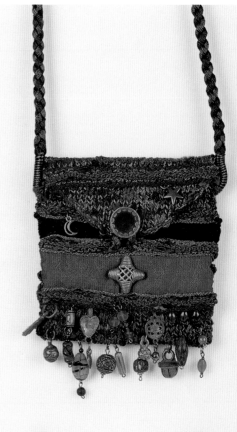
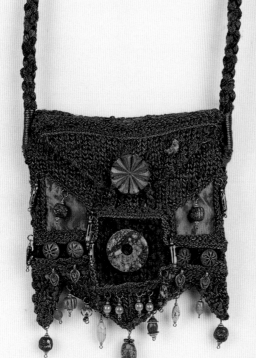
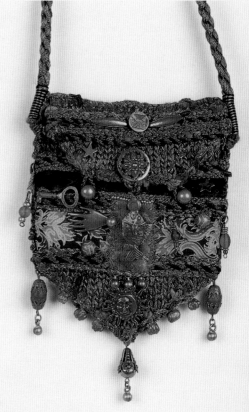

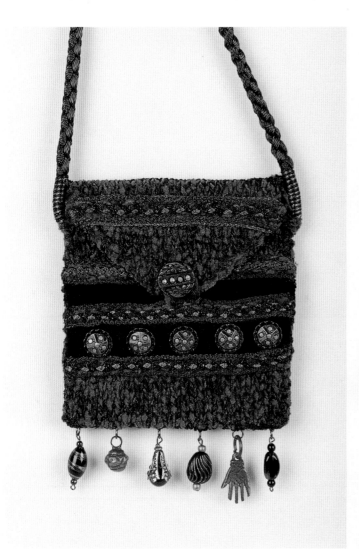

"Seduction," of jewel tone pinks and purples with dangling charms and beads.

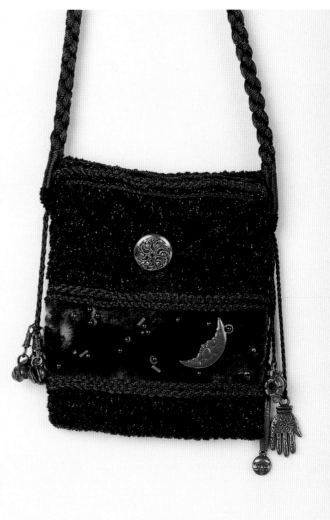

"Mambo Mam'zel," an expression of femininity, in rich red-brown tones, with applied moon and dangling charms.

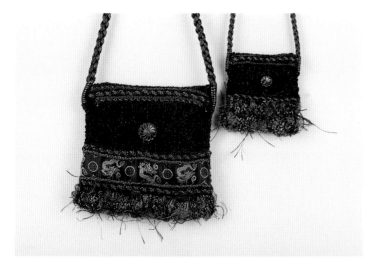

"Jewel Tones," with applied metallic print, 5" x 5", and "Midnight Teal," 2-1/2" x 2-1/2", each in pinks, purples, and turquoise.

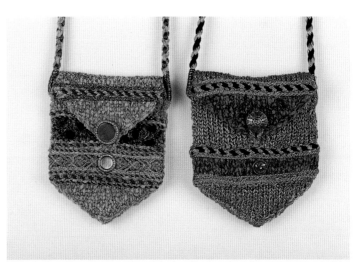

Left: "She-sha" with mirrors and metallic yarns; *right:* "India," both pentangular shape.

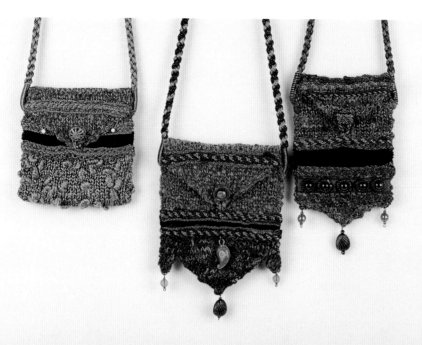

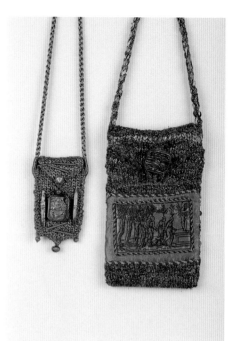

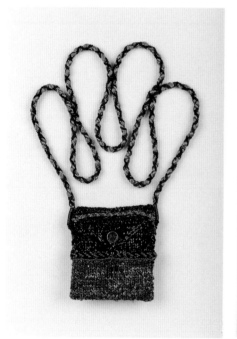

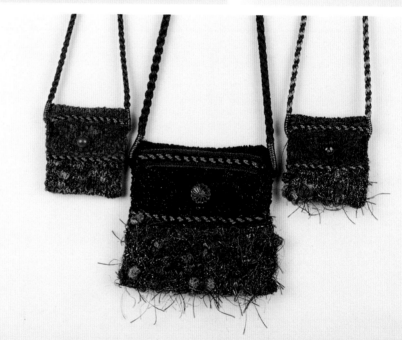

Top left: *Left:* "Sargasso Sea," with nubby texture; *center:* "Puff Paisley;" *right:* "Cha-cha-chatchka."

Top right: *Left:* "Bodhisattva," with metal medallion; *right:* "Tree Woman" with fabric print.

Bottom left: "Walk-a-doo" showing full length of braided cord (included, but not shown on other bags).

Bottom right: *Left:* "Cinnabar;" *center:* "Boysenberry Fizz Gigg;" *right:* Naples Blue;" latter two with fringe yarn.

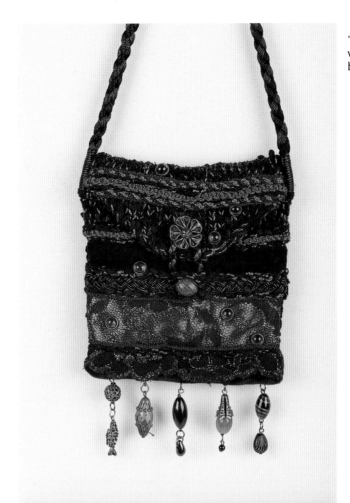

"Barcelona Fantasy" with leather, velvet, lace, stones, and glass beads.

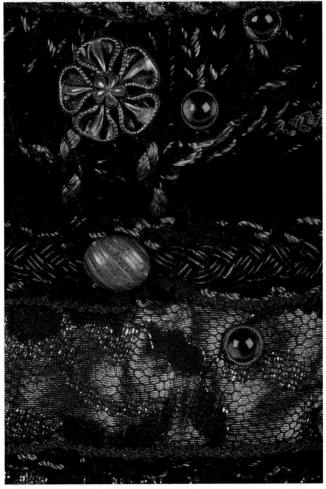

Detail.

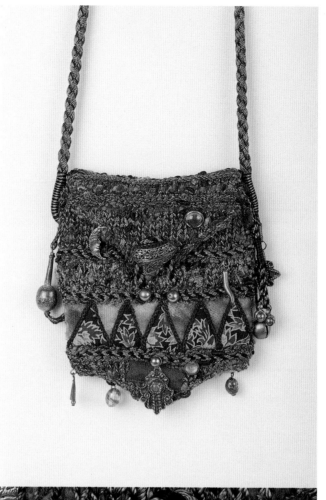

"Transcultural Juju Object" with fabric triangles and silver charms.

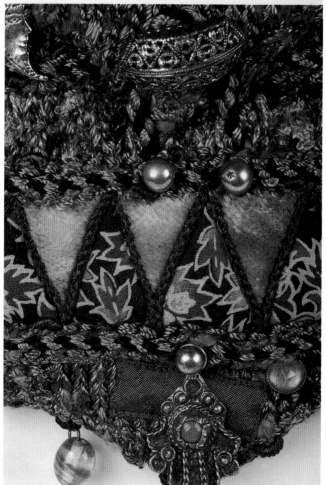

Detail.

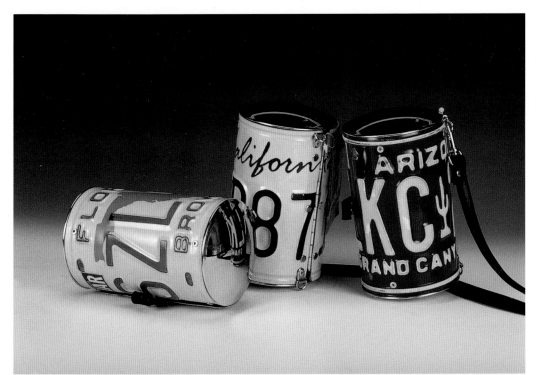

Cylindrical shoulder bags made from recycled state license plates—Florida, Arizona, and California—6-1/2" l., made by Recycle Revolution, late 1990s. *Courtesy of Bonnie's Goubaud.* $65-95 each.

The following figural handbags are from the Timmy Woods Beverly Hills Collection, hand-craved in the Philippines of acacia wood, late 1990s, under $250 each. *Courtesy of Timmy Woods and Bonnie's Goubaud.*

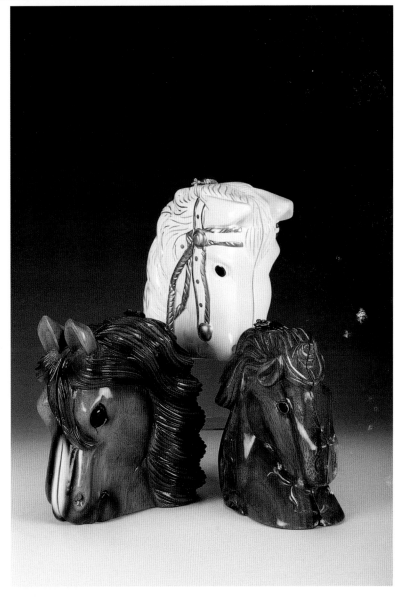

Three horse heads, tallest 7-3/4".

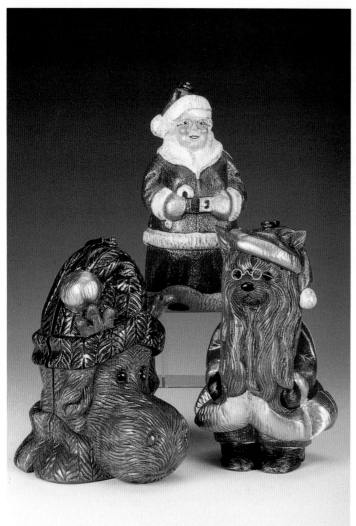

Moose, Santa, and 7-3/4 inch Christmas dog.

Detail.

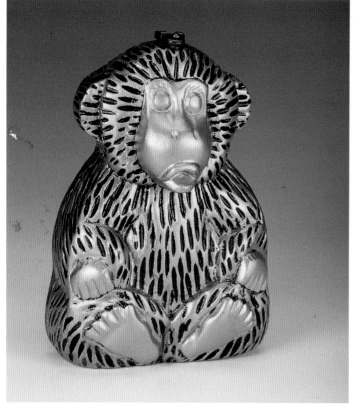

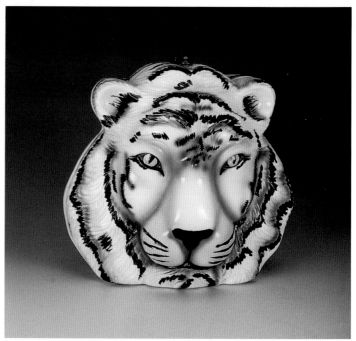

Above: 7-inch wide snow tiger.

Left: 7-1/2 inch gold and black monkey.

Silver, gold, and black ladybug,
7-inch, and moon/sun.

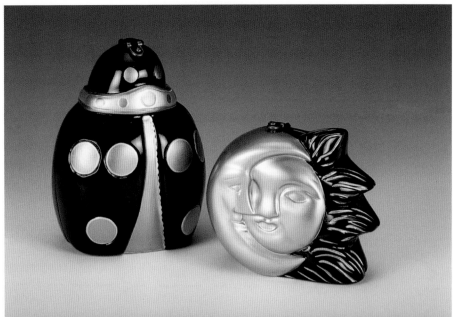

Black cocker spaniel and black
purse with carved relief dog.

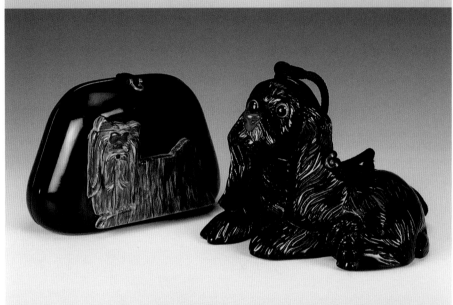

8-1/2 inch long
motorcycle.

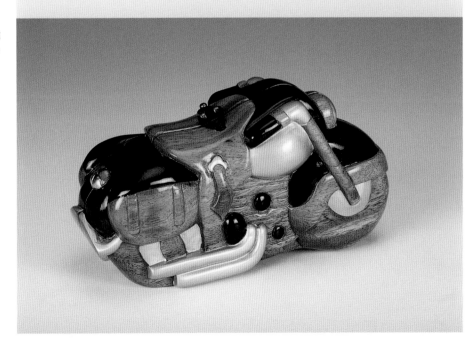

The following 1999 Judith Leiber jeweled evening bags are created by setting each stone by hand; the silk or metal cord can be hidden in the bag or worn on the shoulder. These exceptional wearable art objects speak for themselves. *Courtesy of Saks Fifth Avenue, Beachwood Place.*

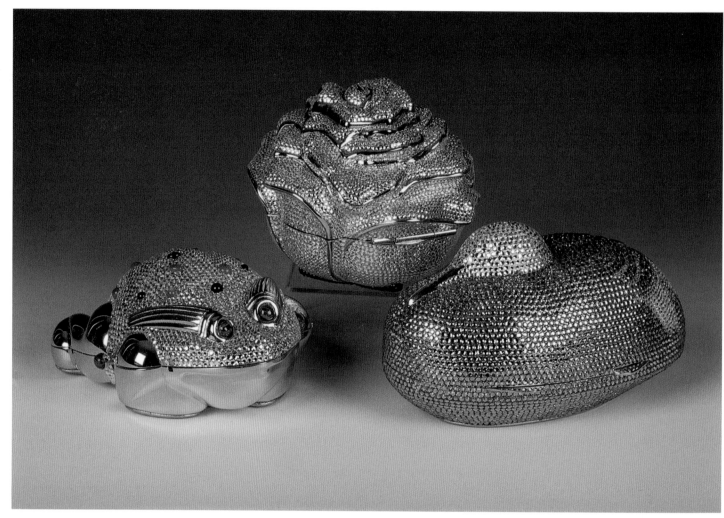

Grouping of primarily gold and silvery bags.

Rose with petals covered in clear rhinestones. $3,100.

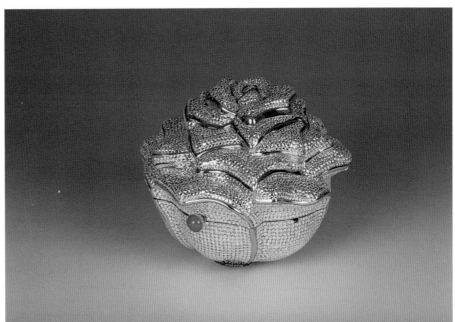

Frog with jade green stones. $2,085.

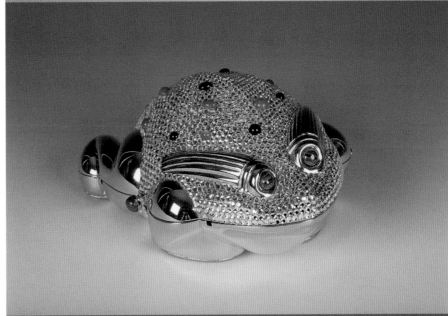

Seated sandpiper in gold and white stones. $2,845.

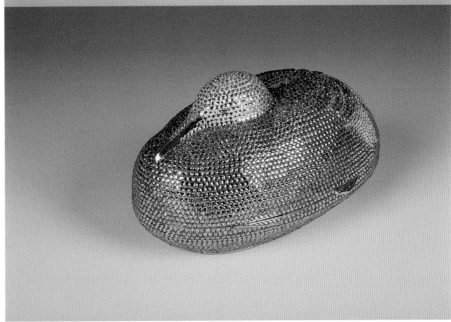

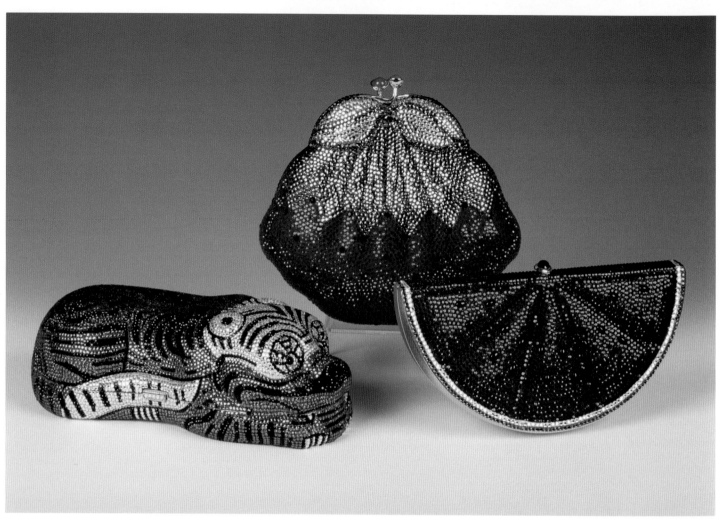

Grouping of boldly-colored fruit and tiger.

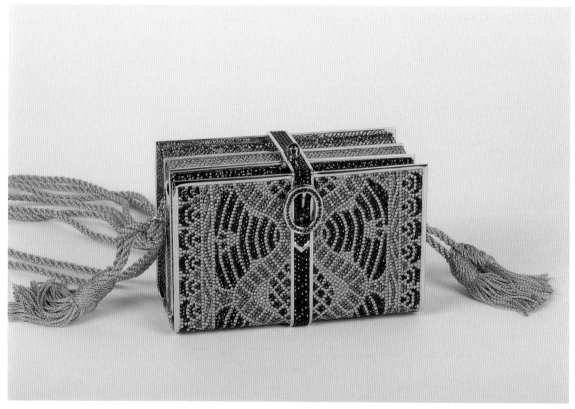

School books in gold metal with topaz and garnet colored stones, silk cord. $3,300.

Strawberry covered in bright red stones and green for the leaves. $3,870.

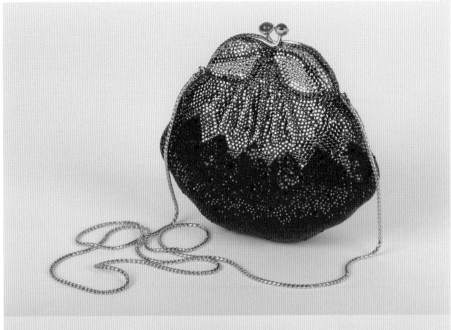

Seated tiger with copper and black stones. $3,555.

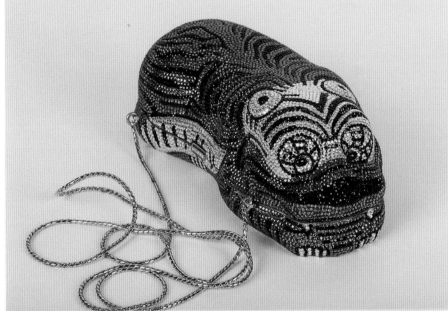

Watermelon slice of dark red stones. $1,985.

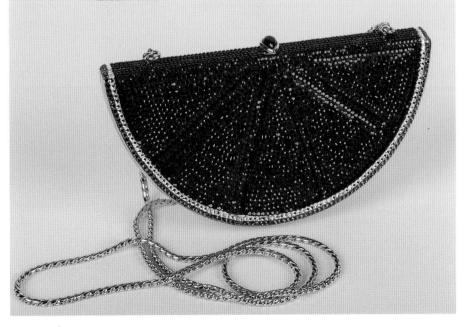

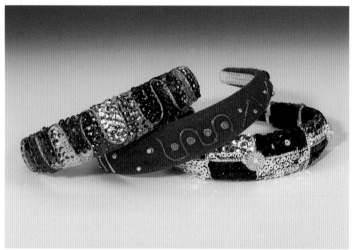

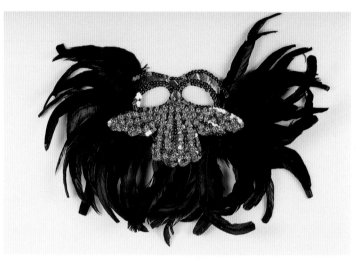

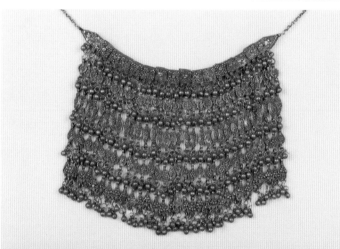

Top left: Tiaras or headbands with sequins and applied decoration, c. 1980s. *Courtesy of Lillian Horvat.* $10-15 each.

Top right: Mask covered with gold sequins and beads, with black feathers, 1980s. $20-30.

Bottom left: Yemenite veil of silver metal bells and linked components, pre-1950s. *Courtesy of Isle of Beads.* $375-425.

Bottom right: Mask covered with black feathers and sequins, with peacock feathers, 1980s. $20-30.

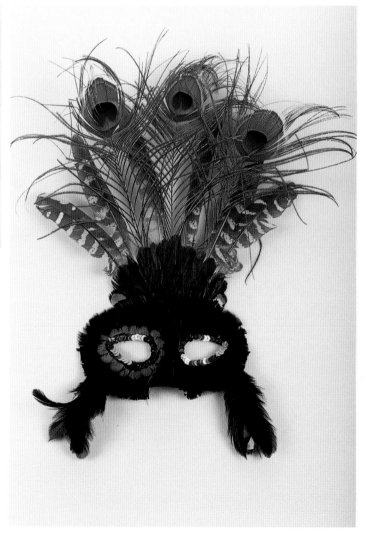

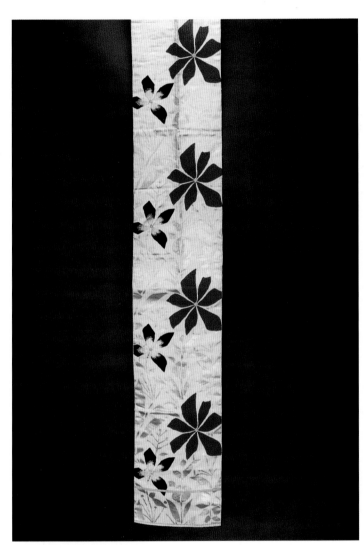

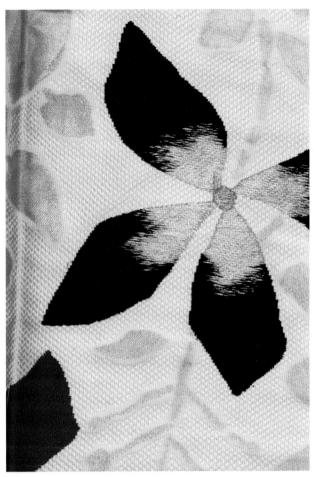

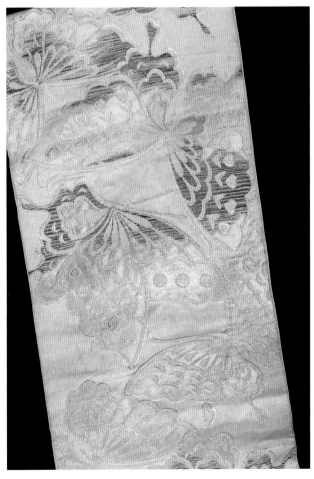

Above: Antique Japanese obi, hand embroidered black and red floral motif on silk, with metallic thread accents. *Courtesy of Sharon Ramsay.* $175-225.

Top right: Detail.

Section of antique obi in satin brocade with pastel butterfly motif. *Courtesy of Sharon Ramsay.* $150-175.

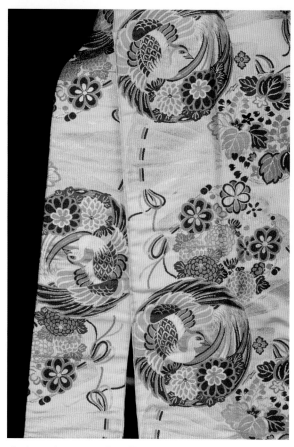

Antique Japanese obi, silk brocade red, green, and yellow traditional floral and bird motifs with gold accents. *Courtesy of Sharon Ramsay.* $300-400.

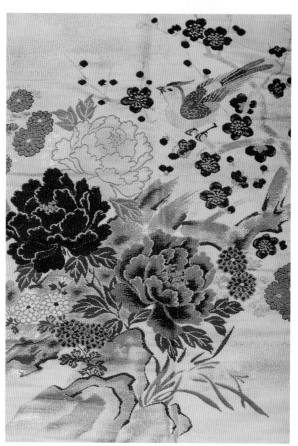

Floral section.

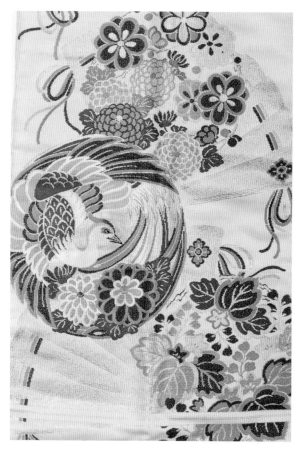

Birds section.

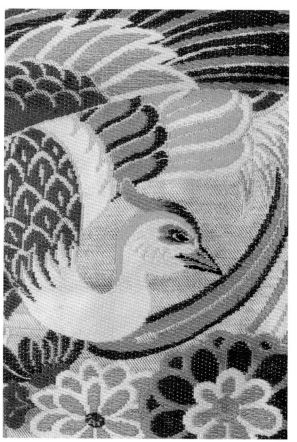

Detail.

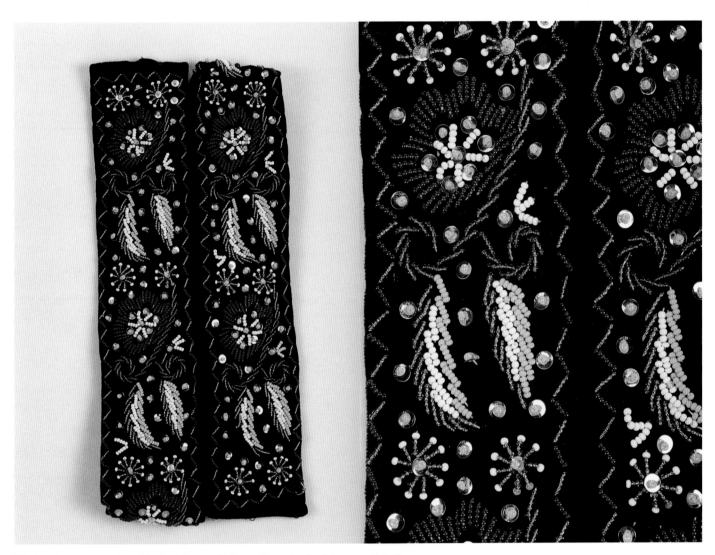

Black velvet cummerbund/belt with overall decoration of colorful seed beads and sequins, c. 1950s. $100-150.

Detail.

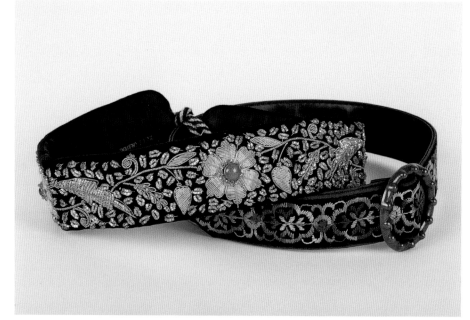

Belts, c. 1970s. *Top:* black velvet embellished with metallic embroidery, faux pearls, and stones, label: Huguette Creations; *bottom:* black velvet with colorful embroidery. *Courtesy of Marilyn Bennett.* $70-80; $25-35.

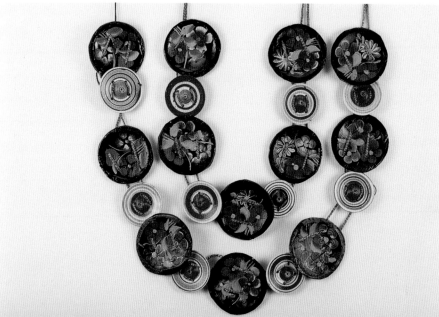

Belts of hand painted wooden discs and sombreros, made in Mexico, c. 1960s. $50-60 each.

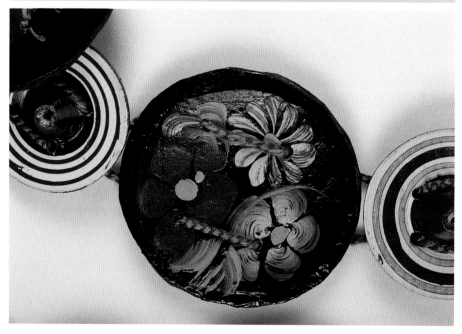

Detail.

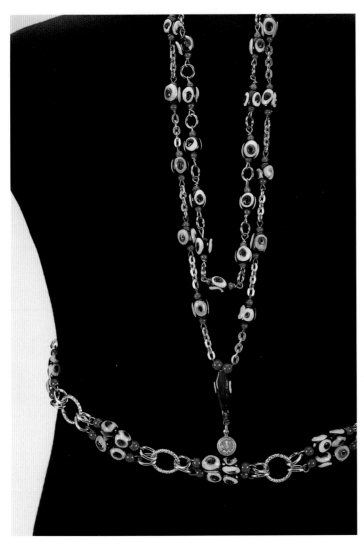

Belt and two necklaces of blue and white glass "eye beads" on metal links, c. 1960s. $40-50 each.

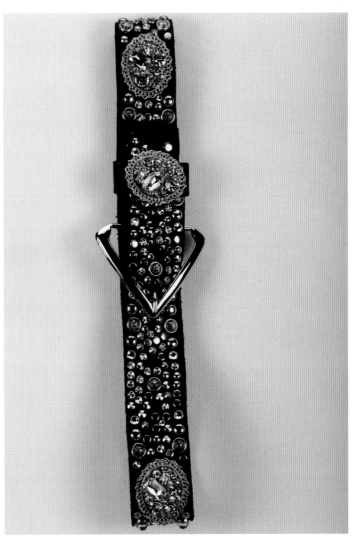

Black leather belt encrusted with metal studs and medallions of cut glass stones, c. 1980s. $100-150.

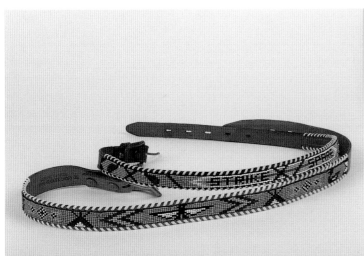

American Indian cowhide belts, hand loom-beaded and laced, c. 1960s and 1970s. $35-45 each.

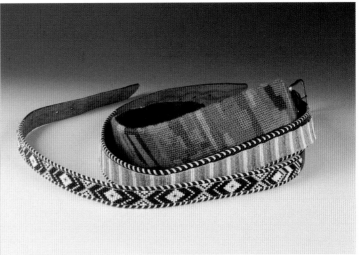

Two American Indian hand loom-beaded belts; colorful needlepoint belt (*top*), c. 1960s and 1970s. $35-45 each.

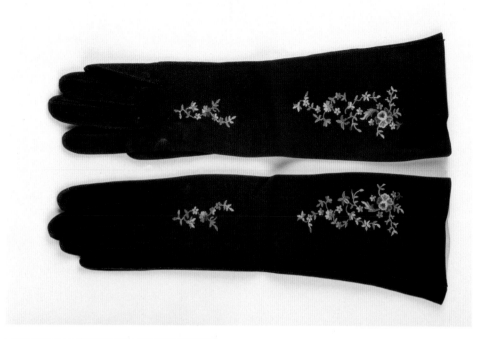

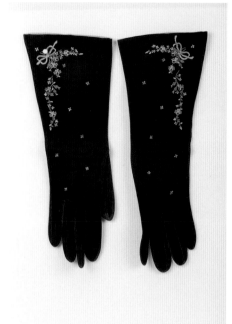

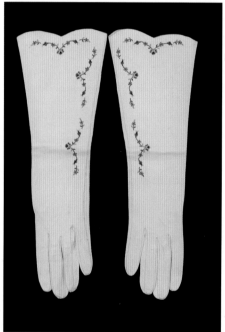

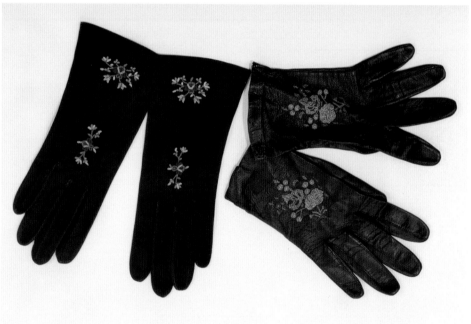

Top left: Black suede evening gloves with hand embroidered floral motifs, made in France, c. 1940s. $80-100.

Top right: Black suede embroidered evening gloves, made in France by Lavable, c. 1940s. *Courtesy of Marilyn Bennett.* $80-100.

Bottom left: White kid embroidered evening gloves, made in France by Lavable, c. 1940s. *Courtesy of Marilyn Bennett.* $65-75.

Bottom right: Black suede (Made in France, for Archie Brown & Son, Bermuda); black leather short gloves with hand embroidered decorations. c. 1950s. $55-75 each.

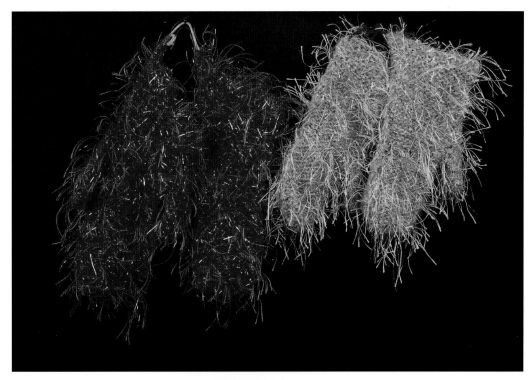

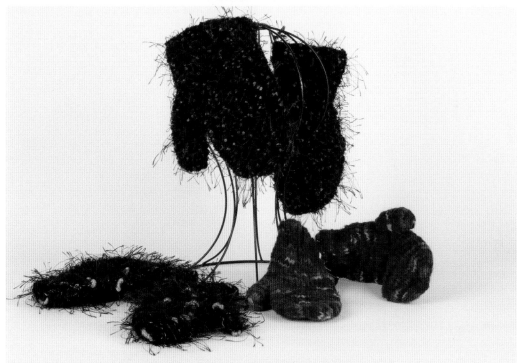

Top: Hand knit mittens in hot pink and lavender fringe yarns, 1990s. *By and courtesy of Liz Tekus.* $50-60 pair.

Bottom: Hand knit mittens in various colorful yarns, 1990s. *By and courtesy of Liz Tekus.* $50-60 pair.

Pot holder mitt, of embroidered pig portrait and red, white, and blue hanging cotton bags, 1980s. $10-15.

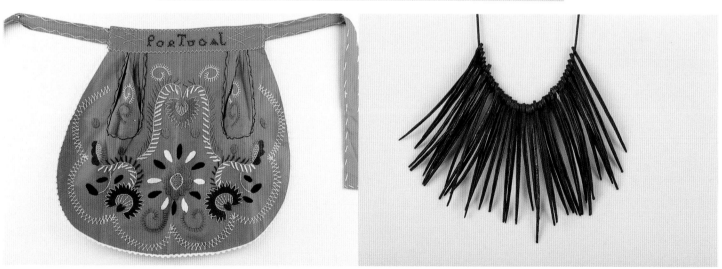

Turquoise cotton apron with embroidered decoration, made in Portugal, c. 1960s. $30-40.

Metal "apron" worn by men, made by the Bamileke tribe of East Africa. *Courtesy of Isle of Beads*. $100-125.

Chapter 6: Shoes & Boots

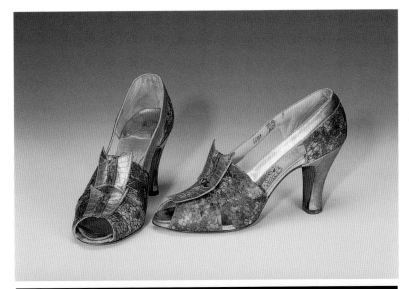

Satin and metallic brocade evening shoes with gold leather trim, Stone Shoe Co., 1930s. *Courtesy of Anna Greenfield.* $40-50.

Detail.

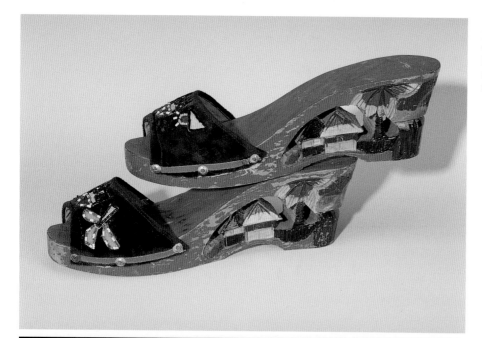

Decorative velvet clogs with carved and painted village scene on platform heel, made in the Philippines, c. 1945. *Courtesy of Ursuline College Historic Costume Study Collection.* $25-35.

Detail.

Detail.

Detail.

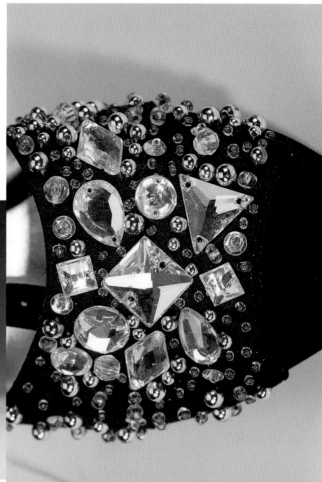

Black suede high heel platform sandals, encrusted with cut glass stones, label, c. 1960s. *Courtesy of Lillian Horvat.* $50-60.

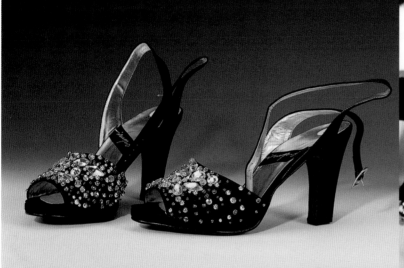

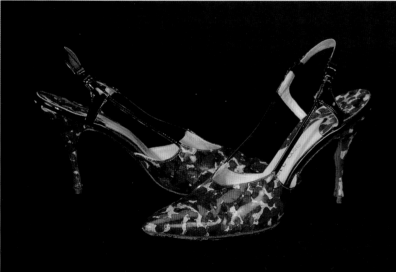

Printed leather, spike heel, sling back with patent leather trim, label, c. 1950s. *Courtesy of Lillian Horvat.* $35-45.

Detail.

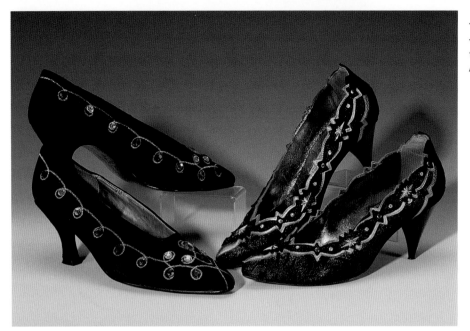

Two pair of black pumps embellished with colored glass stones and metallic trim, c. 1980s. *Courtesy of Lillian Horvat.* $35-45 each.

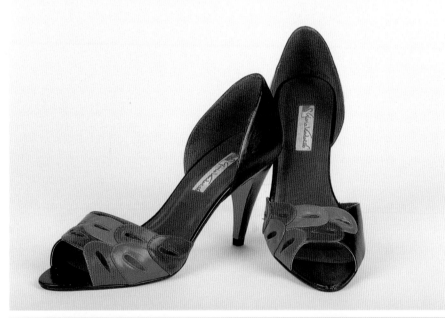

Black leather toeless pumps, the front of multi-colored leather pieces, label: Gloria Vanderbilt, c. 1980s.

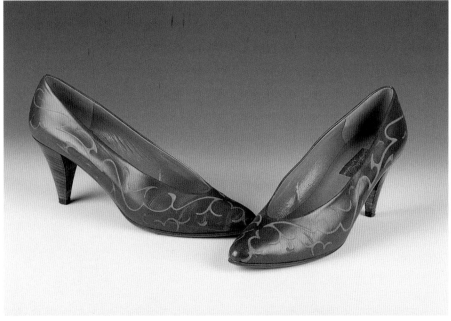

Hand painted grey leather, made in Spain, c .1980s. $35-45.

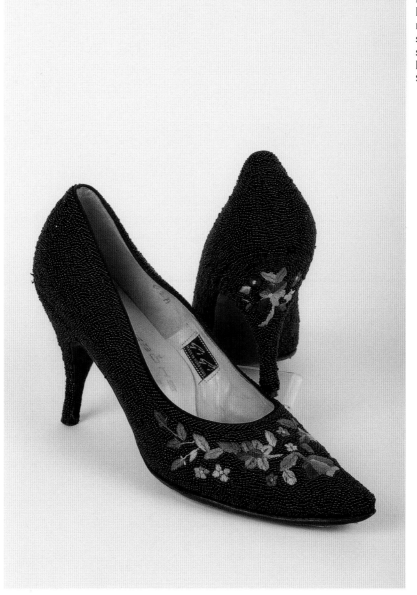

Black evening pumps with hand embroidered floral motif, completely surrounded with black seed beads, made in Hong Kong, c. 1950s. $175-225.

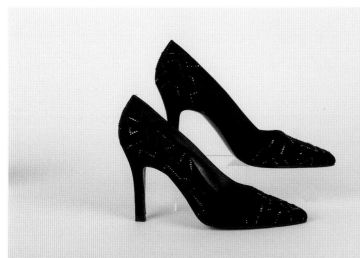

Black evening pumps with stiletto heel, embellished with black seed beads, label: Stuart Weitzman, 1999. *Courtesy of Saks Fifth Avenue*. $655.

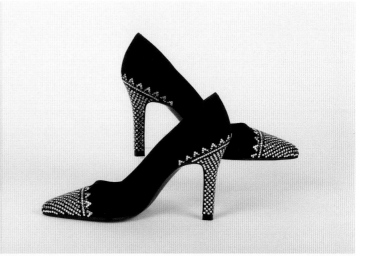

Black evening pumps with toe and stiletto heel studded with rhinestones, label: Stuart Weitzman, 1999. *Courtesy of Saks Fifth Avenue*. $755.

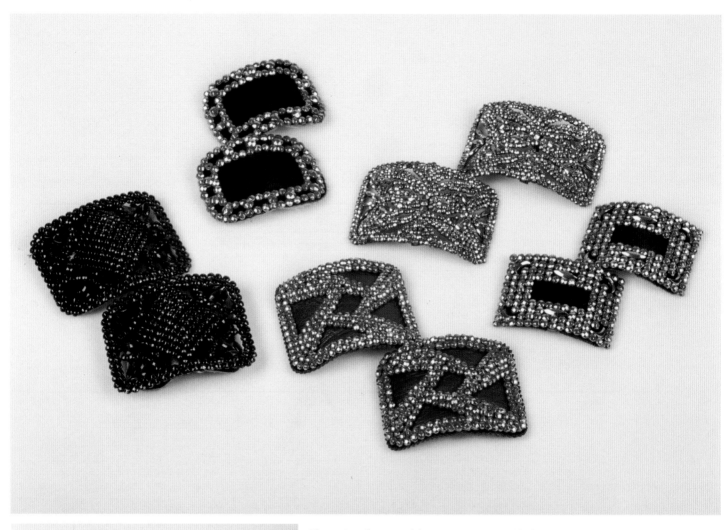

Five pairs of cut steel (to imitate marcasite) shoe buckles, made in France, c. 1920s. $35-75 pair.

Single shoe buckles, c. 1920s. *Top:* turquoise, red, and black enamel, made in France; *bottom:* green enamel on copper, made in Austria. $25-35 each; $75-100 pair.

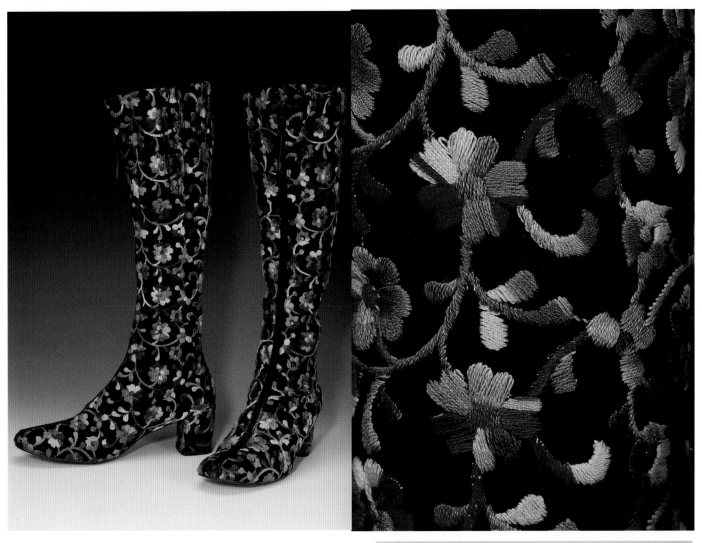

Top left: High black go-go boots with front zipper and overall multi-color floral embroidery, c. 1970. *Courtesy of Anna Greenfield.* $100-125.

Top right: Detail.

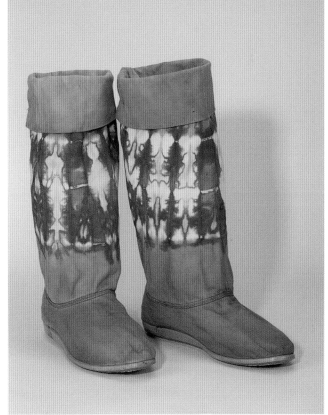

Cotton tie-dyed boots, custom made by Roger's Tie-Dyes for coordinating separates, c. 1980s. $35-45.

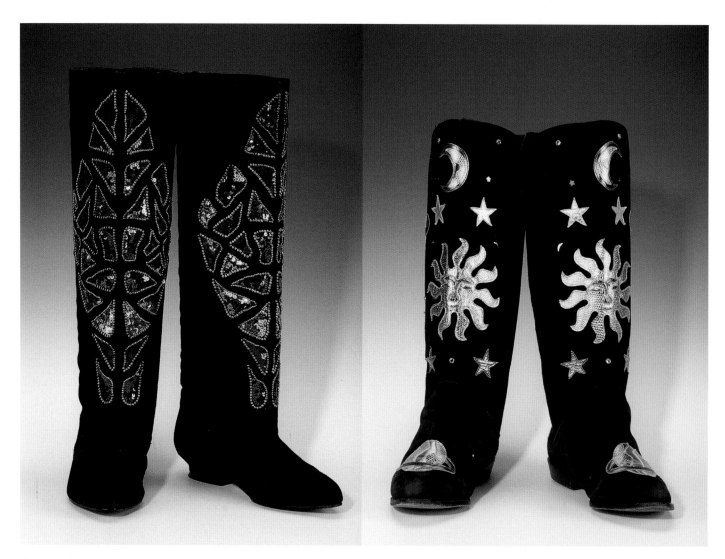

Caparros high black suede boots with colorful sequined
shapes with beaded outlines, 1980s. *Courtesy of Donna
Kaminsky.* $100-125.

High black suede boots with appliquéd metallic sun, moon, and
stars, by Zalo. *Courtesy of Donna Kaminsky.* $100-125.

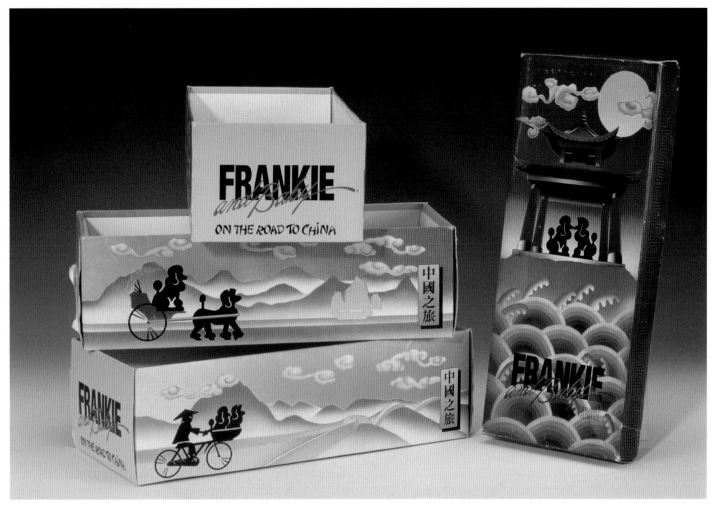

Top: Boxes from Frankie and Baby beaded shoes, c. 1980s-1990s.

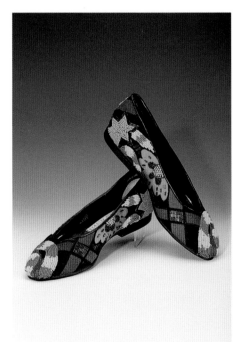

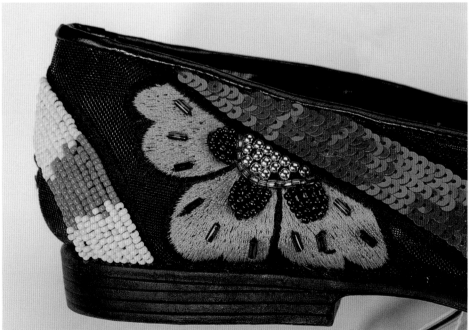

The following Frankie and Baby (and Caparros) beaded and sequined flats are *courtesy of Donna Kaminsky.* $90-150 pair.

Bottom left: "Starshine," Frankie and Baby, Beverly Feldman beaded, sequined, and embroidered flats with colorful bold floral abstract pattern; the company motto is "Too much is not enough."

Bottom right: Detail.

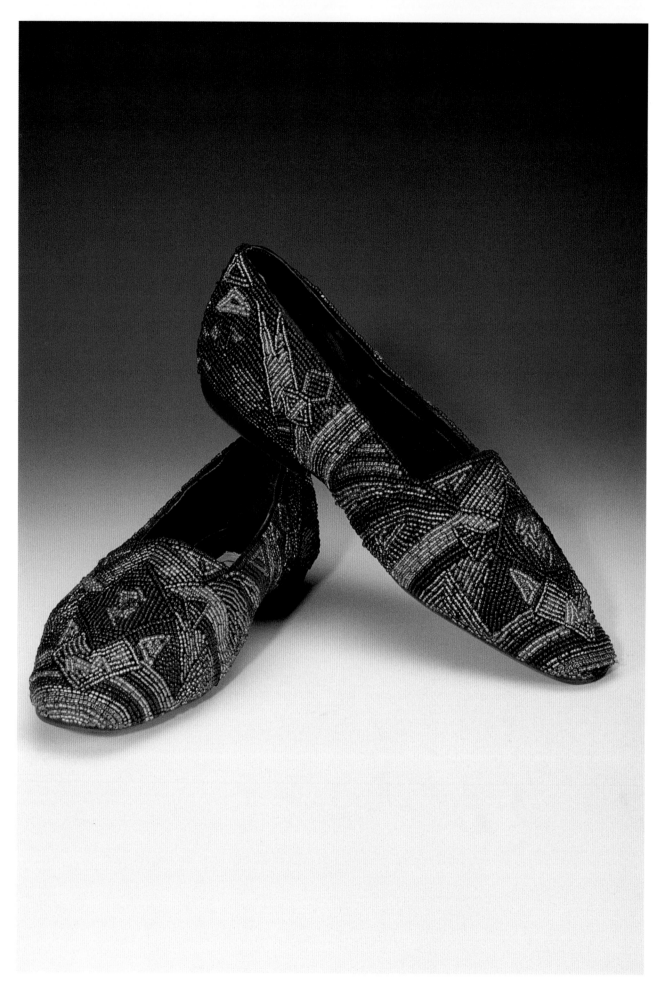

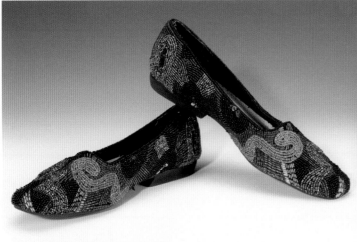

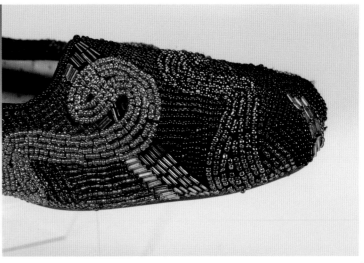

"Inspire," Frankie and Baby, Beverly Feldman beaded flats with jewel tone abstract scroll design.

Detail.

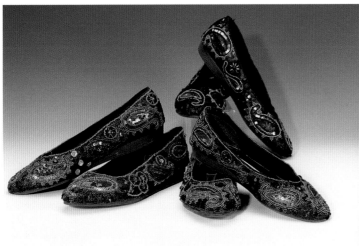

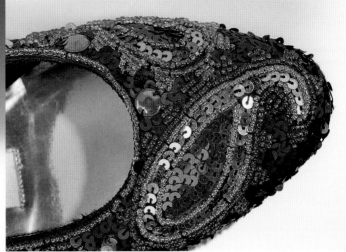

"Taj," three pairs of Frankie and Baby, Beverly Feldman paisley sequined and beaded flats in different color schemes.

Detail.

Opposite page:
Caparros beaded slippers with colorful exotic geometric pattern; the company motto is "The sky's the limit."

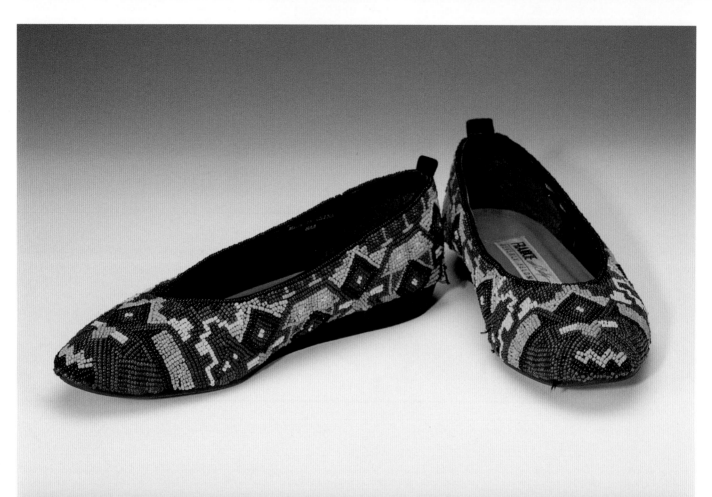

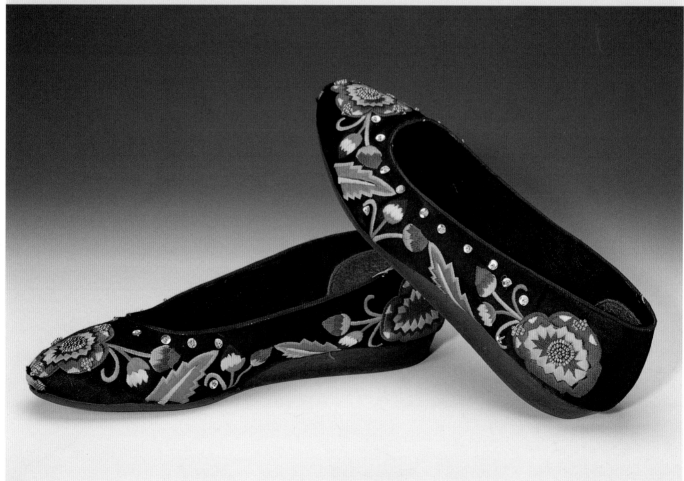

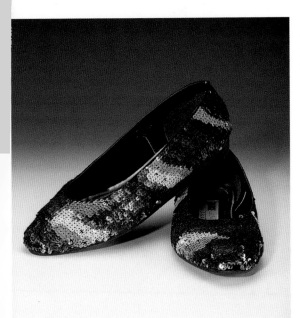

"Illusion," Frankie and Baby, Beverly Feldman sequined flats with colorful rainbow pattern.

"Fancy," two pairs of Frankie and Baby, Beverly Feldman sequined slippers, color block pattern in two schemes.

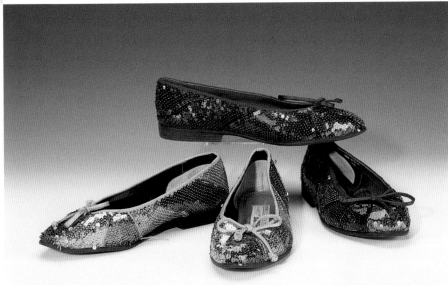

"Beauty," Frankie and Baby, Beverly Feldman slippers with embroidered and sequined abstract motif.

Opposite page:
Top: "Kachina," Frankie and Baby beaded flats, designed by Beverly Feldman with colorful bold geometric pattern.

Bottom: "Lotus," Frankie and Baby, Beverly Feldman satin slippers, embroidered and beaded in stylized floral motif.

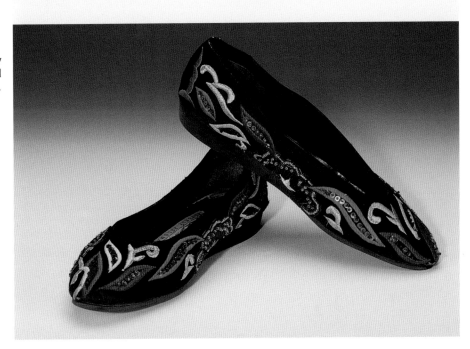

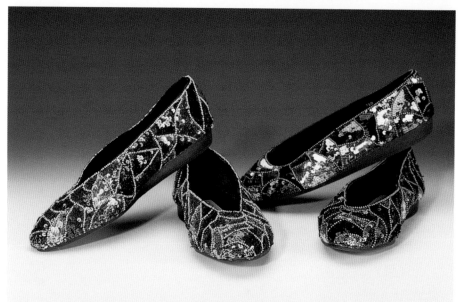

Two pairs of Caparros sequined and beaded flats with color block pattern.

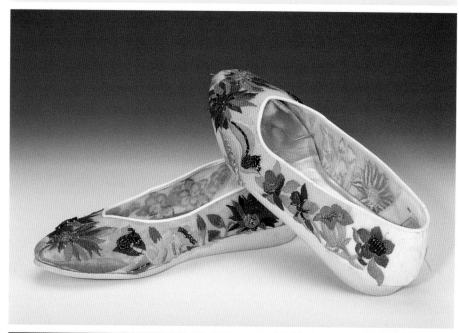

"Lady Bug," Frankie and Baby, Beverly Feldman white mesh flats with colorful floral embroidery and beads on mesh (*last of Kaminsky collection*).

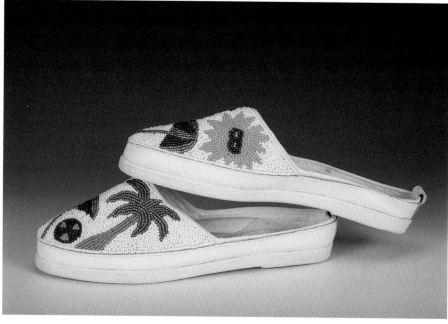

White leather backless slip-ons with beaded palm tree and other motifs, by Colorworks. *Courtesy Bonnie's Goubaud*. $90-110.

Opposite page:
Top: Colorful hand painted leather shoes by Mik Wright. Lace-up high shoe or low boot with flamingos; backless slip-ons with starry night motif. *Courtesy of Fine Points*. $120-170 each.

Bottom: Colorful hand painted leather shoes by Mik Wright. Lace-up oxford type shoes with giraffe and wolf motifs. *Courtesy of Fine Points*. $120-150 each.

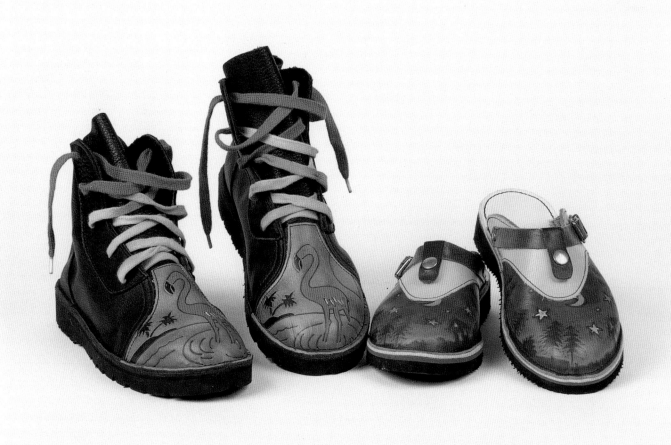

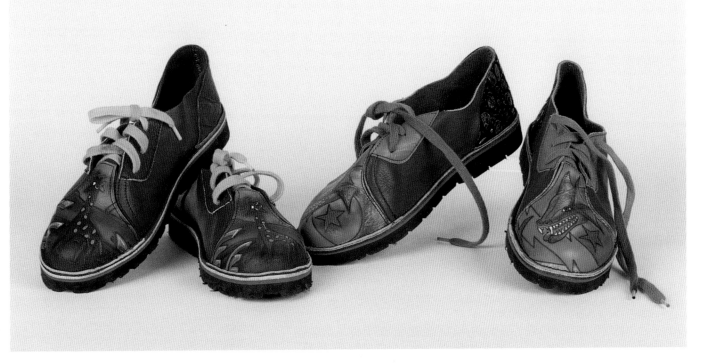

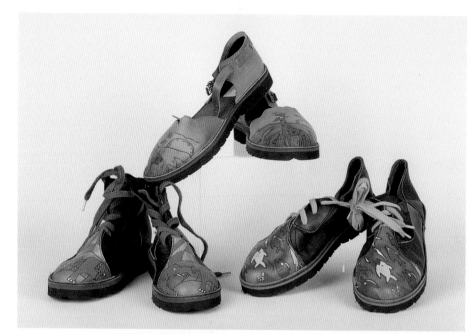

Hand painted leather
shoes by Mik Wright.
Lace-up high shoe or
low boot with elephants;
low oxford with fish;
buckled flat with giraffe.
Courtesy of Fine Points.
$120-170 each.

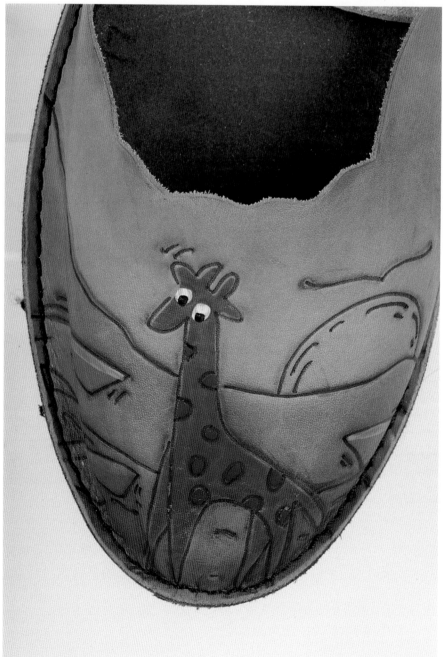

Detail.

Glossary

Abalone - Large sea mollusk with inner layer of shell used in ornamental work (see mother-of-pearl).

Abhala - (see Indian mirror embroidery).

African trade beads - European (primarily Venetian) multi-colored beads made from glass canes and usually barrel shaped; historically used in Africa as currency and for trading.

Appliqué - Design made by applying pieces of fabric or other material to the surface of the fabric.

Aventurine - Venetian glassmaking technique using metallic particles in the glass.

Bakelite - A thermosetting easily carved early plastic, used for a variety of objects from radio cases to jewelry, especially in the 1930s.

Beading - Method of attaching beads to fabric or creating fabric using thread, such as knitting, crocheting, weaving, tambour, and hand sewing.

Brick stitch - Beading technique that looks like the peyote stitch turned sideways.

Bugle beads - Small faceted beads with greater length than diameter.

Cabochon - Stone of convex hemispherical or oval form, polished rather than faceted.

Canvas - Strong netlike foundation onto which needlepoint and petit point embroidery are stitched.

Casing - Two or more layers of glass achieved by blowing while the batch is hot.

Cathedral patchwork - Hand patchwork technique using large squares with precise folds to create a regular pattern of windows.

Charmeuse - Soft, flexible satin (formerly a trademark).

Chatelaine - Hook-like clasp for suspending keys, trinkets, or small purses, worn at the waist.

Chenille - Velvety cord of silk or worsted, used for textural variation in knitting.

Chiffon - Light weight, filmy, translucent fabric of silk or synthetic.

Cloisonné - Enamel on metal with fine wire separating the colors and/or design portions.

Collage - Design formed by piecing shapes of various materials.

Color blocking - Distinct color differences in patches of fabric.

Copal - Semi-fossilized resin used as an economical alternative to amber.

Cording - Strips of fabric-covered cord used as decoration or to separate sections.

Cut Crystal - High quality, clear or colored glass, usually with a high lead content, cut with facets for beads that sparkle.

Dresden mesh - Small loop type mesh popular in evening bags, especially in the 1920s; term sometimes refers to the style of painting loop mesh purses resembling the effect on Dresden china.

Embellishment - Addition of detail or decorative ornamentation.

Embossed - Raised surface design.

Embroidery - Using thread or yarn to create a decorative pattern or design on fabric.

Enamel - Colored powdered glass used to form a design by applying it to metal or other material and heating in a kiln.

Fabric printing - Printing block with cut design is covered with color and pressed onto fabric.

Femo - Clay-like material used in place of glass to make colorful canes for jewelry and other small objects.

Fetish - A small carving of an animal or object, often used in jewelry; has symbolic meaning and/or magical powers for native cultures.

Fiber reactive dye - Bonds with fabric on molecular level once it is steam set and washed.

Filigree - Ornamental work of fine wire, especially in jewelry; lacy pierced designs resembling true filigree, such as on purse frames.

Fringe - Hanging strings or strips of various materials to create a decorative edge or border.

Fringe yarn - Yarn with long hairs hanging at intervals.

Gutta - Synthetic substance used as an outline in fabric painting to prevent one color from running into another.

Hand woven - Woven by a loom powered by hand or foot.

Heishi - Shell beads.

Ikat - Resist dyeing of yarns before weaving; the pattern is resist dyed on the warp and/or weft before dyeing. The cloth is characterized by a blurred or hazy effect.

Indian mirror embroidery - Small mirrors are framed and secured as fabric decoration by the shisha stitch.

Japanese paste resist - Sweet rice paste used to contain the spread of fabric dye.

Jet - Fossilized coal used especially to make shiny black faceted beads and other Victorian and early twentieth-century jewelry.

Knit - Joining loops of yarn by hand with knitting needles or by machine to create fabric.

Lacquer - Resinous varnish used to produce a highly polished lustrous surface on wood or other material.

Lamé - Textile in which the warp or filling uses metallic threads.

Lamp work - Small glass articles or beads made by hand at a bench using a torch.

Lapis lazuli - Deep blue semi-precious stone, composed mainly of lazurite, used as a gem or a pigment.

Limoges enamel - Fine enamel painting on metal, usually done in the Limoges region of France.

Loom beading - Method of even and regular beading with the aid of a loom, producing items such as the bands on beaded collars, belts, and other straight articles.

Macrame - Knotted cord of cotton or other natural fiber to make decorative items.

Marcasite - Iron pyrite faceted to resemble diamonds.

Mesh - Knit, woven, or knotted fabric of open texture; interlocking metal links or wires with uniform openings.

Metallic thread - Core material coated with metal or synthetic to resemble metal; used as decorative accent or for metallic cloth.

Mica - Small bits of the mineral mica used in the hot glass for a metallic effect.

Millefiori - Venetian glassmaking technique: "thousand flower" design using colorful glass canes to create glass objects and beads.

Mola - Reverse appliqué using three or more layers of fabric; colorful designs cut through various layers and hemmed; made by Indians from San Blas Islands, off Panama.

Mosaic - Small pieces of colored glass or other material arranged to form the design.

Mother-of-pearl - Iridescent material from the inside of sea shells, such as from the oyster and abalone.

Natural fiber - Occurring in nature: cotton, wool, silk, linen, flax, ramie, and rayon.

Needlepoint - Embroidery on canvas, usually with uniform spacing of the stitches to create a pattern or design.

Netsuke - Small carved wood or ivory toggle to prevent the inro (small box) from sliding off of the obi (sash) on traditional Japanese costume.

Netting - Thread worked into an open meshed fabric.

Off-loom beading - Method of decorative beading using wire or a needle with thread rather than a loom to produce netting, fringing, or peyote stitch.

Patchwork - Cut pieces of fabric, sewn together to form a pattern.

Petit point - Needlepoint embroidery with extra fine stitches and detail, normally at least 18 stitches to the linear inch.

Peyote stitch - Off-loom bead weaving method resulting in staggered "brickwork" pattern.

Repousse - Decorated or raised in relief by hammering on the reverse side, used especially on silver and other metal.

Resist dyeing - Method or device to protect parts of a cloth while allowing other parts to receive the dye; batik and tie-dye are popular resist methods.

Rondelles - Disc-shaped metal spacers studded with rhinestones, often used with crystal beads or jet to make necklaces.

Rutilated - Fine needles of rutile embedded in a mineral.

Rutile - Common mineral, titanium dioxide, usually reddish brown in color with brilliant metallic luster.

Scrimshaw - Carved or engraved article, especially of whale ivory.

Seed beads - Tiny glass beads.

Seminole patchwork - Pieced fabrics creating a geometric design, originated by the Seminole Indians.

Sequins - Small iridescent discs used to embellish fabric.

Silk screen - Printing method using a framed mesh cloth with the design painted on the screen; a squeegee forces the color onto the fabric.

Sterling silver - 92.5% pure silver with 7.5% alloy, usually copper.

Stump work - Raised or embossed.

Tambour - Method of beading or embroidering, using a hook on the reverse side to pull through threads to create a chain stitch.

Tapestry - Decorative textile woven over vertical warp threads.

Tie-dye - Resist method in which areas of the cloth are tied in knots or with string, allowing the untied areas to receive the dye.

Tulle - Fine netting of silk, rayon, or synthetic fiber.

Variegated - Yarn, thread, or ribbon dyed from one color to another on the same strand.

Vermicelli - Method of beading in a scribbled pattern of long slender threads, resembling thin pasta by that name.

Yemenite silver - Hand wrought, high quality silver beads and objects made in the early twentieth century by Yemenite Jews.

Selected Bibliography

Ball, Joanne Dubbs, and Dorothy Hehl Torem. *The Art of Fashion Accessories.* Atglen, Pennsylvania: Schiffer Publishing Ltd., 1993.

Battenfield, Jackie. *Ikat Technique.* New York: Van Nostrand Reinhold, 1978.

Borel, France. *The Splendor of Ethnic Jewelry from the Colette and Jean-Pierre Ghysels Collection.* New York: Harry N. Abrams, 1994.

Boyce, Ann. *The New Serge in Wearable Art.* Radnor, Pennsylvania: Chilton, 1995.

Cartlidge, Barbara. *Twentieth-Century Jewelry.* New York: Harry N. Abrams, 1985.

Coles, Janet, and Robert Budwig. *Book of Beads.* New York: Simon & Schuster, 1990.

Dale, Julie Schafler. *Art to Wear.* New York: Abbeville, 1986.

Davis, Natalie. *Beads as Jewelry.* Radnor, Pennsylvania: Chilton, 1975.

Elliot, Marion. *Painting Fabric.* New York: Henry Holt & Co., 1994.

Francis, Peter, Jr. *Beads of the World.* Atglen, Pennsylvania: Schiffer Publishing Ltd., 1996.

Gostelva, Mary. *A Complete International Book of Embroidery.* New York: Simon & Schuster, 1977.

Grape, Carol. *Handmade Jewelry.* Cincinnati: North Light, 1996.

Hall, Dorothea. *The Quilting, Patchwork, and Appliqué Project Book.* Secaucus, New Jersey: Chartwell, 1986.

Haertig, Evelyn. *More Beautiful Purses.* Carmel, California: Gallery Graphics Press, 1990.

Innes, Miranda. *Fabric Painting.* London: Collins & Brown, 1996.

Lane, Rose Wilder. *Women's Day Book of American Needlework.* New York: Simon & Schuster, 1963.

Meilach, Dona Z. *Contemporary Batik and Tie-Dye.* New York: Crown, 1973.

Morrill, Penny Chittim, and Carole A. Berk. *Mexican Silver: 20th Century Handwrought Jewelry and Metalwork.* Atglen, Pennsylvania: Schiffer Publishing Ltd., 1997.

Ohms, Margaret. *Ethnic Embroidery.* London: Batsford, 1989.

Probert, Christina. *Shoes in Vogue Since 1910.* New York, Abbeville, 1981.

Reilly, Maureen, and Mary Beth Detrich. *Women's Hats of the 20th Century.* Atglen, Pennsylvania: Schiffer Publishing Ltd., 1997.

Rhodes, Marge. *Needlepoint: the Art of Canvas Embroidery.* London: Octopus, 1974.

Trasko, Mary. *Heavenly Soles: Extraordinary Twentieth-Century Shoes.* New York: Abbeville, 1989.

Wasserstrom, Donna, and Leslie Piña. *Bakelite Jewelry: Good, Better, Best.* Atglen, Pennsylvania: Schiffer Publishing Ltd., 1997.

Index

A

Afghanistan, 91
Africa, 6, 17, 35-40, 47, 48, 50, 51, 60-62, 84, 164
Altman & Fils, 111
American Indian, 42-45, 47, 91, 136, 161
Austria, 83, 116, 117, 170
Art Deco, 23, 88, 101, 103, 123, 124, 126, 135, 140
Art Nouveau, 90

B

Baird, David, 98
Baird, Roberta, 96, 97
Bamileke, 164
Benade, Lynn, 33, 66, 67
Benade, Martin, 67
Bermuda, 162
Bleier, Meta, 65
Blue Moon, 74, 75
Bucherer, 88
Butler, Catherine, 72

C

Caparros, 172, 174, 178
Castlecliff, 90
Cavey, Susan, 144-148
China, 8, 14, 57-60, 64-65, 91, 94, 113, 119, 120
Chuang, Cynthia, 76, 77
City Zen Cane, 73
Codan, 87
Colorworks, 178
Cook, Mike, 67
Czechoslovakia, 100, 101, 106

D

David-Andersen, 87
Delill, 109
Denmark, 87

E

East Africa, 164
Eclat, Sylvia Harwin, 71
Egypt, 22-23
Eisenberg, 90
Evans, 133, 134

F

Fath Jacques, 13
Feinberg, Jay, 49
Feldman, Beverly, 173, 175-178
Frankie and Baby, 173, 175-178
Friedland Shirley, 27, 137, 138
France, 7, 13, 89, 104, 105, 111, 162, 170
Fauré, Camille, 89

G

Gell, Wendy, 88
Germany, 81, 106, 131
Gina Designs, 71
Ghana, 41
Gyokuseki, 68-70
Guatemala, 17, 139

H

Halle Bros. Co., 13
Hawaii, 34, 47
Heller, Yaacov, 93
Hobé, 92, 93
Hong Kong, 169
Huguette Creations, 160

I

Icis Co., 71
India, 40, 47, 59, 62
Iran, 61
Ismoloff, Barbara Cohen, 142
Israel, 63, 93
Italy (see also Venice), 83

J

Japan, 68-70, 73, 137, 157, 158
Jensen, Georg, 87
Jomaz, 92
Joseff of Hollywood, 92

K

Kanda, Mary, 83
Koppel, Henning, 87
Kroma, 78
Kwan Yin, 65
Kyman, Ruth, 76

L

Lavable, 162
Leiber, Judith, 9, 152-155
Lessere, 13
Limoges, 89
Lunch at the Ritz, 71, 72

M

Mandalian, 121, 122, 124-130
Masai, 45
Matisse, 92
Mauritania, 50
Mexico, 18, 62, 87, 93, 95, 160
Meyer, Sharon, 81
Mihalisin, Julie, 79
Miller, Ann, 78
Mr. D., 11

N

Nepal, 62
Newman, Denise, 27, 46, 82, 83
Norway, 87

O

Ockner, Lois, 73
Op Art, 139
Osborne, Sandy, 49, 53

P

Panama, 138
Paris, 13, 111
Pary, Irene Bors, 26
Peru, 18, 94
Philippines, 84, 149-151, 166
Polsky Co., 11
Portugal, 164
Pre-Columbian style, 48, 94, 95
Pucci, Emilio, 140

R

Rebajes, 92
Recycle Revolution, 149
Roger's Tie-Dyes, 171
Rosenstein, Nettie, 90
Russia, 86

S

Schiaparelli, 13
Schwegler, Gunter, 27
Shishak, Okpowruk W., 67
Skove, Susanne Bodenger, 28-32
Smith, John, 67
Spain, 168
Spratling, William, 93
Swarovsky, 80
Switzerland, 7

T

Tekus, Liz, 20, 21, 24, 163
Thailand, 19
Tibet, 8, 59
Tsai, Erh-Ping, 77

U

Vanderbilt, Gloria, 168
Venice, 52, 53, 56-58, 61, 103

W

Weber, Mary Ann, 106
Weitzman, Stuart, 169
Whiting & Davis, 121-126, 128, 131-133, 135
Willcox, Kimberly, 72
Woods, Timmy, 149-151
Wright, Mik, 179, 180

Y

Yemen, 61, 91, 156
Yoo, Jane, 143

Z

Zalo, 172
Zecca, 74, 75
Zuni, 87